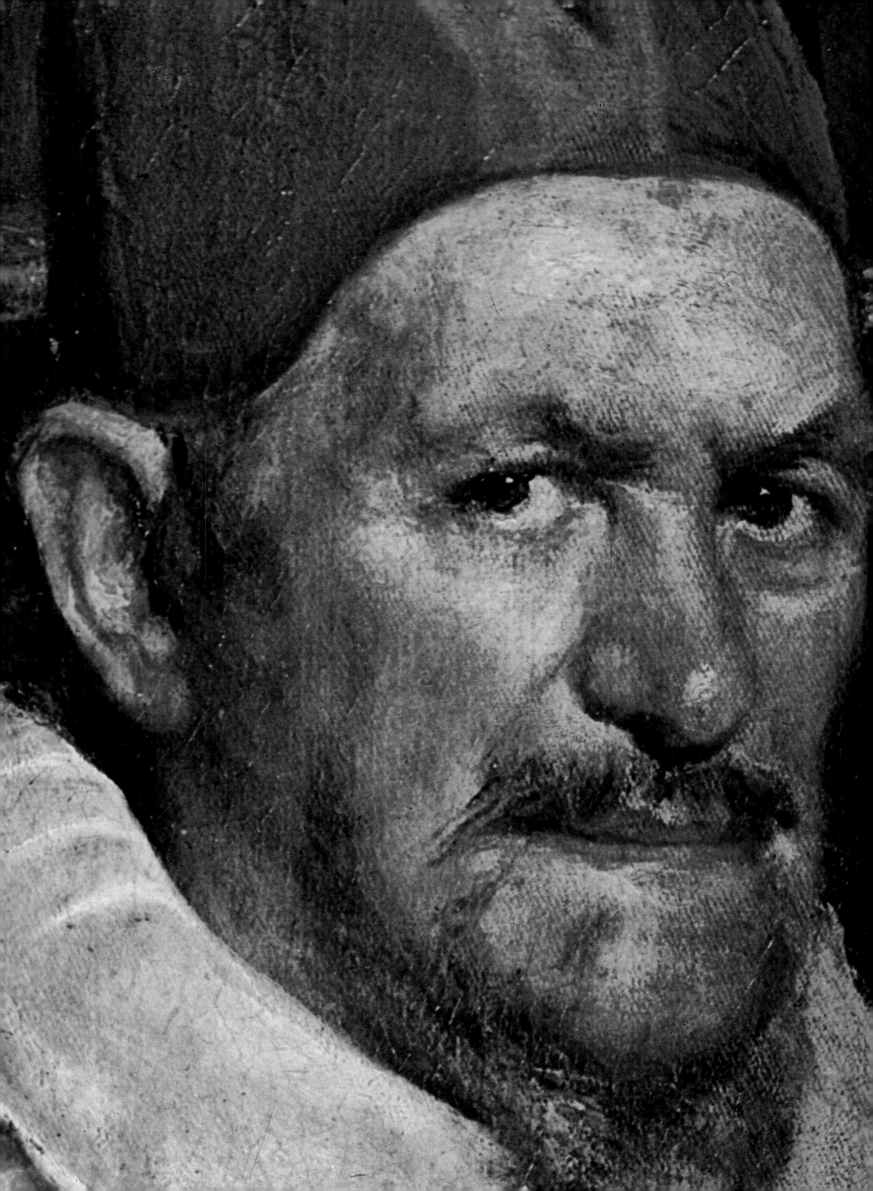

JOSÉ LÓPEZ-REY

VELASQUEZ

Title-page:
POPE INNOCENT X
Detail
Oil on canvas; 55 x 47 in (140 x 120 cm)
1650
Rome, Galleria Doria-Pamphilj
See page 150

VELASQUEZ

JOSÉ LÓPEZ-REY

Captions and catalogue copy
translated from the Italian
by NICOLETTA SINBOROWSKI

A Studio Vista book
published by Cassell Ltd.,
35 Red Lion Square, London WC1R 4SG
and at Sydney, Auckland, Toronto, Johannesburg,
an affiliate of
Macmillan Publishing Co. Inc, New York.

ISBN 0 289 70914 8

© 1978 Arnoldo Mondadori Editore S.p.A.
1st Italian edition: October 1978
Libri Illustrati Mondadori
Printed in Italy by Officine Grafiche di
Arnoldo Mondadori Editore, Verona

*This study is based on my earlier works on the same subject, including my 1978 Velasquez
monograph and catalogue raisonné. I have shortened or omitted the discussion of some lesser
or incidental issues but I have at no point tried to dilute the complex nature of Velasquez'
work or to simplify my interpretation of it.*
*I should like to thank once more all those who throughout the years have helped in my
research on Velasquez. A word of appreciation is due to Anne Birgitté Knudsen who has
assisted me in the preparation of the manuscript and has typed it.*

 J.L-R.

Contents

The apprentice

Diego, the first child of Juan Rodríguez de Silva and Jerónima Velásquez, was baptised at Seville on 6 June 1599. Juan Rodríguez de Silva belonged to the gentry, but with the freedom in the adoption of family names then prevailing, the boy used his mother's name, and it was as Diego Velásquez that he was apprenticed to the painter Francisco Pacheco at Seville in 1611. Later in life, when he had become famous, he sometimes sought to add a nobler ring to his name and signed himself Diego de Silva Velásquez, as he did on a number of documents from 1647 on, and notably on the portrait of *Pope Innocent X*, painted at Rome in 1650, a work of great consequence for his artistic and social success.

Velásquez, however, remained the name by which he was known at the Court in Madrid and elsewhere, except to those of his friends and colleagues who called him just 'the Sevillian'. In fact, in 1627 when he signed the painting, now lost, by which his superiority over the other painters to Philip IV was decisively acknowledged, he added *Hispaliensis*, Latin for Sevillian, to his name.

His early education was, in the fashion of the time, grounded in the study of the humanities, in which he did very well, revealing a knack for languages and philosophy. This was a taste which he kept throughout his life, as the books he collected in his library show. Nevertheless, his vocation for painting led him to enter a painter's workshop at the then not unusual age of eleven.

He seems to have received his training as a painter from more than one master. According to Palomino, an eighteenth century painter and writer on art, whose life of Velásquez is generally reliable, Francisco de Herrera the Elder (c. 1590-1656), and Francisco Pacheco (1564-1644) were his teachers. The story has been developed by other writers that Velásquez entered Herrera's workshop late in 1610 only to be quickly frightened away by the unbearable temper of the master, whom he left for Pacheco.

Pacheco had just returned to Seville from an extended journey when, in September 1611, he signed on Velásquez as an apprentice for the customary period of six years. It was, however, agreed that this period of time would run from the first of December of the preceding year. This agrees with Pacheco's statement that he gave 'five years of education and training' to Velásquez.

According to the terms of the contract, Pacheco undertook to teach the twelve-year-old boy the art of painting as thoroughly as he knew how. This was not the only training that he imparted to Velásquez during those five years, as the education which, though unmentioned in the contract, went with it was of great importance to the young artist. Both the teacher and his pupil had a penchant for studying the humanities.

Pacheco's workshop was a meeting place not only for painters but for poets, public figures and scholars as well. Most of them were men of substantial attainments and learning. Velásquez was thus constantly made aware of new ideas in art and literature. Pacheco was also an amateur theologian, as is reflected in the chapters on sacred iconography in *Arte de la Pintura*. Even his approach to nature was mystical rather than materialistic. If the subjects touched on in

SELF-PORTRAIT
Oil on canvas; 45.5 × 38 cm.
(18 × 15 in.)
c. 1640 (?)
Valencia, Museo de Bellas Artes.
Fragment; heavily damaged and badly restored.

Pacheco's *Arte de la Pintura* are any guide, the young Velásquez probably listened to discussions of such favourite topics of the day as, for instance, *ut pictura poesis*, the superiority of painting over sculpture, the hierarchy of the different kinds of subject matter in painting, or naturalistic painting and the importance of plastic form. He must also have heard Pacheco expound the importance of copying after antique sculptures, and from Michelangelo's or Raphael's works, in order to achieve mastery in painting.

Titian, who had long been regarded as a paragon by the leading painters at the Spanish Court, must have come up for discussion after Pacheco's return from Madrid at the time when he signed on Velásquez as an apprentice. Pacheco was then, of course, fresh from his visits to the Royal collections, rich in master-pieces by the Venetian painter, whom he extols in *Arte de la Pintura* as one of the greatest colourists, even making an effort to explain the 'unfinished' nature of his works.

Pacheco must also have mentioned his astonishment at the views expounded by El Greco, whom he had visited in Toledo, that Michelangelo was a good man who did not know how to paint. This was probably the first time that Velásquez heard about that singular painter who, according to Pacheco, was a great master in spite of his extravagant brushstrokes and paradoxical views on art.

Pacheco, in discussing his ideas on portraiture in *Arte de la Pintura* on which Velásquez must have been raised, tells in a truly understanding manner how the lad, while still an apprentice, devised a method of his own to 'attain assurance in portraying'. He used to bribe a peasant-boy apprentice to sit for him 'in different gestures and poses, now crying, now laughing, without shrinking from any difficulty', and would draw from him a good many heads and other parts of the

HEAD OF A CHILD
White and red chalk on yellowish paper;
21.8 × 16.8 cm. (8½ × 6½ in.)
1617-1618
Madrid, private collection.

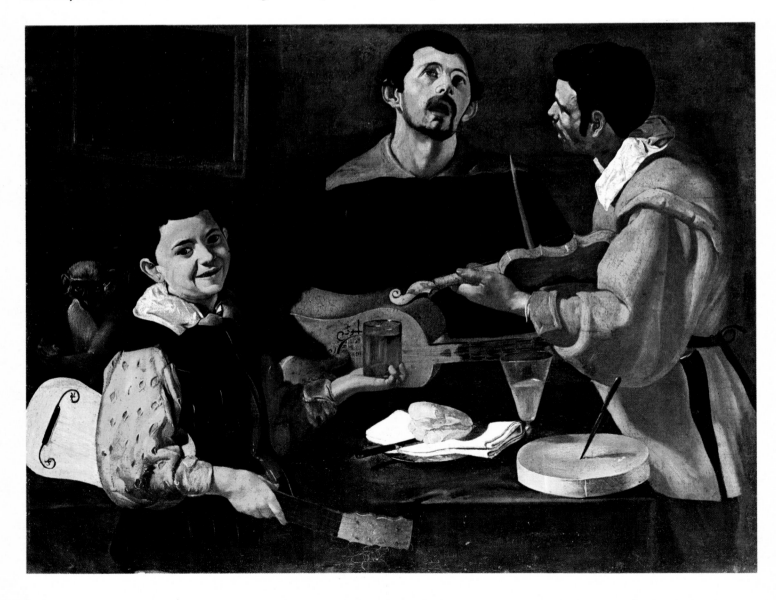

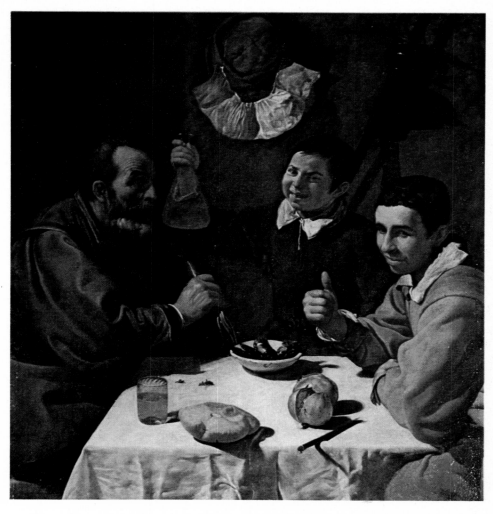

THREE MEN AT TABLE
Oil on canvas; 107 × 101 cm. (42 ¼ ×
39 ¾ in.)
c. 1618
Leningrad, Hermitage Museum (389).
Retouched. Notably darker (the original
colour, however, is still visible under a
strong light).

THREE MUSICIANS
Oil on canvas; 87 × 110 cm. (34 ¼ ×
43 ¼ in.)
1617-1618
Berlin, Staatliche Museen Preussischer
Kulturbesitz, Gemäldegalerie (413F).
Heavily restored.

body in charcoal with white chalk for the highlights on blue paper. Unfortunately, none of these drawings has survived.

On 14 March 1617 Velásquez, having passed a qualifying examination, was made a member of the Guild of St. Luke. This entitled him to have his own workshop, to take in apprentices, and to paint for churches and public places, privileges he lost no time in availing himself of.

On 23 April 1618 he married Pacheco's daughter, Juana who was three years younger than himself. Pacheco favoured the marriage because of Velásquez's 'virtue, purity of blood, and good parts and by the hopes of his natural and great intellect'. Within less than three years, two daughters were born to the young couple. One of them, however, died soon after, and Francisca remained their only child.

Velásquez advanced smoothly into comfort and recognition. His works, especially his *bodegones*, kitchen or tavern scenes with the emphasis on still-life, had made an impact on the Sevillian painters of his generation and possibly on older ones, such as Pacheco, too. Indeed, according to Pacheco, Velásquez soon stood head and shoulders above any other painter of *bodegones*.

Of the extant twenty-odd works which he painted at Seville between 1617 and 1622, nine are *bodegones*, including *Christ in the house of Mary and Martha* (page 16) and *The Supper at Emmaus* (page 28) which lend themselves to this classification in spite of their Biblical subject matter. A large number of copies or imitations of Velásquez' *bodegones*, datable to approximately these years, reveal an eager acceptance of the young master's achievements by his contemporaries. Velásquez went on to create new forms of expression, not only in his *bodegones* but in his portraits and religious compositions as well.

By the spring of 1622 he felt confident enough to set out for Madrid, according to Pacheco 'desirous of seeing the Escorial', which housed a wealth of pictures by great masters, and with the ambition of portraying the seventeen-year-old Philip IV and his Queen.

The young Velásquez in Madrid

Philip IV had come to the throne just one year earlier, in 1621, and had from the beginning left the cares of state to the Count-Duke Olivares. However, the young monarch took from the start a keen interest in matters of art. He retained, as custom decreed, the Court painters who had served under his father, Philip III; yet he decidedly favoured Rodrigo de Villandrando over the others, Bartolomé González, Eugenio Caxés, and Vincencio Carducho. In fact, a few months after coming to the throne, Philip IV signified his preference by fulfilling Villandrando's ambition to be Usher of the Chamber, a much coveted distinction that the sovereign would bestow only on one other painter—Velásquez. It is likely that Velásquez' work was known to Olivares, who in 1619 had spent several months at Seville, where he surrounded himself with scholars, poets, artists and connoisseurs. One of them was Francisco de Rioja, who had the year before acted as a witness at Velásquez' wedding; he might have mentioned the promising young painter to the Count. Pacheco also knew the Count, whose portrait he had painted in 1610, and he surely would not have let his son-in-law go unnoticed by so important a prospective patron as Olivares.

Don Juan de Fonseca, a canon from the Cathedral of Seville and a writer on art, was then chaplain to the new King. He admired Velásquez' painting, and determined to further his career; although he failed in his efforts to secure an opportunity for his protégé to portray the Sovereigns. It was instead with a portrait of the famous poet *Don Luís de Góngora* that Velásquez' first won recognition in Madrid (page 38).

Besides the royal collections at the Alcázar, or Royal Palace, the Escorial and other nearby places, Velásquez would naturally have seen some of the outstanding private collections in Madrid. It is likely that he stopped at Toledo on his way to or from Seville, as Pacheco would probably have urged him to do so. Góngora or any other of El Greco's admirers who were prominent in Madrid's intellectual life might also have suggested that he visit Toledo, where, as Góngora put it, El Greco had achieved eternal life.

While in Madrid, Velásquez would surely have heard that Philip IV had rewarded Rodrigo de Villandrando the year before with the appointment to the position of Usher of the Chamber. On his way back to Seville, the young painter probably mused over the high recognition and honours that an artist could attain only at Court.

Within a few months, in December 1622, Villandrando died, and in the spring of 1623 Don Juan Fonseca, that early and as such discerning admirer of Velásquez, was able to convey to him Count-Duke Olivares' command to come to the Court. Velásquez set out again for Madrid, this time with brighter prospects. His protector, Fonseca sat to him and as soon as the portrait was finished it was taken to the Royal Palace, where within an hour everybody, the courtiers, the Infantes, and even the King, had seen and admired it. Velásquez was directed to paint the portrait of the Cardinal Infante but 'it was thought more advisable' that he should first portray His Majesty, an indication of the painter's, and Fonseca's, success.

The King was very pleased with his portrait; Olivares said, with the rest of the nobility in agreement, that it was the first true portrait of Philip IV. The young artist's highest expectations were fulfilled as Olivares invited him to move to Madrid and promised him that from then on he would be the only painter to portray the King and that such other portraits of the sovereign as then existed would be withdrawn.

At the same time as Velásquez painted the portrait of the King he also did a colour sketch, now lost, of the Prince of Wales, the future Charles I, who was in Madrid to discuss the possibility of marriage to the Infanta Maria, Philip IV's sister. The young painter was rewarded with one hundred *escudos* for this portrait. Velásquez was formally admitted into Philip IV's service on 6 October 1623 at a salary of twenty ducats a month with the obligation to paint such works as might be ordered. But before the month was over Philip IV bettered the financial terms, ordering that, in addition to his salary, Velásquez was to be paid

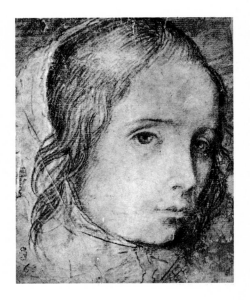

HEAD OF A GIRL
Charcoal on yellowish paper; 15 × 11.7 cm. (6 × 4¾ in.)
c 1618
Madrid, Biblioteca Nacional (16-40, 22). Damaged by damp among other things. Crudely retouched along the line of the jaw by another hand.

BUST OF A GIRL
Charcoal on yellowish paper; 20 × 13.5 cm. (8 × 5¼ in.)
c. 1618
Madrid, Biblioteca Nacional (16-40, 21) 'Velazquez' written in ink is a later addition. Damaged by damp, mainly in the area around the mouth and chin

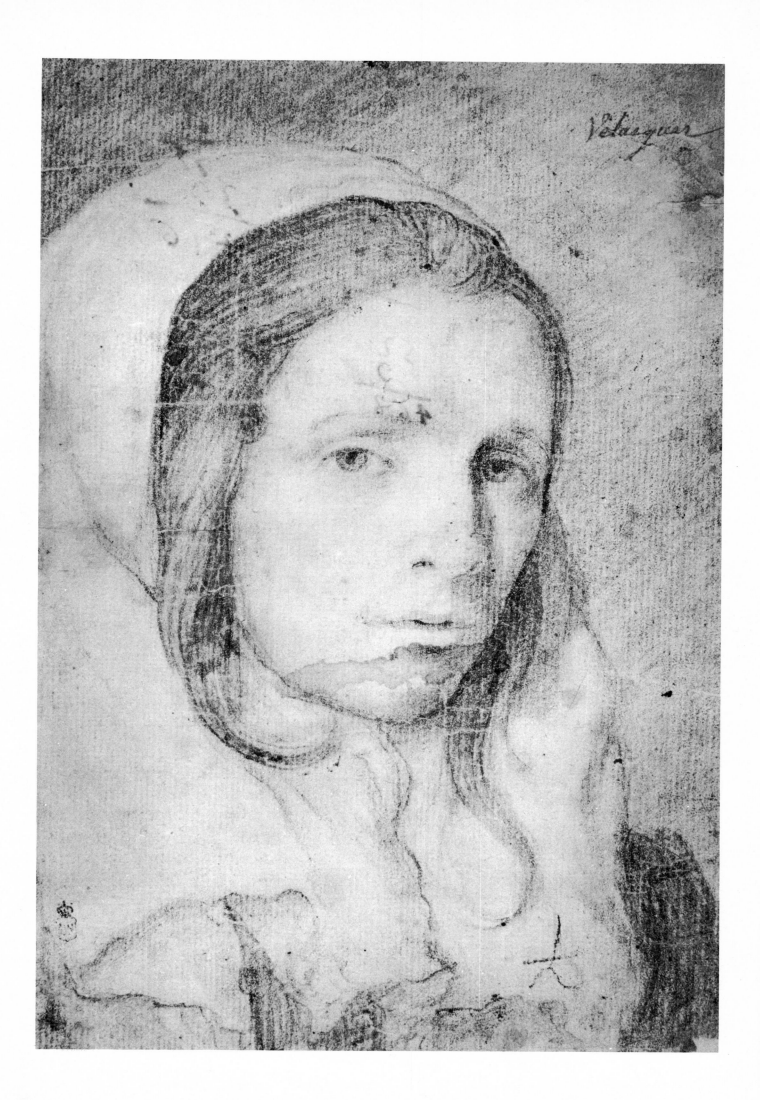

for whatever paintings he executed as painter to the King.

The twenty-four-year-old Velásquez had now joined the exclusive company of three painters who were at least twice his age and who had achieved recognition in the reign of the preceding monarch: Bartolomé González (1564-1627), Vincencio Carducho (1570-1638), and Eugenio Cáxés (c. 1577-1634).

As Pacheco saw it, Velásquez had achieved a 'true imitation' of nature in both his *bodegones* and his portraits. Vincencio Carducho, however, looked down on *bodegones* and naturalistic portraits as unsuitable subjects and may well have had Velásquez' works in mind when he chastised men of letters, art lovers and wealthy individuals who paid high prices for paintings which faithfully imitated everything, cloth, linen, 'the pitcher, the knife, the bench, the loaf of bread, the fruit', animals and even man—all without the benefit of intellectual endeavour, without reflection on the design or sufficient study.

Carducho's treatise, *Dialogos de la Pintura*, did not appear in print till 1634, but his views on art must have been widely known in Madrid in the mid-1620's, when Velásquez came to the fore as a Court painter. Carducho's book embodied the faded convictions, persistent routines, vested interests and carping recognition which stood in Velásquez' way and which, from what we know, he simply ignored. Everything indicates that Carducho and other painters of his persuasion regarded Velásquez as an upstart who ought to be kept in his place. The resounding success of Velásquez' equestrian portrait of Philip IV, of 1925, now lost, only increased their animosity.

The animosity that Velásquez' fellow Court painters harboured against him was put to a decisive test by Philip IV, who in 1627 commanded Carducho, Caxés, Velásquez and Angelo Nardi—the latter probably filling in for Bartolomé González, who was apparently ill—each to paint a large canvas with the portrait of Philip III and the explusion of the Moors decreed by him in 1609. Philip appointed Juan Bautista Maino and the Roman architect Giovanni Battista Crescenzi as a two-man jury; both found Velásquez' picture superior to the others. The King agreed with their verdict and as a reward he appointed Velásquez Usher of the Chamber. This was the first in a long series of royal distinctions that the King was to bestow on him throughout his life. On 7 March

1627 Velásquez was sworn in. Following this success he was moreover, able to reach a settlement with the Treasury of the Royal Household which had been decidedly remiss in making the payments due to him.

Before the end of 1627 there was another brush between Velásquez and the older Court painters, Carducho and Caxés, when the three were commanded to select the best candidates out of the twelve applicants for the salaried position of titular painter to the King left vacant by the death of Bartolomé González. The disagreement centred on Félix Costelo, a former pupil of Carducho, whom both Caxés and Carducho eagerly listed as their second choice, while Velásquez acidly stated that he had no knowledge of his competence. Actually none of the candidates seems to have been worthy of immediate choice, and Philip IV decided not to appoint any of them for reasons of economy. Yet, some years later he appointed Angelo Nardi, Velásquez' second choice, to the vacant position, though at a lower salary.

Carducho and Caxés continued losing ground with the King, who consistently denied their petitions, despite the open support lent to them by royal officials. Indeed, even though Caxés petitioned time and time again for an appointment as Usher of the Chamber, pointing out that Philip IV had so honoured both Villandrando and Velásquez, his wish remained unfulfilled.

In August 1628 Peter Paul Rubens arrived in Madrid. Even though he made this second trip to Spain in the political service of his sovereign, Philip IV, it was his

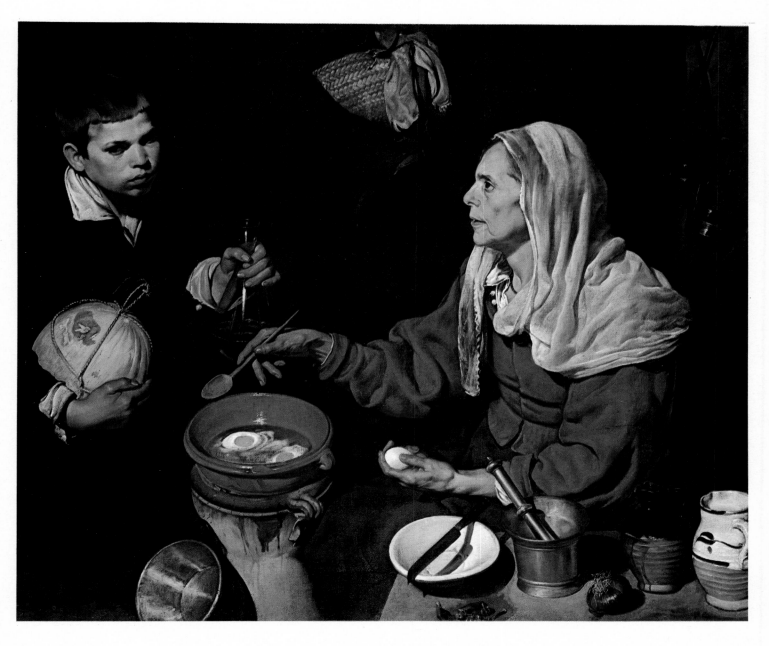

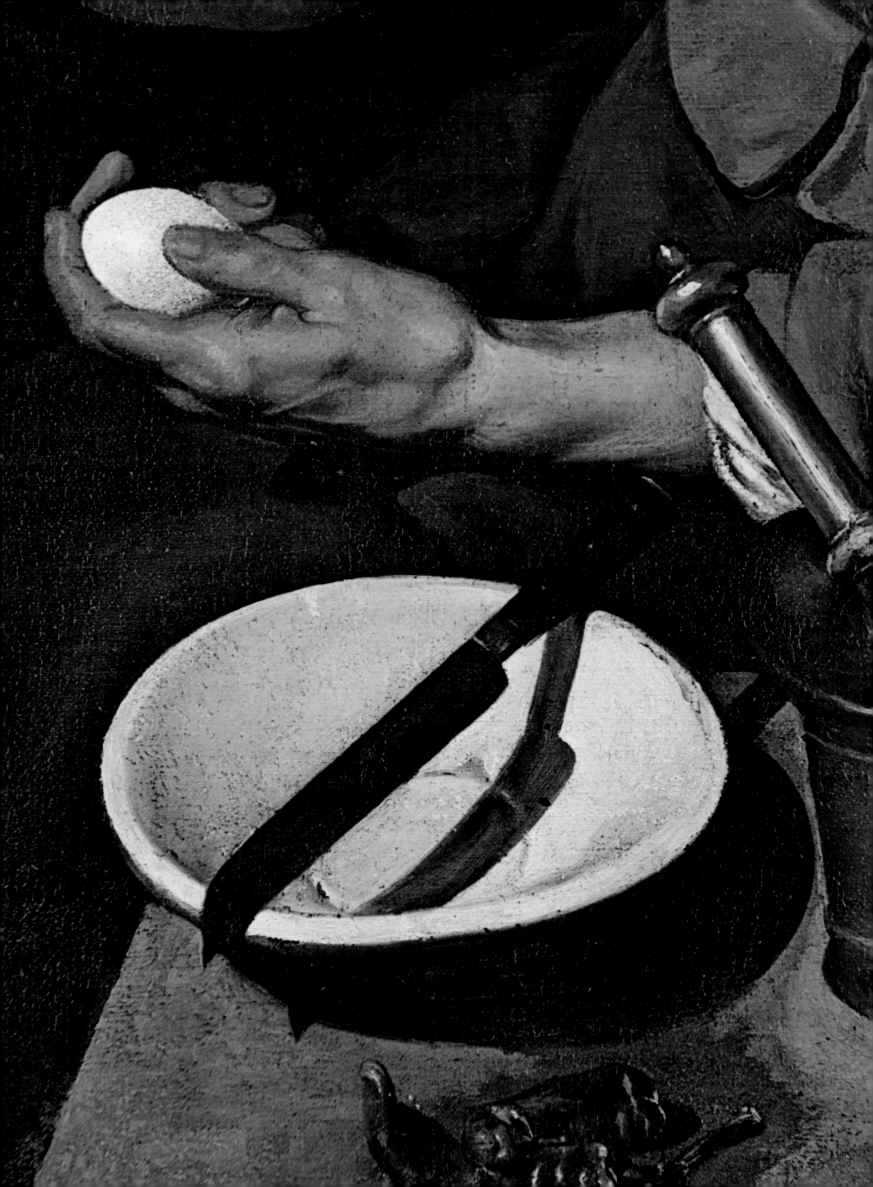

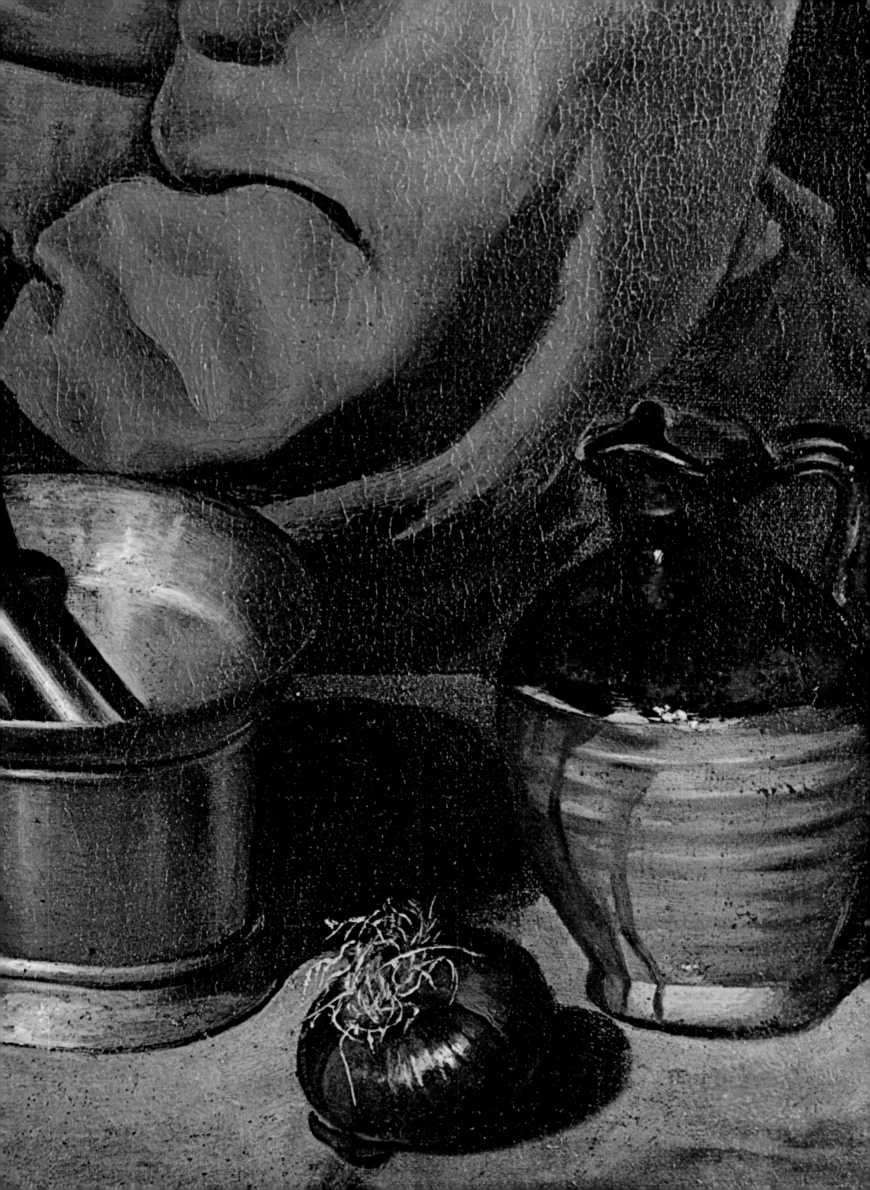

personality as a painter which was to the fore at the Court. We know from Pacheco that during the nine months he stayed in Madrid he had little contact with painters, other than Velásquez whose work he admired. Among the many paintings that Rubens executed for the King or for private individuals were a number of copies after Titian and several portraits. Velásquez, with his admiration for Titian and his own mastery of portrait painting, must have been particularly interested in these aspects of Rubens' art. The Flemish master painted no fewer than five portraits of Philip IV, as well as several of the Queen and other members of the royal family. Pacheco, possibly reflecting Velásquez views, singled out for praise an allegorical portrait of Philip IV, now lost, which was greatly admired at the Court.

After the daily contact with hostile colleagues at the Royal Palace, Velásquez must have found the challenge of the Flemish master's works, success and views very refreshing. Yet, his artistic intent was, and remained, essentially different from that of Rubens. He continued to represent the person of Philip IV as the quintessence of kingly power, but dispensed with allegory, which he appears to have thought unsatisfactory and in doing so he achieved enduring success. As Picasso put it, the Philip IV painted by Velásquez appears to be a quite different person from that painted by Rubens (page 130), but 'it is in Velásquez' one that we believe: one is convinced of his right to power'.

CHRIST IN THE HOUSE OF MARY AND MARTHA
Oil on canvas; 60 × 103.5 cm. (23¾ × 40¾ in.)
Dated 1618.
London, National Gallery (1375).
Heavily restored.

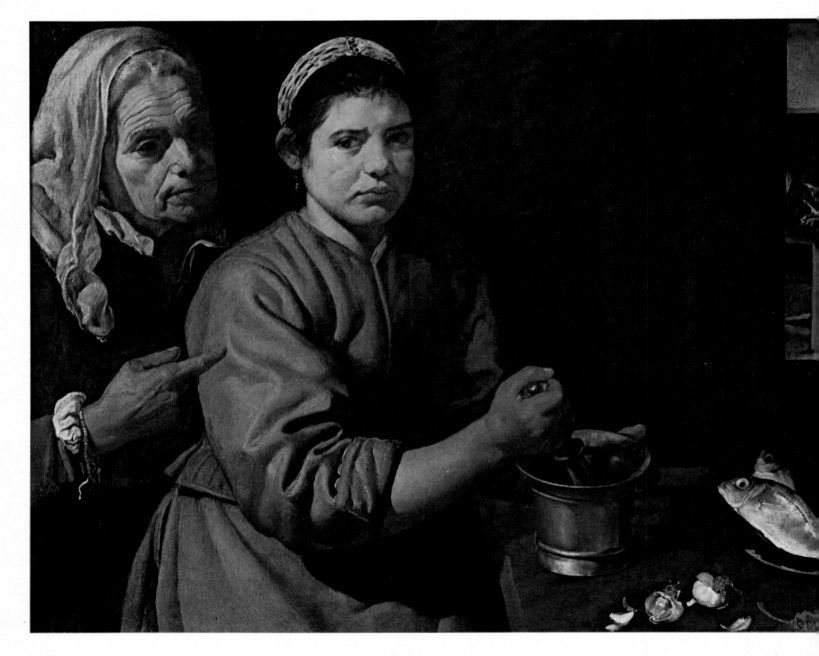

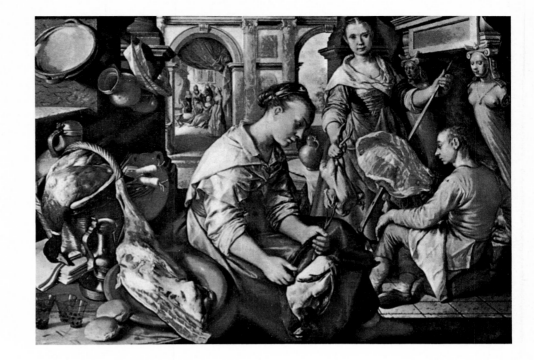

Joachim Beuckelaer
CHRIST IN THE HOUSE OF MARY
AND MARTHA
Oil on panel; 113 × 163 cm. (44 ½ ×
59 ½ in.)
1565
Brussels, Musée Royaux

Velásquez' first visit to Italy

Velásquez' success in the 1627 competition finally compelled the King to grant
the painter his wish to go to Italy. The Italian ambassadors in Madrid were re-
quested to provide him with passports and letters of recommendation. The re-
quest was complied with, but not without some apprehension that the true aim
of the painter's visit to Italy might be espionage. The suspicion probably arose
from the knowledge that Velásquez' position at the Court was actually far super-
ior to that which his office, of Usher of the Chamber, would suggest. He was not
only a favourite of King, who often watched him painting, but also of the
King's chief minister Olivares. He was, moreover, to sail with the famous
General Spinola, who was to take command of the Spanish armies in Italy.
Landing at Genoa on 19 September 1628, Velásquez proceeded a few days later
to Milan; he then set out for Venice, where he stayed at the home of the Spanish
ambassador, Don Cristobal de Benavente. Since there was unrest in the city,
where moreover Spaniards were then rather unpopular, the ambassador ordered
that some of his men should accompany his guest whenever he left the house.
'Leaving that unquietness', as Pacheco wrote, Velásquez started with his servant
on his way to Rome.

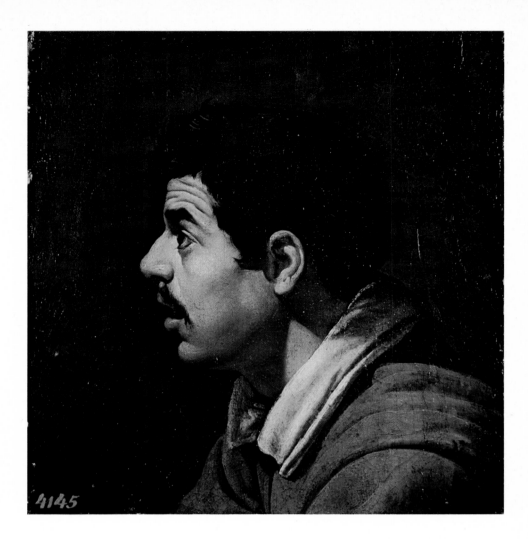

YOUNG MAN IN PROFILE
Oil on canvas; 39.5 × 35.8 cm. (15 $\frac{5}{8}$ ×
14 $\frac{1}{8}$ in.)
c. 1618-1619
Leningrad, Hermitage Museum (295)
Recent X-ray examination has revealed,
beneath a layer of varnish, the face of a
young man fairly similar to that of the
central figure in *Three Musicians* (page
8). It thus seems that Velásquez painted
this profile of a young man on canvas
that he had already used for a previous
study or composition.

His first stop was Ferrara, where Cardinal Giulio Sachetti, who had been Papal
Nuncio in Spain, extended many courtesies to him. He then stopped at Cento,
possibly, it has been suggested, to visit Guercino who was a protégé of Cardinal
Sachetti; there is no evidence though that the two painters, who artistically had
little in common, met then or at any other time.
It is likely that he stopped off at Florence, as he had intended to do when he
secured letters of introduction from Averardo Medici, Florentine ambassador in
Madrid, a protocol-minded individual whose main concern was that Velásquez,
the 'favourite painter' of both Philip IV and Olivares, should not be treated
with either too much or too little courtesy.
In Rome he was lodged at the Vatican. Finding his lodging rather isolated he left
it, having made sure that the Vatican guards would let him in without difficul-
ty, whenever he wished to draw from Michelangelo's *Last Judgement* or
Raphael's works. It would seem that Velásquez enjoyed the city's social life and
appears to have won the friendship of many men who, by reason of their back-
ground, profession and social status would have been discriminating in their
choice of friends.
Much as he cared for city life, however, he feared the heat of the Roman
summer. Hence in April 1630, he expressed a desire to visit the Villa Medici,
situated away from the heat of the city and where there were many antique
statues and other treasures which he could study. The Spanish ambassador, the
Count of Monterrey, Olivares' brother-in-law, took care of the matter, and a
room was quickly made available for Velásquez at the villa, where he stayed for
more than two months until a tertian fever forced him to return to the city, to a
residence near that of the Count of Monterrey. The Count placed him under the
care of his own physician, and did him many other kindnesses.
During his stay in Rome Velásquez made 'studies' for the most part, one of
them being 'a famous self-portrait', according to Pacheco. It is also known that
the Countess of Monterrey, on the advice of her brother, the Count-Duke of
Olivares, had her portrait painted by Velásquez. Neither of these portraits has

been convincingly identified among the artist's extant works.

On his way back to Spain at the end of 1630, Velásquez stopped off at Naples where his fellow-countryman, José de Ribera (1591-1652), was the outstanding painter. The sister of the Spanish monarch, the Infanta María, was in Naples as well, on her way to join her future husband, Ferdinand III, in Hungary and Velásquez painted a portrait of her to be taken back to Philip IV (page 62).

The painter was back in Madrid in January 1631 where he was cordially received by the Count-Duke of Olivares. The Duke ordered him to go at once to kiss the hand of His Majesty and thank him, for Philip had not allowed himself be portrayed by another painter during Velásquez' absence and had waited for him to paint the first portrait of Prince Baltasar Carlos, born shortly after the painter's departure for Italy. Velásquez immediately began to work on the portrait of *Prince Baltasar Carlos with a Dwarf* which he completed in March of that year (page 67).

On 21 August 1633, Velásquez' fourteen-year-old daughter, Francisca married Juan Bautista Martínez del Mazo, a painter about whom nothing is known before this date. Born probably between 1610 and 1615, he died in 1667. As his daughter's dowry, Velásquez passed on to his son-in-law the position of Usher of the Chamber, which he had held for several years. Mazo was not actually one of Velásquez' assistants but he did learn a great deal from him. Velásquez furthered his career to a great extent, securing palace appointments for him and later for his children. In the early 1640s, Mazo became master of drawing and painting to Prince Baltasar Carlos, who in 1645 was godfather to Mazo's fifth child. The Prince died the following year, but Philip IV decreed that the salary Mazo had been receiving be continued and kept him employed as a painter. After Velásquez' death he was appointed to the position of official Court painter.

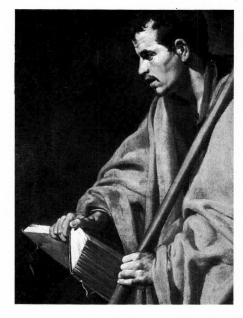

SAINT THOMAS
Oil on canvas; 94 × 73 cm.
(37 × 28¾ in.)
1618-1620
Orléans, Musée des Beaux-Arts (264).
Restored, mainly around the left eye.

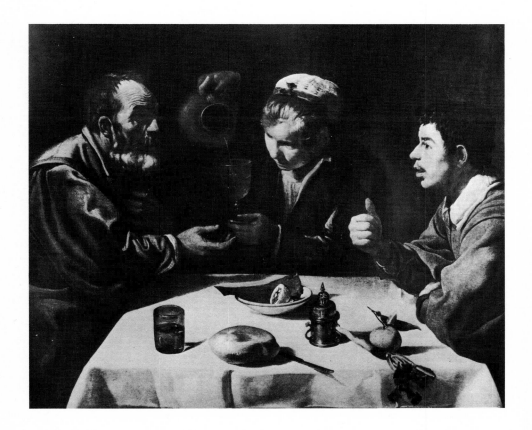

GIRL AND TWO MEN AT TABLE
Oil on canvas; 96 × 112 cm. (37⅞ × 44¼ in.)
1618-1819
Budapest, National Museum (3280)
Heavily damaged and restored.

The Buen Retiro and the Torre de la Parada

In 1630 work commenced on the new Royal Palace in Madrid, the Buen Retiro. Hastily built for reasons of economy, it was partially in use two years later. However, it was not till April 1635 that all the rooms were completed, including the ceremonial great hall, or the *Salón*, as it was soon called.

The decoration of the new palace was a vast artistic project in which Velásquez, because of his office and position at Court, probably played an active part. From at least August to December 1635 Velásquez was at work on paintings for the *Salón*. Entirely by him are *The Surrender of Breda*, the *Equestrian portrait of Philip IV* and *Prince Baltasar Carlos on Horseback*. (pages 101, 98 and 99); his hand is also recognizable in the *Equestrain portrait of Queen Isabella* , and, to a lesser degree, in those of the King's parents *Philip III* and *Queen Margarita oɟ Austria*, which were, however, mostly executed by other painters (pages 97,92,93 and 95).

The Surrender of Breda was one of twelve lifesize battle-pieces intended to imortalise the victories won by Philip IV's armies since the commencement of his reign in 1621. Above these were hung, frieze-like, ten paintings of the labours of Hercules.

The Hercules paintings, as well as two of the battle-pieces (one of them now lost) are by Zurbarán. Vincencio Carducho painted three battle-pieces and Eugenio Caxés two which were, however, left unfinished at his death in December 1634 and were completed by Antonio Puga and Luis Fernández. Maino, Pereda and Jusepe Leonardo also contributed battle-pieces.

Hardly had the Buen Retiro Palace been completed when Philip IV started on a new project. In January 1638 the King decided to enlarge and make fully habitable a hunting lodge at El Pardo, near Madrid, known as the Torre de la Parada. Velásquez was occupied for a long time with the decoration of the hunting lodge, selecting and hanging pictures by other painters as well as executing paintings for it himself.

Together with mythological and other subjects from antiquity painted by Rubens or executed by others after his colour sketches, there were many pictures of animals and hunting scenes by other Flemish masters. Velásquez' own works for the Torre de la Parada included the portraits of *Philip IV*, *Prince Baltasar Carlos*, and the *Cardinal Infante Fernando*, all three dressed as huntsmen (pages 83,104 and 85); the pictures of *Mars*, *Aesop*, and *Menippus*, the portrait of the dwarf *Francisco Lezcano*, and that of *A Dwarf with a Book on his Knee* (pages 127,123-5,123,128 and 132).

The decoration of the Torre de la Parada doubtless added to Velásquez' workload but it also increased his stature at the Court. In fact, on 28 July 1636, an observer at Court reported that the King had just appointed Velásquez 'Gentlemen of the Wardrobe, without duties ', and commented that the painter's ambition went higher; that indeed he aimed at becoming 'Gentlemen of the Bedchamber' (which he did become seven years later) and at wearing the robe of a military order, something which, like Titian, Velásquez also achieved later in life.

SAINT JOHN ON PATMOS WRITING THE APOCALYPSE
Oil on canvas; 135.8 × 102.3 cm. (53 ½ × 40 ¼ in.)
c. 1619
London, National Gallery (6264)

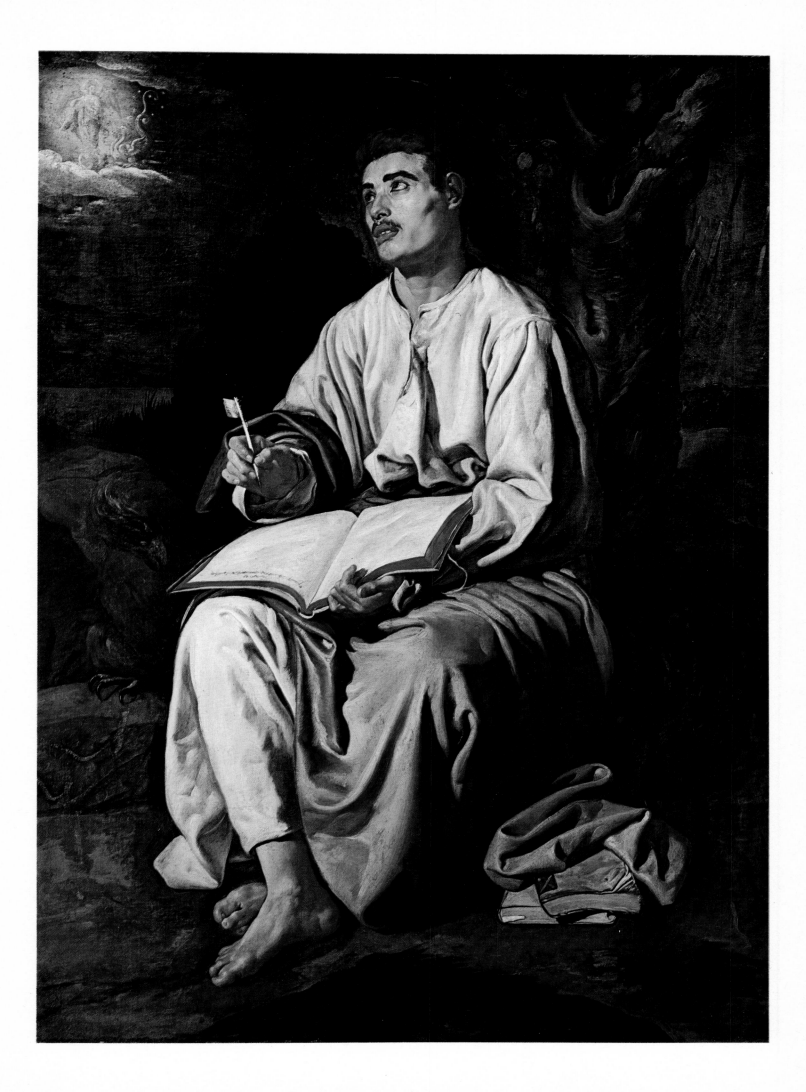

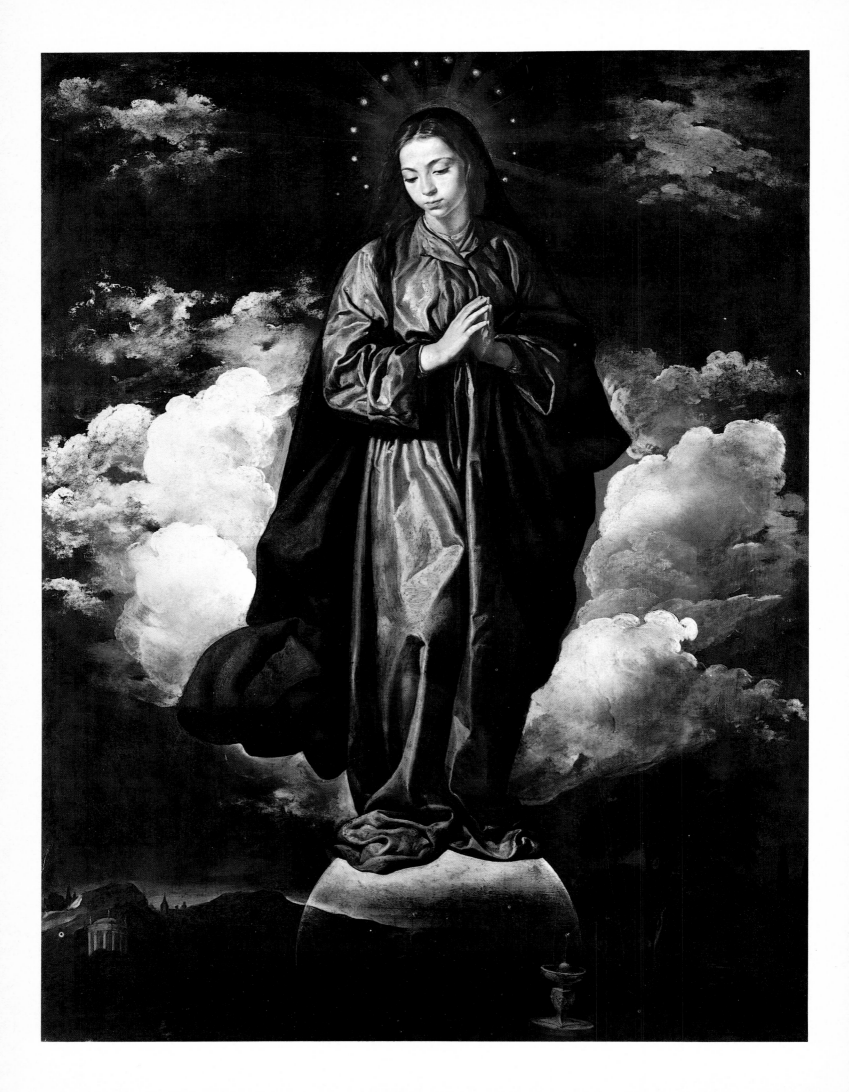

The Court after the fall of Olivares

The Count-Duke of Olivares was removed from the office of chief minister and banished from the Court in January 1643 in the wake of a succession of military and political defeats. Velásquez had received the royal appointment of 'Gentlemen of the Bedchamber', without duties but with the corresponding revenue, a couple of weeks before the downfall of Olivares. Less than five months after the new chief minister, the Marquis of Carpio, came to power, the painter was made Assistant Superintendent of Works of the Royal Palaces, to be in charge of such projects as the King might designate, meaning the refurbishing of the old Alcázar, made necessary by the transfer of many of the Court functions to the new Buen Retiro Palace. Velásquez never took part in the politics of the Court, remaining unembroiled in the strife of the various factions.

THE IMMACULATE CONCEPTION
Oil on canvas; 134.6 × 101.6 cm. (53 × 40 in.)
c. 1619
London, National Gallery (6424)

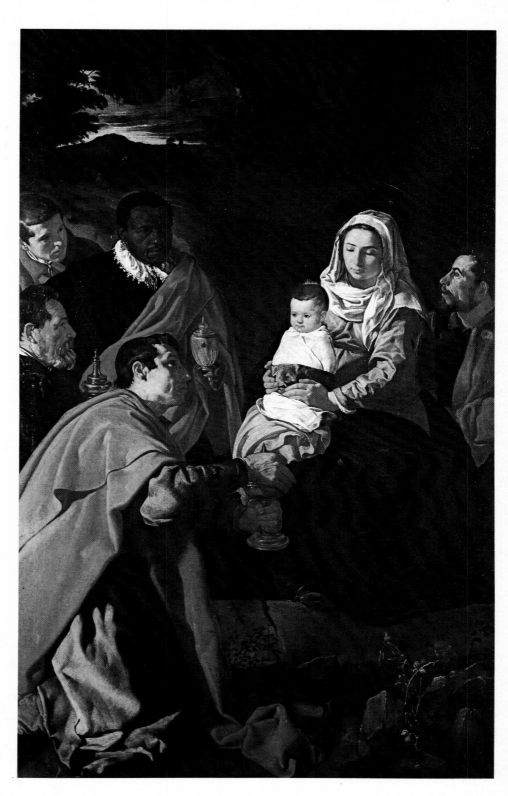

THE ADORATION OF THE MAGI
Oil on canvas; 204 × 126 cm. (80 $\frac{1}{4}$ × 49 $\frac{1}{4}$ in.)
Dated 1619
Madrid, Prado (1166)
Cut down on both the right and left sides

In the spring of 1644 Philip IV decided to join his troops engaged in the freeing of the city of Lérida from French occupation. Accompanied by a large retinue which included Velásquez the King set out on a slow-moving journey to the distant battlefield. In May, during a halt at the city of Fraga, Philip decided to have Velásquez paint his portrait in the red and silver uniform of Commander-in-Chief. The portrait, which required three sittings, was completed in June, when it was sent to the Queen in Madrid (page 133). It was greatly admired at the Court, and the Catalans resident in the capital obtained permission to display it at the church of Saint Martin during their celebration of the recapture of Lérida. Many people came to see it, and within a matter of days, copies were being made of it.

By the end of 1646, one and a half years after Velásquez had portrayed Philip IV

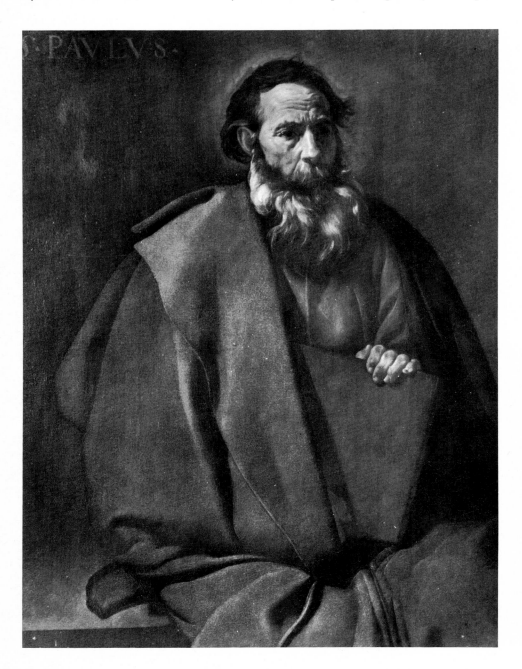

SAINT PAUL
Oil on canvas; 98 × 78 cm.
(38 $\frac{5}{8}$ × 30 $\frac{3}{4}$ in.)
c. 1619-1620
Barcelona, Museo de Bellas Artes da Cataluña (24242)

SAINT PAUL (?)
Oil on canvas; 38 × 29 cm.
(15 × 11 $\frac{1}{2}$ in.)
Madrid, Countess de Saltes Collection. Fragment of a painting. The poor condition of the canvas means it cannot be definitely attributed to Velásquez

in uniform at Fraga, Queen Isabella was dead and so was Baltasar Carlos, the heir to the throne in whom many had put their hopes for the Spanish monarchy. For some time, Velásquez appears to have painted little for the King. Indeed, from the mid-1640s until 1648, he had time to execute a number of paintings for private individuals, including such large compositions as *The Spinners* and the *Rokeby Venus* (pages 143,138,140-141)

Philip went on dispensing honours to Velásquez, although the painter still

encountered ill-will from the office which paid his salary and fees for paintings. He continued to have to petition repeatedly to arrive at a settlement of salaries and fees due to him. As contemporary documents show, tardiness in paying the royal servants was then much more of a custom than an irregularity. This time, however, the situation was somewhat different. Even former officials who drew pensions, as well as the recipients of regular royal assistance were being paid, while Velásquez was advised to have patience until money should become available. He felt discriminated against, and said so in the petition which he addressed to the King, and which led to a clear-cut decision in his favour.

At the time that he wrote the petition his position at Court had been considerably strengthened. Early in the year, he had been appointed supervisor and accountant for the building of the Octagonal Room in the Alcázar. By

THE WATERSELLER
Oil on canvas; 106.5 × 82 cm. (42 × 32 ¼ in.)
c. 1620
London, Wellington Museum, Apsley House (1600)
Detail: *pages 26-27*

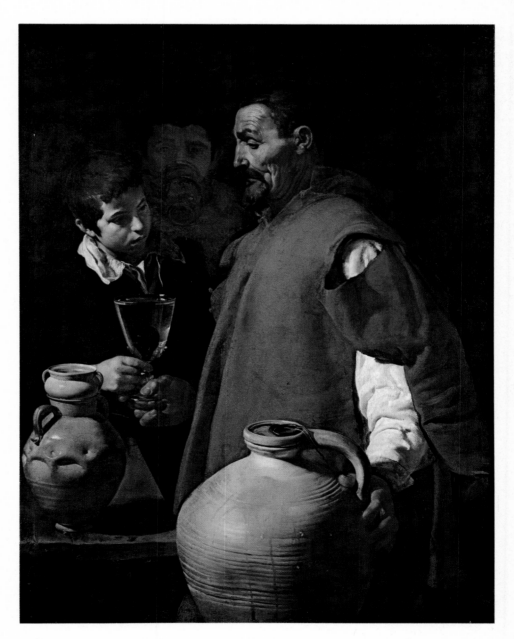

taking this important responsibility away from the Superintendent, Don Bartolomé de Legasca, and entrusting it to Velásquez, at that time the Assistant Superintendent, the King enhanced the latter's prestige. Naturally the new chief minister, the Marquis of Carpio, influenced the way in which the King's favour was expressed, whether in the form of privileges or a decision in his favour over a matter of contention. Velásquez' prestige must also have been helped by the admiration that the Marquis of Eliche, the chief minister's son, showed for his art. Indeed, by 1651 Eliche's remarkable collection included four paintings by Velásquez, among them the *Rokeby Venus*.

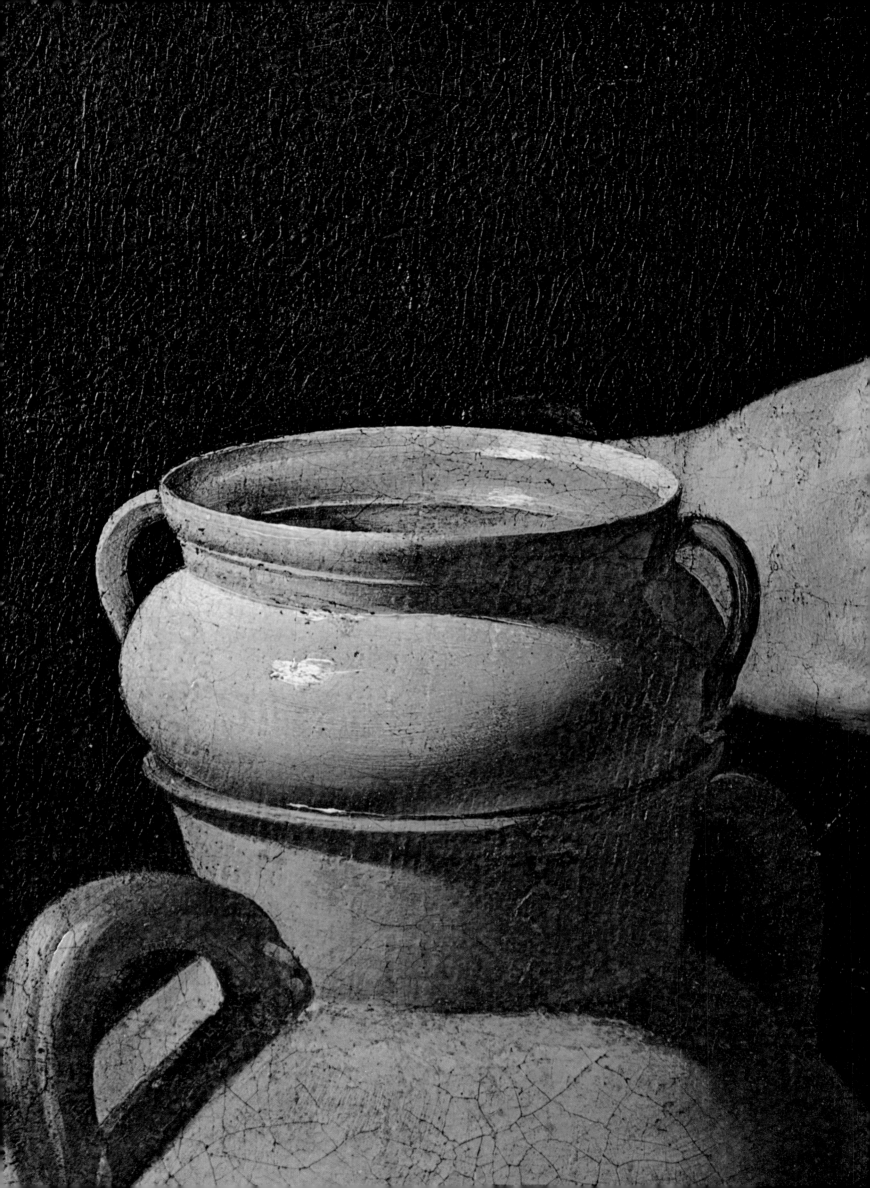

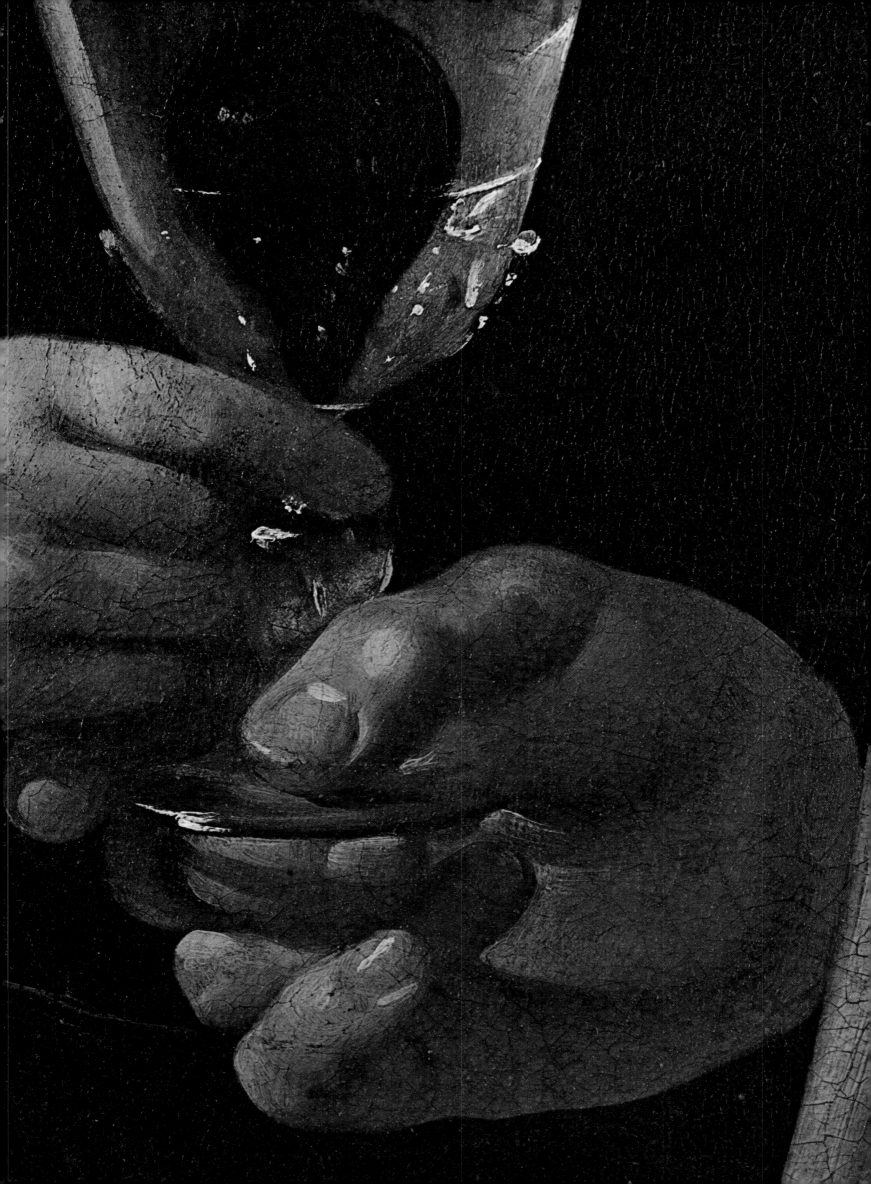

Velasquez' second Italian journey

Soon after this, Velásquez found an opportunity to suggest that the King should again send him to Italy. According to Jusepe Martínez, a friend of Velásquez, the sovereign asked Velásquez to look for painters, the best of whom would be chosen to paint pictures for a new gallery at the Royal Palace. Velásquez answered that Philip should not be satisfied with paintings which were within the reach of everyone, and requested leave to go to Venice and Rome where he would secure for the King the best available works by Titian, Paolo Veronese, Bassano, Raphael, and other artists of equal stature, as well as antique statues, or moulds of them to be cast in Spain. Philip agreed, and in November 1648 the administrative machinery was set in motion for Velásquez' second Italian journey.

Great changes were then being anticipated at Court. It had been decided that Philip, then forty-three, should marry his thirteen-year-old niece Mariana of Austria, whom a few years earlier it had been intended should marry the now dead Baltasar Carlos. The Duke of Najera was about to leave, at the head of a party of royal envoys, for Trento where they were to meet the King's bride and escort her to Spain. Philip ordered that Velásquez should travel with the Duke and his suite to Italy, and that he be given the carriage to which he was entitled by reason of his office.

Not long before leaving for Italy, probably sometime in 1648, Velásquez painted the earliest extant portrait of the *Infanta Maria Teresa*, then about ten years old (page 147). It is possible that this portrait may have been intended to acquaint the future Queen with the likeness of Philip's only surviving child.

Even if it was not the case, it is more than probable that word of Velásquez' fame reached Mariana before she set foot on Spanish soil. One may confidently assume that a copy of a poem by Bocángel[1], published in 1648, was sent to Mariana at Vienna since it was dedicated to her. The name of Velásquez appears in one of the stanzas, where two ladies are described as so beautiful, graceful and statuesque that they appear to be 'now miracles by Velásquez, then reliefs by Phidias'.

On 15 November 1649, when Mariana made her official entry into Madrid, she passed, en route from the Buen Retiro Palace to the Alcázar, the church of San Salvador, whose facade was decorated with the likenesses of members of the House of Austria, embroided after Velásquez' portraits, which 'attracted much attention'.

THE SUPPER AT EMMAUS
Oil on canvas; 55.8 × 118 cm. (22 × 46½ in.)
c. 1620
Blessington (Dublin), Sir Alfred Beit Collection. Cut by at least three inches on the left-hand side. The background scene was painted over later, exact date not known, and was revealed in 1933 during cleaning.

Francisco Pacheco
SAINT SEBASTIAN NURSED BY
SAINT IRENE
Destroyed in 1936

THE SCULLERY-MAID
Oil on canvas; 55 × 104 cm. (21¾ ×
41 in.)
c. 1620
Chicago, Art Institute
Replica of *The Supper at Emmaus*,
without background scene.

To return to Velásquez' second trip to Italy, the Duke of Najera's fleet set sail from Malaga on 7 December . After a good many stops at ports along the Spanish coast they reached Genoa on 11 March, where Velásquez parted company with the Duke and started on his way to Venice.

He arrived on 21 April, as the Spanish ambassador, the Marquis de la Fuente, hastened to report, explaining that the painter was staying at his house and seeing as many paintings as possible. According to Palomino, Velasquez bought at that time Veronese's *Venus and Adonis* and several works by Tintoretto, including scenes from the Old Testament which had ornamented a ceiling, and a sketch for *Paradiso*, works which are now in the Prado Museum.

Velásquez' stay in Venice in 1649 was probably short. The Spanish ambassador, wrote that three days after his arrival he wanted to set out for Modena where, he had been advised, he could find 'something very much to his purpose'. The reference probably was to Correggio's *Notte* (night), then in the collection of the Duke of Modena, which he was set on buying for Philip IV. However, he went first to Padua for the purpose of seeing another work by Correggio, probably the *Assumption of the Virgin* in the Cathedral.

Finally, he arrived in Modena. The Duke, Francesco d'Este, had been in Madrid in the autumn of 1638, and had sat to Velásquez, who was still at work on his portrait in March 1639 (page 120), according to a dispatch from the Duke's Minister in Madrid. This dispatch contains what was probably the current estimate of Velásquez as a painter : like other 'famous men', he hardly ever got around to finishing a work, and never told the truth as to when it would be finished; he was also expensive, but as a portrait painter he was the equal of the most renowned artists 'ancient or modern'. Velásquez' habit of procrastinating was well known by then. Indeed, in May of the same year the Cardinal Infante Fernando referred quite affably to his dilatory ways in a letter to Philip IV written from Brussels, and a few months later, in November, Sir Arthur Hapton, the British ambassador in Madrid, wrote about his 'laziness'.

Velásquez left Modena for Bologna and, and stopping probably in Florence, arrived in Rome by the end of May 1649, where he stayed for a short while before proceeding to Naples. In Rome as well as in Naples, he was busy commissioning moulds from antique sculptures to be sent to Madrid, where they were to be cast in plaster or bronze for the decoration of the Royal Palace, notably the Octagonal Room.

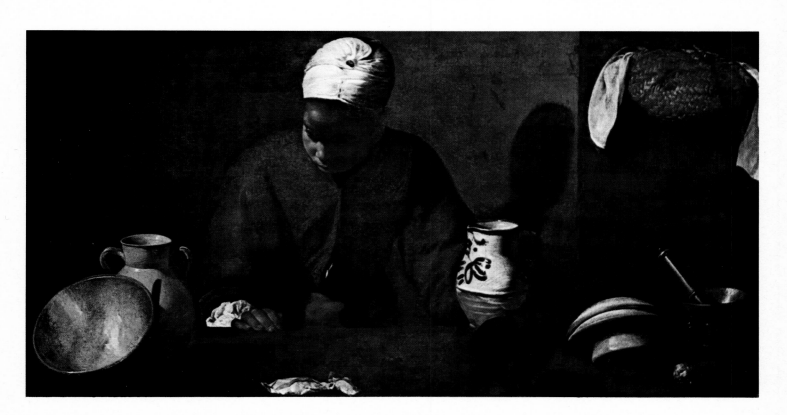

FATHER CRISTOBAL SUAREZ DE RIBERA
Oil on canvas; 207 × 148 cm. (81 $\frac{1}{2}$ × 58 $\frac{1}{4}$ in.)
1620 (?)
Seville, Museo de Bellas Artes
Father Cristobal Suarez was godfather to Velasquez' wife Juana Pacheco. He died in 1618 at the age of 68; the portrait appears to have been executed posthumously. The canvas is damaged in several places by numerous scratches and nicks.

Much deference was shown to Velásquez at the Papal Court, where Prince Ludovisi and Cardinals Pamphilj and Francesco Barberini, among others, honoured him with their favour. Pietro da Cortona, Bernini, Poussin and Preti were among the artists that the Spanish painter had contact with in Rome.

During his stay in Rome, from early in July 1649 till the end of November of the following year, at the latest, Velásquez showed the full measure of his art, painting several portraits, in particular that of *Pope Innocent X* (page 150). Other members of the Pope's household, from his domineering sister-in-law, Olimpia Maldachini, to his brother (page 151), also sat to him; another sitter was a woman painter, Flaminia Triunfi, of whom the only thing known today is that the Spanish master painted her. Neither this portrait nor that of Olimpia Maldachini has survived.

It is not known through whom it was arranged that the Pope should sit to Velásquez. For the painter of Philip IV it must have been a challenge to portray Innocent X, an artistic patron of true discernment. It is, however, known that when it was decided that he should portray the Pontiff, Velásquez apparently felt he was out of practice, and prepared himself by painting 'a head from life', asking his assistant Juan de Pareja to sit for him (page 149).

Velásquez was made a member of the Academy of St. Luke in January 1650, and a few weeks later he was admitted into the 'Congregazione de Virtuosi al Pantheon', a religious brotherhood of painters. On 19 March, his portrait of Pareja was exhibited at the Pantheon where it was unreservedly admired by painters of all nationalities.

The portrait of the Pope made an even greater impact on the Roman painters of the day and afterwards. Many copies, some with variations, most of them bust-length, were made after it. Velásquez himself must have been pleased with it for he took a copy back to Spain with him (page 151). The Pope expressed his pleasure by sending him as a present a gold medal with his portrait in relief. Moreover, Innocent X encouraged the painter's desire to be admitted into one of the three Spanish military orders.

While he was painting portraits one after the other, and doubtless enjoying his freedom, Philip IV was putting pressure on him to return to the Court. The King urged his ambassador in Rome to make sure that Velásquez proceeded rapidly with the task of acquiring works of art, warning against the painter's dilatory disposition, which might lead him to stay in Rome longer than absolutely necessary. He should be back in Madrid no later than May or early June, wrote the sovereign on 17 February 1650. In spite of this royal command, which was constantly repeatedly, Veláquez managed to delay his return for a whole year.

He was in Naples sometime in February 1650, but by 8 March he had left for Rome, where he again busied himself with the acquisition of moulds from antique sculptures for Philip IV. At the end of 1650, Velásquez was in Modena, seemingly to keep the promise he had made to Francesco d'Este to visit him again. The Duke was absent and his secretary, Gemignano Poggi, a timid character, was reluctant to let Velásquez' into the ducal gallery for fear that he might steal some of the paintings. So he took him on a tour of the nearby Palazzo Sassuolo, decorated with frescoes which could not easily be removed!

A poem by Boschini provides the only information we have concerning Velásquez' whereabouts from the end of 1650, when he was in Modena, until he sailed from Genoa to Barcelona, where he landed in June 1651. According to Boschini, Velásquez was in Venice in 1651, probably shortly after his stay at Modena, and was acclaimed as the painter of the portrait of *Innocent X* painted in Rome 'with a truly Venetian brushstroke'. A replica, presumably the one he later took to Madrid, was shown and admired in Venice. During the time that he spent there looking for old master works for his King, Velásquez was full of praise for the great Venetian painters, especially Titian and Tintoretto. To him it seemed that the latter's *Paradiso* was in itself enough to ensure the painter's immortality. Boschini reports that in Rome, whence he returned from Venice, Velásquez , in answer to a challenging question from Salvator Rosa, said, with a ceremonious bow, that, to tell the truth freely and candidly, Raphael did not

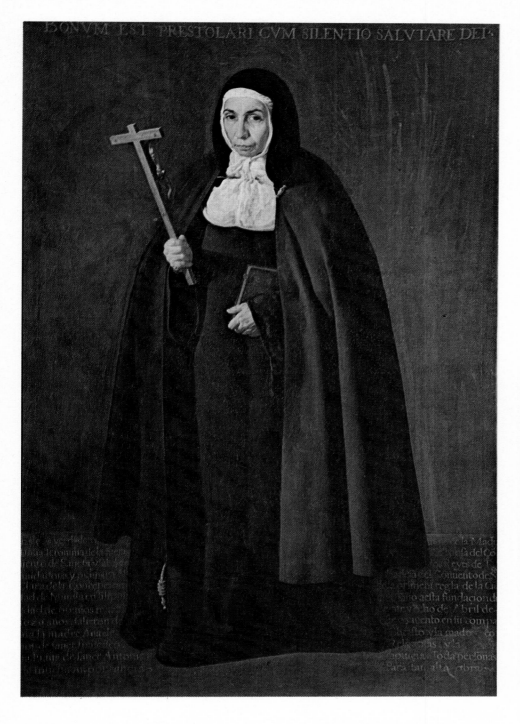

MOTHER JERONIMA DE LA FUENTE
Oil on canvas; 160 × 110 cm. (63 × 43 ¾ in.)
Signed and dated: 'Diego Velazquez f. 1620'
Madrid, Prado (2873)
Originally the painting bore the same inscription as the almost identical portrait illustrated alongside. The Museo del Prado acquired the painting in 1944 and owing to the mistaken assumption that the words were a later addition, they were partially removed and later faded.

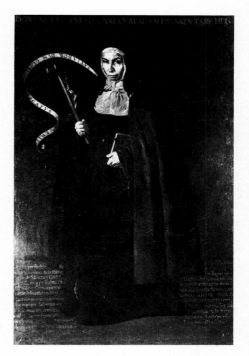

MOTHER JERONIMA DE LA FUENTE
Oil on canvas; 160 × 106 cm. (63 × 41 ¾ in.)
Signed and dated: 'Diego Velasquez. f. 1620'
Madrid, Fernandez de Aroaz Collection. Almost identical portrait to that shown alongside, apart from the position of the crucifix in the nun's hand. Considerably darkened.

please him at all, and that when it came to good and beautiful painting, Venice was the leader and Titian her standard bearer—or, as Boschini put it in his rhymed account of Velásquez' reply:
'...Raphael (a dirue el vero;/ Piasendome esser liber, e sinciero)/ Stago per dir, che nol me piase niente./... / A Venetia se troua el bon, e'l belo:/ Mi dago el primo liogo a quel penelo;/ Titian xé quel, che porta la bandiera.'
On his return journey to Spain, Velásquez stayed at Genoa for some days before sailing for Barcelona, where he arrived in June 1651. He hastened to Madrid bringing with him 'many paintings by the best masters', as well as the portrait of *Innocent X* with which Philip IV was particularly pleased. He also brought with him the hope of being made a knight of one of the military orders, an ambition that the Papal Nuncio, on the Pope's instructions, undertook to support at the Spanish Court.

Velásquez' elevated position at Court

Philip's wish to have a portrait of his new Queen by Velásquez, and the need he felt to refurbish the old Alcázar, may have been responsible for his urging the quick return of the artist to the Court. It was, however, not until some time after his return that Velásquez could portray the Queen, who was about to give birth to her first child at the time of his return and was ill for several months afterwards. But from then on, he, with his assistants, painted a large number of portraits of the Queen, the now marriageable Infanta María Teresa, and the little Infanta Margarita, several of which, together with other portraits of the King, were sent to foreign courts.

Velásquez was considerably busier after being granted the office of Chamberlain of the Royal Palaces. There had been six applicants for this high office, and a committee had examined their qualifications. Although Velásquez was top of the list of none of its six members, it was he whom Philip appointed to the coveted post on 16 February 1652.

Velásquez' new position brought him a handsome salary and the right to a large apartment in the Casa del Tesore (Treasury House), which was connected by a passageway with the Royal Palace where for years he had had his studio. As to his new duties, they included looking after the decoration and furnishings of the royal residences, which had to be made ready, one after the other, as during the year the Court moved from Madrid to Aranjuez, then to the Escorial, to el Pardo, and back to Madrid, as well as making arrangements for the King and his suite whenever he travelled. All this entailed frequent and extended absences from Madrid. He had likewise to supervise the arrangements and decorations required for ceremonial events and also for less solemn festivities.

For a long time he was busy with the refurbishing of several rooms in the Royal Palace in Madrid, for which he had acquired moulds from antique sculptures in Italy, and the casting of which he supervised. He designed and oversaw the refurbishing of the 'Room of Mirrors', so named because of the Venetian mirrors if contained. On the walls of this room hung paintings, all in black frames, by Titian, Tintoretto, Veronese, Rubens, José de Ribera, and Velásquez; most of these were mythological compositions, although there were also several biblical subjects. Four focal points were provided by large portraits of the monarchs of the reigning Spanish dynasty: Titian's *Charles V at the battle of Mühlberg* (page 99) and *Philip II after the battle of Lepanto* (Prado), Velásquez' *Philip III and the expulsion of the Moors* and Rubens' *Equestrian portrait of Philip IV with the Allegorical figures of Faith and Divine Justice*. The mythological compositions painted by Velásquez for the 'Room of Mirrors' were *Mercury and Argus* (page 170), *Apollo flaying Marsyas*, *Venus and Adonis*, and *Cupid and Psyche*, of which only the first one has come down to us. At this time although the Spanish monarchy and treasury were steadily declining, an effort was being made to give new splendour to the decaying Court, where the new young Queen made hopes rise for a male heir to the throne, and there was the expectation that the young Infanta would make an advantageous alliance.

Velásquez' studio, which Philip IV often visited to watch him painting, was by no means just a professional painter's workshop. Important writers, among them Quevedo, Gracián, Gabriel de Bocángel, Manuel de Gallegos and

SAINT IDELFONSO RECEIVING THE
CHASUBLE FROM THE VIRGIN
Oil on canvas; 165 × 115 cm. (64 $\frac{3}{4}$ ×
45 $\frac{1}{4}$ in.)
Beginning of 1620 (?)
Seville, Museo de Bellas Artes
In a very delicate condition; heavily re-
stored.
Detail: *pages 34-35*

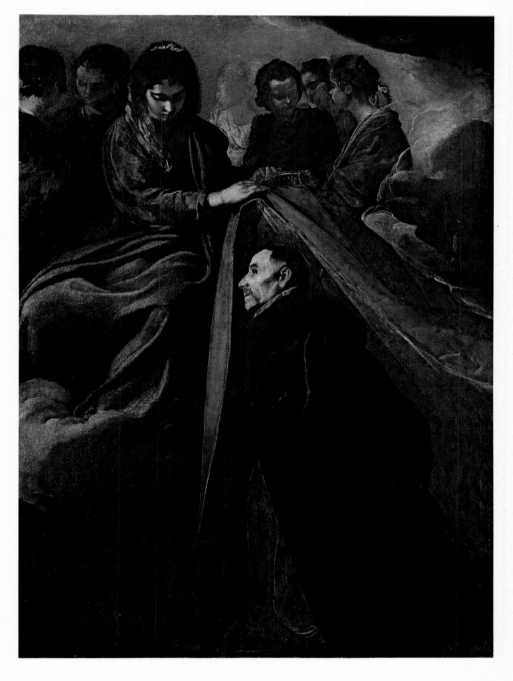

Saavedra Fajardo, most of whom were also courtiers, are likely to have visited his
studio at one time or another.

The weariness which had pervaded the ageing Spanish monarchy became
increasingly evident throughout the 1650s with Philip's increasing penury and
lack of purpose. Yet the splendid refurbishing of the Madrid Alcázar—in which
Velázquez had been very active since 1643—went on with no curtailing of

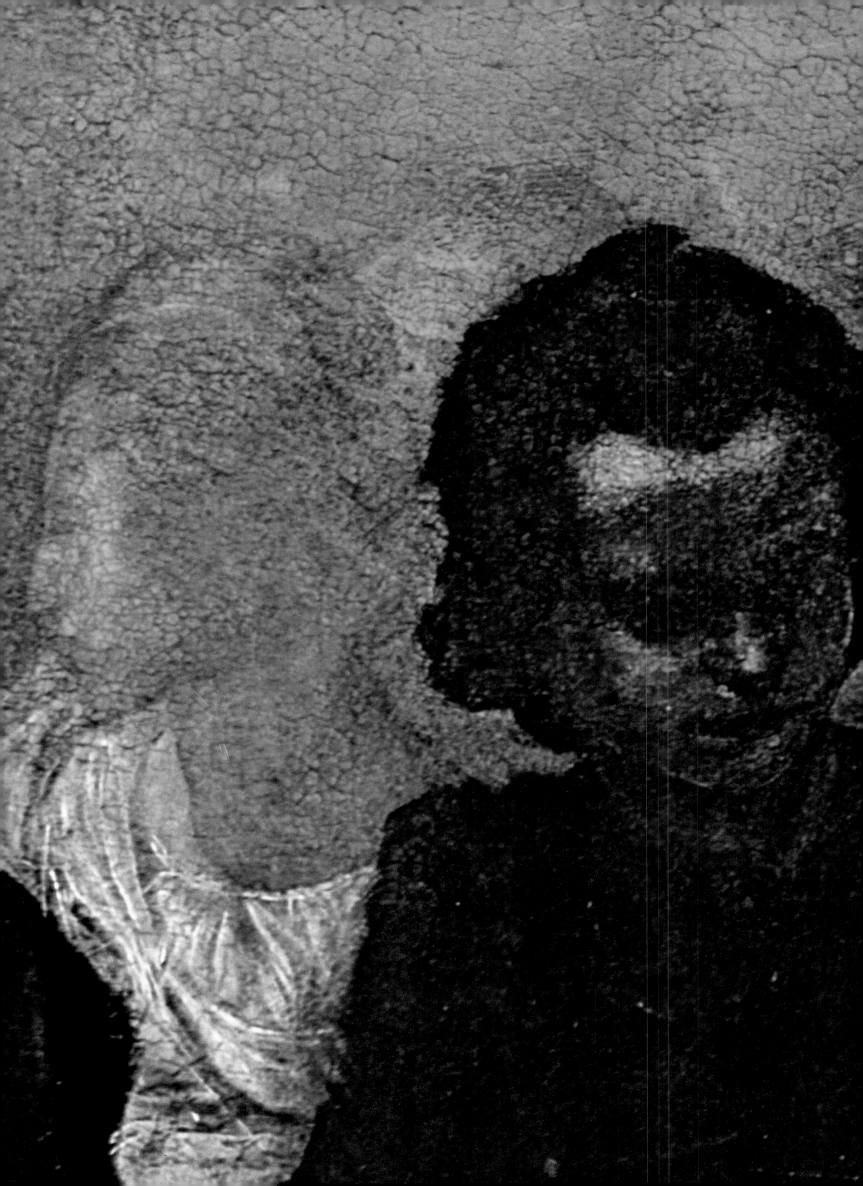

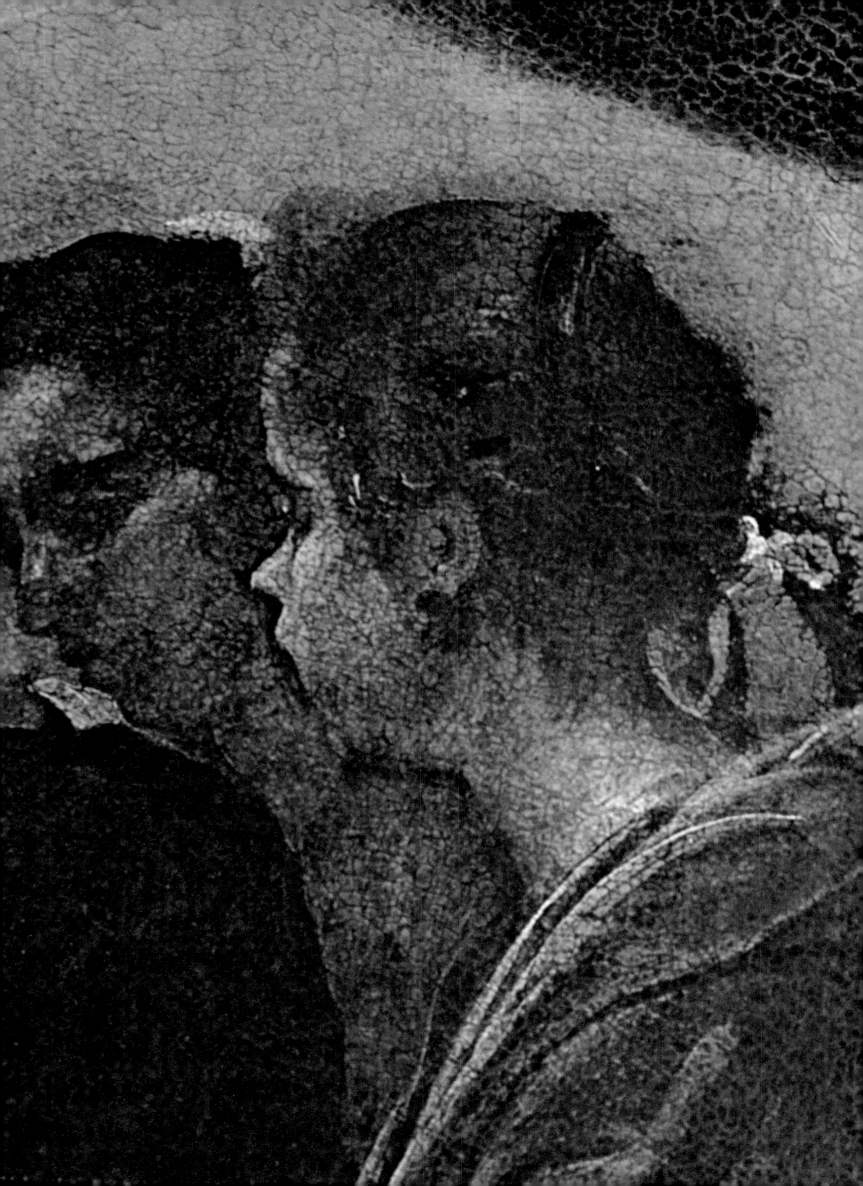

expense. One of Velásquez' achievements at the Alcázar was the rebuilding of an old tower into a magnificently decorated 'Octogonal Hall'.

Velásquez' architectural activity was not limited to the Alcázar. He took charge of similar work at other royal palaces, including the Torre de la Parada and the Escorial. In 1656 and again 1659 Lázaro Díez del Valle referred to Velásquez as a 'renowned architect and painter', though his architectural work never commanded, nor deserved, more than a fraction of the admiration that his painting won for him.

Velásquez' last years were both successful and melancholy. On 5 November 1652, his seventh and last grandchild was born. Shortly afterwards the mother, Velásquez' only surviving daughter, died. On 3 November 1654, Inés de Silva

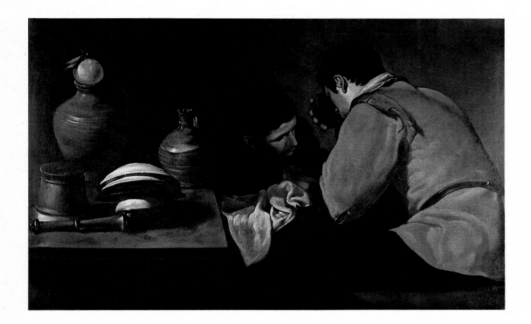

TWO YOUNG MEN AT TABLE
Oil on canvas; 64.5 × 104 cm.
(25 ½ × 41 in.)
c. 1622
London, Wellington Museum, Apsley House (1593)

Velásquez, his granddaughter, married Dr. Onofrio de Lefranchi, who received an appointment as magistrate to the Court of Justice of his native Naples, granted expressly by Philip IV as a dowry. Lefranchi died in 1657 at Naples, and Velásquez had to send Mazo there, apparently to expedite the recovery of Inés' dowry. The King helped with the expenses of Mazo's journey and appointed him assistant to the Chamberlain of the Royal Palace (that is to Velásquez) and authorized him to pass on to his son Gaspar the position of Usher of the Chamber which twenty-four years earlier Velásquez had passed to his son-in-law as a dowry for his daughter. However it must have been a blow to Velásquez when his two-year-old great-grandson, Jerónimo Lefranchi, who was living with him, died on 27 March 1658.

Within three months of this melancholy event, Philip IV appointed Velásquez to the Order of Santiago, decreeing that the inquiry required for the investiture be promptly opened. In compliance with the rules of the Order, an investigation was carried out in Tuy, Verín, Vigo and on the Portugese border as well as in Seville and Madrid, to determine whether Velásquez' ancestry was free from the taint of any Jewish or Moorish blood, and whether he descended from the nobility on both the paternal and maternal side of his family. One hundred and forty witnesses came forward to testify to this. Several of them were aristocrats, such as the Marquis of Malpica, who described himself as Velásquez' colleague in the royal service. Among fellow artists were Zurbarán, Cano and Nardi, as well as Juan Carreño de Miranda (1619-71) and Sebastian de Herrera Barnuevo (1614-85) from the younger generation of artists.

Another point to be proved was that Velásquez had never had a shop of any sort or practiced any menial craft or occupation. Luckily, the rules of the Order, as revised in 1653, stated that only those painters who practiced their art as a trade

MAN WITH A GOATEE BEARD
Oil on canvas; 40 × 36 cm. (15 ¾ × 14 ¼ in.)
1620-1622
Madrid, Prado (1209)

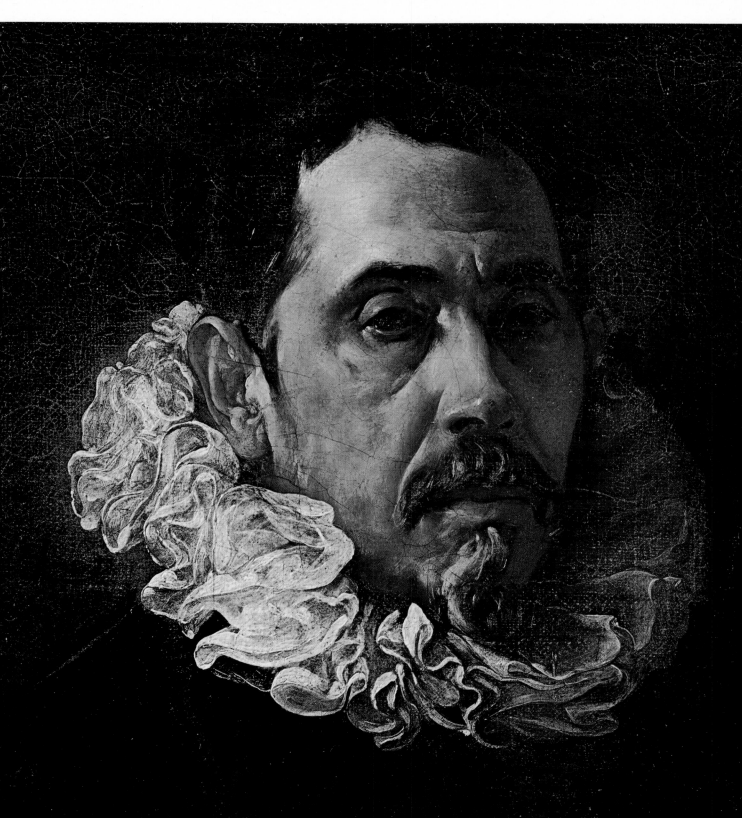

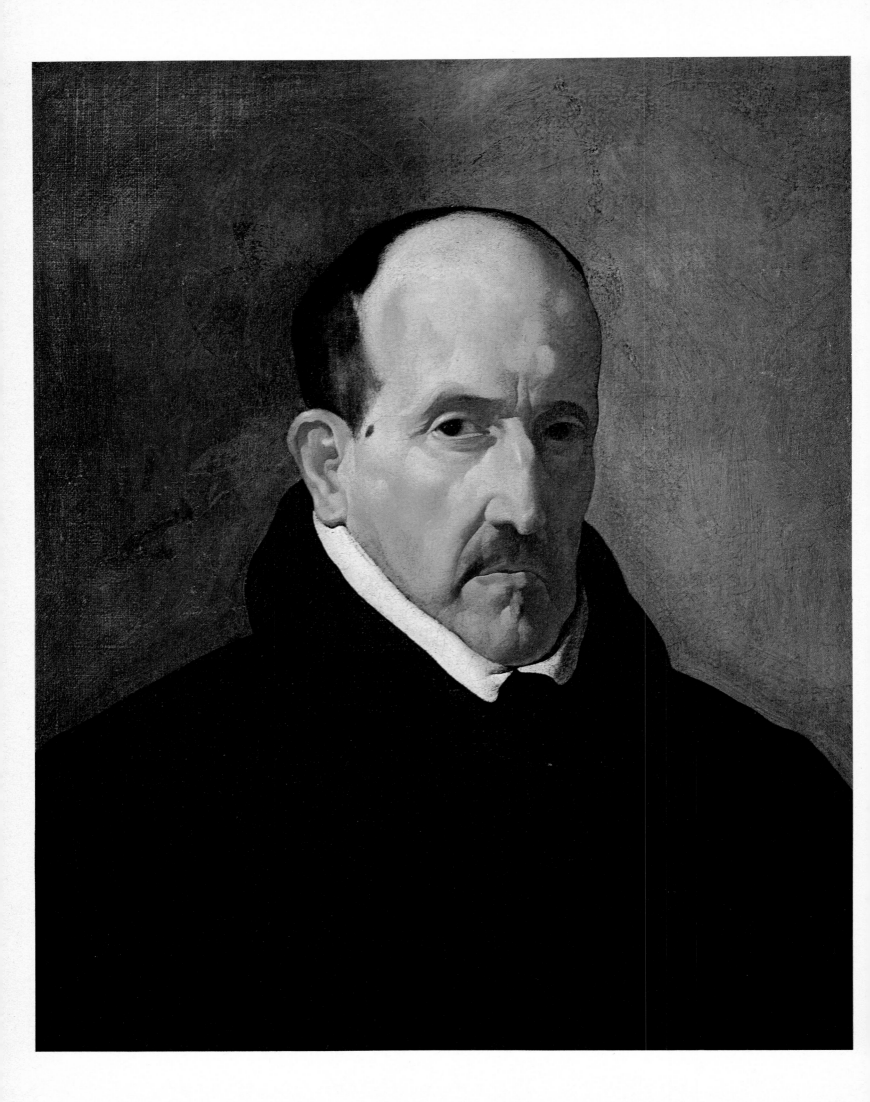

should be regarded as engaged in a menial occupation. Velásquez' friends took full advantage of this loophole. Reading their testimonies in the light of what we know of his life it is obvious that many of them felt free to stretch the truth, even though they were under oath. They affirmed, for instance, that Velásquez had not studied his art under another painter, or had ever had a workshop in the professional sense, not even in Seville, or sold any of his paintings, and that, in fact, he had always painted either for his own pleasure or for that of the King. The stumbling block was the nobility of Velásquez' ancestors, which could not be substantiated, particularly on his mother's side. Early in April 1659, the outcome was still unpromising. At this point, however, the King decided to take a short cut through the mass of red tape and instructed his ambassador in Rome to request the Pope, Alexander VII, to issue a brief exempting Velásquez from the need to provide proof of nobility. The Pope complied promptly with this request, and on 28 November 1659, Philip invested his favourite painter with the Order of Santiago, thus fulfilling the artist's highest hopes.

DON LUIS DE GONGÓRA Y ARGOTE
Oil on canvas; 51 × 41 cm.
(20¼ × 16¼ in.)
1622
Boston, Museum of Fine Arts (23.79)
Maria Antoinette Evans Fund
This portrait of the great Baroque Spanish poet (1561-1627), orginally depicted Gongóra with a laurel wreath, but the artist later deleted this.

The last years

The last years of Velásquez' life were a time of melancholy and dismay for Spain. Philip IV was becoming increasingly aware of his inadequacies as king, and watched ever more helplessly the threatening march of world events. Reverses of every kind, military, diplomatic and commercial, compounded with the self-righteous thoughts and actions with which they were received, had been steadily narrowing the approaches of the Spanish monarchy to the future for over two decades.

The portraits of *Felipe Próspero* and his sister, the *Infanta Margarita* (pages 172, 173) for Emperor Leopold I, whom she was to marry years later, and a lost miniature portrait of Queen Mariana, were, as far as it is known, the last works painted by Velásquez.

From October 1659 until the following spring, Velásquez, as Chamberlain of the Palace, was busy with the arrangements for the Spanish section of the building erected on the Isle of Pheasants, off the north coast of Spain, close to France, where peace between the two countries was to be formalized and the Infanta Maria Teresa given in marriage to Louis XIV. He left Madrid on 8 April 1660, two weeks ahead of the King, to attend to one of his duties, the preparation of lodgings for the royal party along the route to Fuenterrabia. He was accorded the use of a travelling litter for the journey, which he made in twenty-four days.

On 7 June Velásquez, wearing a gold chain from which hung the diamond-studded badge of the Order of Santiago, was one of the magnificently dressed courtiers present at the great hall when Philip led the Infanta from the Spanish section, decorated with tapestries of scenes from the Apocalypse, to the French side, hung with tapestries with episodes from the lives of Scipio and Hannibal. The following day, he started back to Madrid, this time with the royal party. He arrived home on the 26th, much to the relief of his family and friends, for rumours of his death had circulated at Court. He felt 'weary of travelling by night and working by day, but in good health', as he wrote to a fellow painter to

PORTRAIT OF AN ECCLESIASTIC
Oil on canvas; 66.5 × 51 cm. (26¼ × 20¼ in.)
1622-23
Madrid, Private collection
Damaged, restored and heavily varnished.

whom he also reported that Queen Mariana and Prince Felipe Próspero, who had stayed at Court, looked 'very pretty'.

Routine matters were awaiting him at the Palace, and he had to busy himself with payments due to others for services rendered or small purchases made in the course of the royal journey. On 1 July, he went to a bullfight, as he occasionally did. It turned out to be a rather simple affair, without horsemen, which made him and the other courtiers think of the more elaborate one they had watched with the King, a few days earlier at Valladolid.

On 31 July having attended the King at the Palace for the whole morning, he felt tired and feverish, and had to retire to his apartments. Philip sent two of his doctors to attend him but was told that there was little or no hope of recovery. Velásquez died on Friday, 6 August 1660. His body, clothed in the robes of the Order of Santiago, lay in state in his bedroom, where an altar was erected, till

PORTRAIT OF A YOUNG MAN
Oil on canvas; 56 × 39 cm. (22¼ × 15½ in.)
1623-1624
Madrid, Prado (1224)

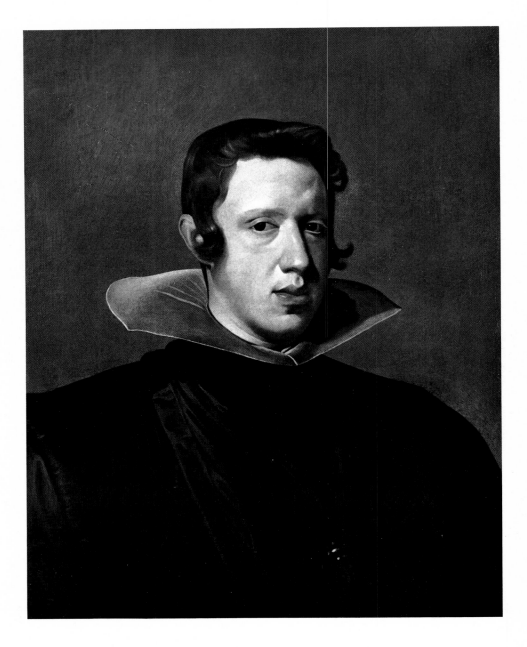

PHILIP IV
Oil on canvas; 61.6 × 48.2 cm. (24½ × 19 in.)
1623-1624
Dallas (Texas), The Meadows Museum at Southern Methodist University (67.23)
Born in 1605, Philip was crowned King of Spain in 1621 and died in 1665.

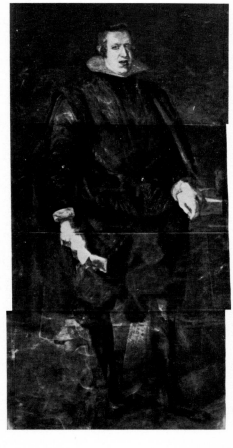

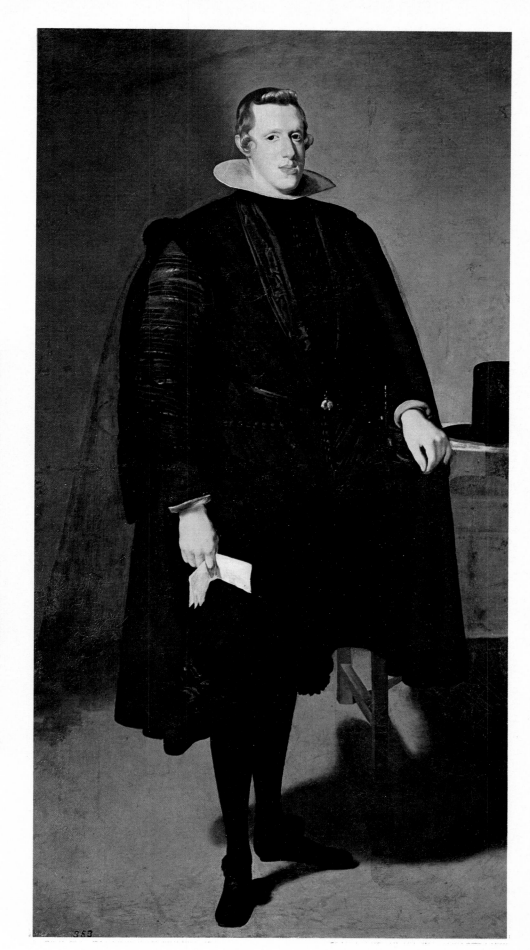

PHILIP IV
Oil on canvas; 198 × 102 cm. (78$\frac{1}{4}$ ×
40$\frac{1}{4}$ in.)
Painted first in 1623, and then repainted
by Velásquez in about 1628.
Madrid, Prado (1182)
Above: X-ray showing the first version of
painting beneath the present one

PHILIP IV
Oil on canvas; 199.9 ×
102.8 cm. (78 $\frac{1}{2}$ ×
40 $\frac{1}{2}$ in.)
1624
New York, Metropolitan
Museum of Art
(14.40.639) bequeathed
by Benjamin Altman,
1913
Date has been verified by
means of a receipt signed
by Velásquez. Face, eyes
and background have
been damaged and
restored.

THE COUNT-DUKE
OLIVARES
Oil on canvas; 201.2 ×
111.1 cm. (79 $\frac{1}{2}$ ×
43 $\frac{3}{4}$ in.)
1624
San Paolo (Brasil), Museu
de Arte
Date has been verified by
means of a receipt signed
by Velásquez. Don
Gaspar de Guzman,
Count of Olivares and
Duke of San Lúcar la
Mayor (1578-1645) was
Philip IV's Prime
Minister from 1621 to
1643. Restored, mainly
around the left eye, the
hands and the
background.

the following night when he was buried in the church of San Juan Bautista at a solemn service attended both by titled aristocrats and royal servants. His wife, who survived him by only seven days, was also buried there. Nothing remains of either their tomb or the church of San Juan Bautista.

Even if we take into account documentary references to Velásquez paintings which have been lost, his *oeuvre* was not numerically great. Velásquez put on canvas sentient images of the King, Queen, aristocrats, dwarfs, ordinary men and women, and occasionally mythological and religious images. His works certainly throw light on his time; yet, like other great masters, he was rather a creator of artistic reality than a recorder of the real world around him.

HEAD OF A WOMAN
Oil on canvas; 32 × 24 cm. (12 $\frac{3}{4}$ × 13 $\frac{1}{2}$) c. 1625
Madrid, Royal Palace.
Fragment of a painting. Restored.

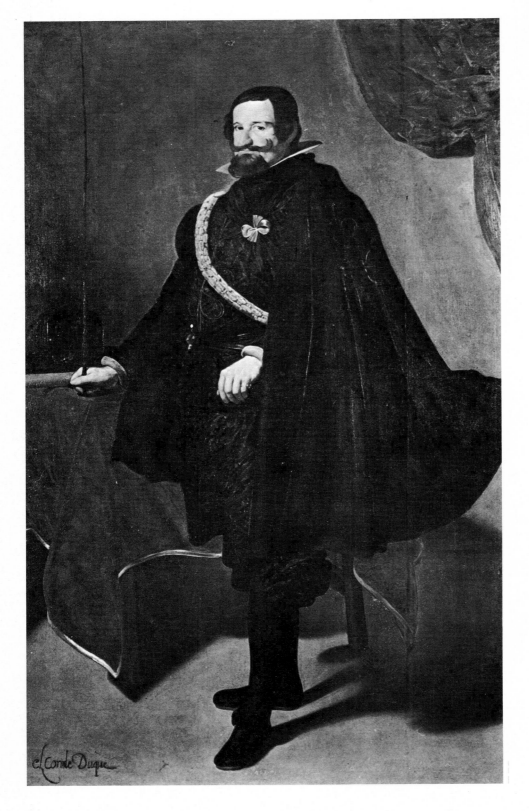

COUNT-DUKE OLIVARES
Oil on canvas; 216 × 129.5 cm. (85 $\frac{1}{4}$ × 51 in.)
1625 (?)
New York, The Hispanic Society of America (A 104)
Damaged, the face in particular; restored. The condition of the canvas and the lack of accurate documentation as regards the commissioner of the painting, its execution and provenance, make it impossible to attribute it definitely to Velásquez.

44

Velásquez and Caravaggio

Between 1610 and 1620 nearly every painter, both in and outside Italy, admired or were interested in the naturalism of Caravaggio. As Giulio Mancini wrote at the end of the decade: 'our time is greatly indebted to Michelangelo da Caravaggio for the colouration of his works, now followed quite widely'.[2]

Velásquez and others of his generation could see paintings by Caravaggio, or copies after them, in Seville and elsewhere in Spain. Pacheco praised Caravaggio as an excellent painter who achieved a striking relief quality in his works, even if they lacked beauty or polish.

Caravaggio's vivid chiaroscuro was of fundamental importance to his followers.

PORTRAIT OF A MAN
Oil on canvas; 104 × 79 cm.
(41 × 31¼ in.)
1626-1628
New York, location unknown.
Originally a full- or three-quarter-length figure, the portrait was later cut down, emphasising the subject's bulk. Cleaned and restored. Attribution to Velásquez uncertain.

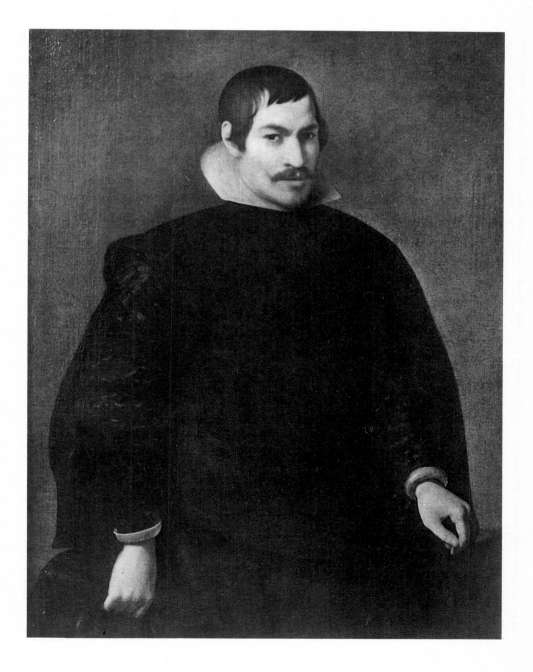

He achieved it by the use of light which draws men and objects out of shadow, heightening their shapes and colours. Whatever the subject may be neither the quality of the brushwork, nor the texture of pigment, nor the intensity of light varies significantly within any one of Caravaggio's works. The brushwork that he uses for the depiction of divine, mythological or human figures is the same as that used for the portrayal of ordinary people or objects. In this, he was faithful to the tradition from which he otherwise departed, adopting a naturalistic style

that was as creative with him as it was appealing or offensive to others. His portrayal of men and objects is all the more emphatic as direct light shapes the corporeal out of shadow in a limited space.

If Caravaggism was the main tenet of modernism to Velásquez' generation, the Spaniards' early works show that he saw it not as an aim, but as a stimulating point of departure, which he soon left behind. There is a distinct analogy between the young Velásquez' way of drawing from his model 'in different gestures and poses, now crying, now laughing' and what, to Mancini, was the highest accomplishment, as well as the limitation, of Caravaggism: the portrayal of human figures 'laughing or crying, walking or still', but lacking in refinement, grace and sentiment. However, unlike Caravaggio, the young Velásquez uses a diffuse light, with a greenish tinge, that sets men and objects in a fluid environment, bringing out at the same time the differing textures. Although he may have had Caravaggio as his starting point, Velásquez achieved from the beginning a vital depiction of the variety of shape, colour and texture, an atmospheric rendition of spatial depth, and a distinct expression of the polarity of the divine and the human—all of which were alien to Caravaggio's work. In this way Velásquez revealed an acute feeling in both the treatment of the subject and the colour and texture of the paint itself. This led him to a fluid handling of light and shade and to use a variety of brushstrokes more akin to Titian than to Caravaggio.

The young Velásquez obviously admired, first in Madrid and later in Italy, Titian's sketchy brushstrokes and *chiaroscuro* which gave such depth to his compositions. It may well be that he imparted his enthusiasm to his father-in-law, Pacheco, whose praise of Titian, admittedly based on Lodovico Dolce's *L'Aretino* (1557), appears greater than his understanding of the Venetian master's works.

HEAD OF A STAG
Oil on canvas; 66 × 52 cm.
(26 × 20 $\frac{1}{2}$ in.)
1626-1627
Madrid, Viscount de Baiguer Collection
Cut down along the top and sides; restoration visible to the naked eye, particularly on the background.

Men, objects and artistic reality

Velásquez' earliest extant paintings are two *bodegones*, *Three Musicians* (page 8) and *Three Men at Table* (page 9) both datable to 1617-18, that is roughly at the time he was completing his training and passed his examination for admission to the painters' guild. Unfortunately neither, particularly *Three Musicians*, is in a good state of preservation.

In Velásquez' time, the word *bodegón*, when used in reference to a painting, retained wider connotations than its literal meaning of a tavern; it generally meant a picture of ordinary people together with food, drink and tableware. Painters particularly in Flanders, Holland, Italy and Spain had for a long time used this sort of subject matter. In 1592, Juan Pantoja de la Cruz (1553-1608), painter to Philip II and well known for his portraits and religious compositions, painted three large *bodegones de Italia*, now lost or unidentified.

Although today *bodegón* is frequently regarded as synonymous with still-life, in Velásquez' day, there was a clear distinction between *bodegón*, which included one or more human figures, and paintings of fruit, fish, fowl, meat and vegetables, a genre which had been widely popular in Spain since the turn of the century though the term 'still-life' is indeed of Dutch origin.

It has been suggested that still-life sprang up as an independent art form for easel painting in Holland around 1600 as a manifestation of the national *élan* which pervaded the country in the wake of the recently won democratic freedom and independence and her ensuing prosperity and recognition as a colonial and world power. Positive forces which, it is said, found support in the opposition of the Dutch Church to any form of figural decoration in the House of God. Yet still-life had become an art form in its own right in Spain also around 1600, or even slightly earlier, when the country, under the rule of an absolute monarch, was declining as a world power, her empire threatened by the Dutch and the English, and her finances in a ruinous state, while Spanish churches and convents were being decorated with large altarpieces and other series of paintings.

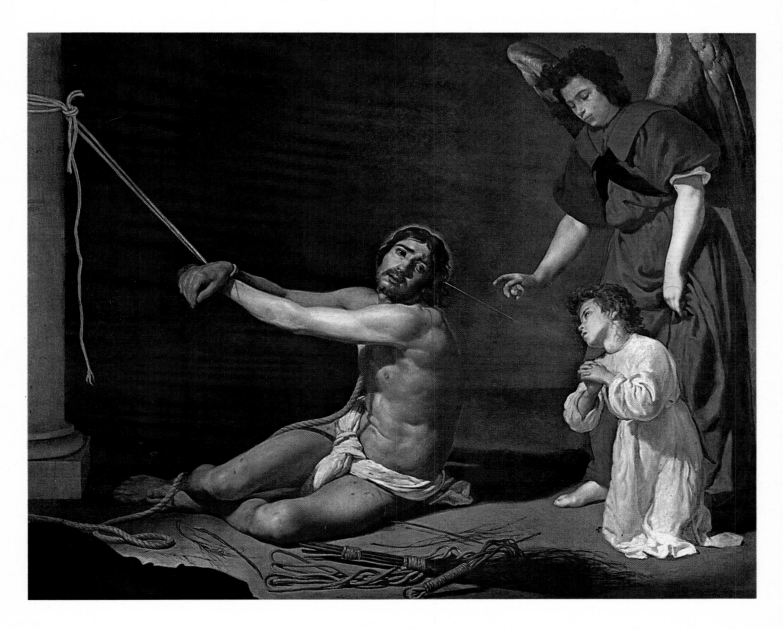

THE CHRISTIAN SOUL CONTEMP-
LATING CHRIST AFTER THE
FLAGELLATION
Oil on canvas; 165 × 206 cm. (65 ×
81 ¼ in.)
1626-1628
London, National Gallery (1148)

In fact, still-life sprang up as an independent subject for easel painting late in the sixteenth century all over Europe, in Italy, Spain, Flanders, Holland, France and Germany, countries then separated from one another not only by their political boundaries, new or old, but also by bitter religious differences, conflicting political views and divergent social structures.

New schools of painting, national or local, evolved, each with individual characteristics. Naturalism was a common trait, as was the naturalistic painter's penchant for letting the brushstroke accent the very texture of the pigment while shaping vivid images on the canvas, thus emphasizing the superiority of art over nature. It was, indeed, the naturalistic painter's way to emerge as a

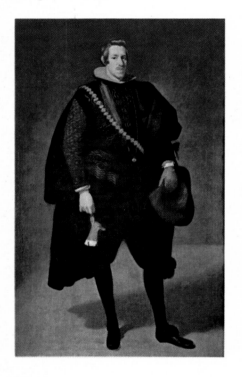

creator of artistic reality. A parallel can be drawn with writers such as
Shakespeare or Cervantes, Marino or Molière, who used conceits, puns and other
wordplay, sometimes involving vulgar expressions, to underscore the very
structure of words, the writer's medium as paint is with the artist, while creating
literary images of reality with them. Naturally, the lower the subject, the greater
the challenge, which explains the fascination that *bodegónes* and *nature morte*
painting held, even for painters who did not practice either genre. Pacheco him-
self tried his hand at least once at *bodegón* painting, in 1625, in Madrid,
encouraged he explained by his son-in-law's achievements. He also explained
that in a good *bodegón* the human figures ought to be life-like, and the objects
with which they are grouped just as vividly depicted.

Velásquez' bodegones

In *Three Musicians* and *Three Men at Table* three half- or three-quarter length
figures sit or stand round a table laid with food and drink. There is, in both
paintings, in the portrayal of human expression an intensity which calls to mind
Velásquez' early application to depictions of elementary moods, modelled for
him by a hireling apprentice at Pacheco's workshop. The viewpoint is high, and
local highlights accent the shapes of the food and tableware and stress the three-
dimensional grimacing faces and gesturing hands, while the bodies are not so
substantially set in space; indeed, spatial depth is mainly achieved by the multi-
plicity of points of distance marked off by hands, faces and objects. This is parti-
cularly true of *Three Musicians*, a rather tentative work which seems to have
exercised Velásquez' sense of composition.
Such a manner of defining space, fairly common in the late Cinquecento, had
been handed down to the young Velásquez but did not serve for long his
purpose of portraying reality. He nonetheless achieved a sort of equilibrium as
the vivid depiction of the grimaces and gestures of the figures, whose bodies do
not quite occupy the space plotted by means of the table, vies with the depic-
tion of the food or tableware which the underlying shadows make stand out
more sharply. In *Three Men at Table*, the shadow of the sword hanging on the
wall reveals Velásquez' gift for the depiction of aerial depth, of which he was
soon to show his mastery.
Old Woman Frying Eggs, (pages 13, 14-15) dated 1618, shows a surer sense of
composition than either of Velásquez' earlier *bodegones*, although he still
appears to be under the restraint of his apprenticeship, as his rather too studied
knife point, which bends down, and the boy's forearm, seen distorted through
the glass, shows. More objects are represented in this picture than in either
Three Musicians or *Three Men at Table*. He has abandoned the fussiness of local
definitions of objects which make both of these compositions somewhat
unstable, and also the emphasis on human expressions and motions. Now a
subtle interplay of light and shade rounds the figures and objects in a quietly
effective atmosphere. Both the woman and the boy truly occupy the space
beyond and above the food and kitchenware which occupy the foreground. The
gestures of both converge round the terracotta frying pan; yet their expressions
are unrelated; both are 'real' in the same way as the many-hued objects which
they are handling.

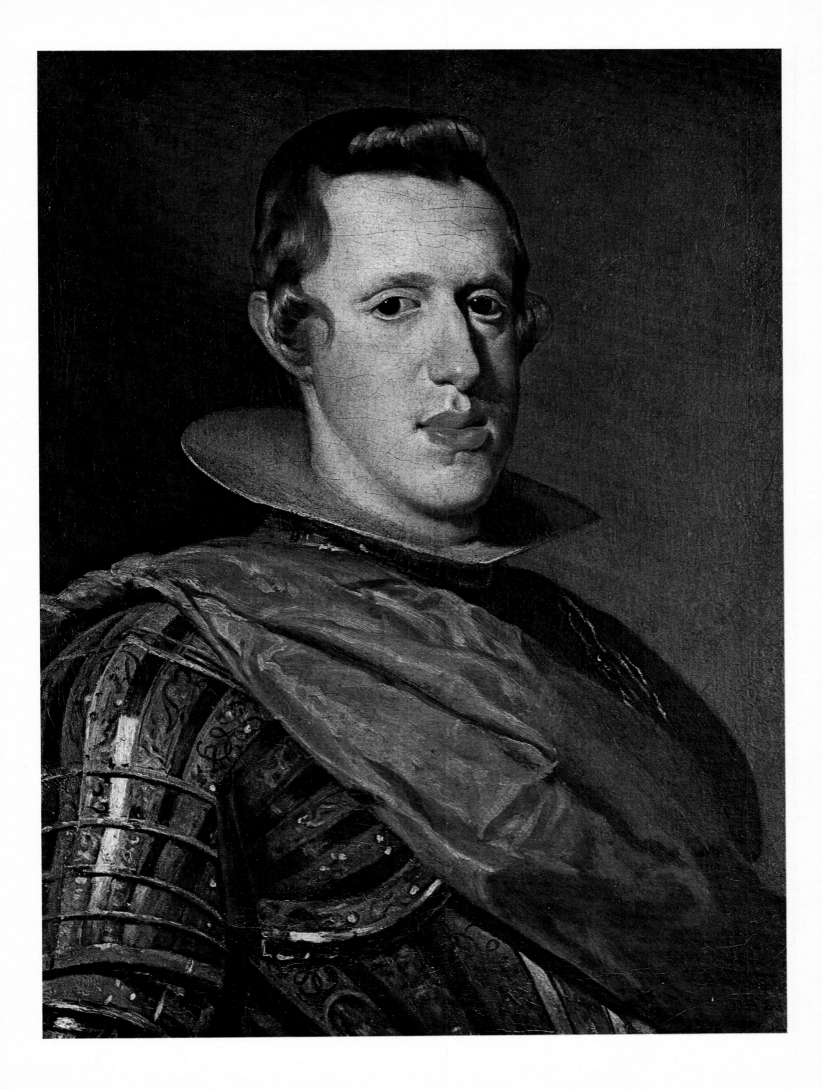

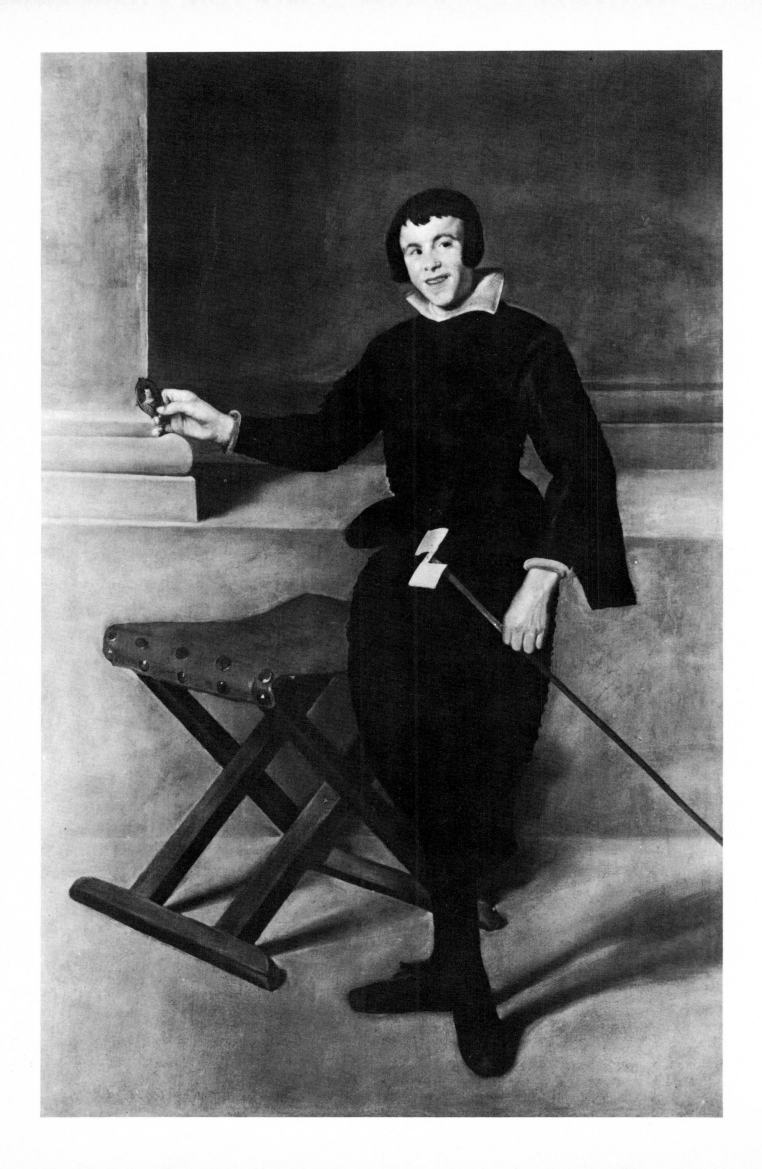

THE COURT JESTER CALABAZAS
Oil on canvas; 175.5 × 106.7 cm. (69 ¼ × 42 in.)
c. 1628-1629
Cleveland, The Cleveland Museum of Art (65.15)
The jester may have been painted occasionally at the Royal Court in Madrid before 1630, the date from which his service to the Cardinal-Infante Fernando is recorded. From 1632 to 1639, the year in which he died, he served King Philip IV.
Calabazas holds a miniature and a pinwheel.
Restored, mainly around right eye.

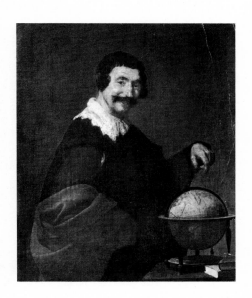

DEMOCRITUS
Oil on canvas; 98 × 80 cm.
(88 ¾ × 31 ½ in.)
1628-1629
Rouen, Musée des Beaux-Arts

The figure of the old woman, with her head but not her body in profile, makes one realize the problem which exercised Velásquez' sense of composition when he transformed one of the figures in *Three Men at Table*, of about 1618, into that of the young man in *A Girl and two Men at Table* (page 19), datable to 1618-19. The glass and the loaf of bread on the table are almost identical in both paintings, as is the figure of the old man, with the exception of the hands. The young man's arms and body are almost identical in both works, but not his head—for which Velásquez made a study (page 18) now at the Hermitage. Incidentally, Velásquez painted this study over what appears to be discarded sketch for *Three Musicians* or a fragment of a similar painting.

Velásquez achieved a compelling stillness in *The Waterseller* (pages 25, 26-27), datable to about 1620, and in *Two Young Men at Table* (page 36), painted some two years later. The inter-relationship of the figures is achieved by their converging poses rather than by their slightly vacant expressions.

In *The Waterseller* men and objects have a subtle greenish tinge. The vendor hands a glass of water, with a fig to freshen it at the bottom, to a boy while another shadowy youth drinks behind them. The shapes and expressions of the three men are no more vivid, or less quiet, than the watery film shimmering on the stopper of the jug, or the three drops of water which trickle down its side, or the interplay of differing degrees of transparency which intensely define the glass, the water and the fig within. In this *bodegón*, as in *Two Men at Table*, Velásquez has depicted men and objects with exactly the same intensity achieving a completely balanced whole, in which the narrative counts for little or nothing.

Two Velásquez *bodegón*-like paintings have biblical scenes in the background. Their composition stems from a sixteenth-century Flemish tradition which originated with Pieter Aertsen (1508-1575). Even if, as seems probable, Velásquez had never seen any work by either Aertsen or his outstanding follower, Joachim Beuckelaer (c. 1535-1574), he may well have been acquainted with their compositional schemes through derivative paintings or drawings, or engravings, of which Pacheco owned a large number, or perhaps even via oral descriptions, not so infrequent a means of communication among painters as might be supposed.

Many of Aertsen's and Beuckelaer's works represent an interior, where pots and vessels together with baskets of fruits, vegetables, raw or cured meats, cheese, game or fish fill the foreground, their profusion emphasised by bright colours and the somewhat jerky manner in which the various planes recede. Figures occupy the middle distance or occasionally the foreground or both and can be related to the narrative, or at least to the general mood, of the smallish figure-scene from the New Testament in Velásquez' *bodégones*.

Several of these paintings have Christ in the house of Mary and Martha as their subject matter, as does the earlier of the two extant Velásquez *bodegónes* with biblical subject matter (page 16), dated 1618. Though the condition of this much restored painting is poor, the main lines of its composition remain visible as a tantalizing suggestion of what it must originally have been like. The foreground is taken up by the three-quarter length figures of an old woman and a girl who is busy with mortar and pestle at a table where other pieces of kitchen-ware, some fish and food are displayed. The girl, identifiable as Martha, looks into the space outside the field of the composition. In the background, in what appears to be a reflection in a mirror, there is the scene of Jesus seated talking to Mary. The sides of the mirror, seen as is the rest of the composition in diagonal perspective, are naturally of unequal width and height.

The other Velásquez *bodegón* of a subject from the New Testament is of *The Supper at Emmaus*, and reveals a finer interplay of light and shade. This suggests that it was painted later, probably circa 1620-1622 (page 28). This composition also has two points of focus. It represents a kitchen interior where, in the foreground, is a mulatto servant behind whom there is an open hatch, with its door plainly visible, which gives onto another room where Christ and his two companions are seated at table. The canvas has been cut down on the left side and, as a result, the left arm is all that remains of the man that Velásquez

represented on Christ's right. A contrast with this work is provided by a copy, without the background scene, in which the figure of the servant is at the centre of the darker composition (page 29).

The analogies between either of the two *bodegón*-like biblical paintings by Velásquez and works by Aertsen or Beuckelaer are evident but can be seen to be limited. In Velásquez' works there is neither the profusion of food or vegetables to which the figures are rather ancillary in both Aertsen's and Beuckelaer's compositions, nor the sense of bustling activity which fills them. In Velásquez' compositions the food and pieces of kitchenware are few in number, and, striking though they are, they do not dominate the composition; secondly, instead of the manifold bright colours of the Flemish pictures (page 17), there is in Velásquez' a unifying atmospheric tint which, however, allows the textures of food, brass and earthenware to contrast with one another. It is, moreover, to the three-quarter or half-length human figures that the overall composition is keyed.

A closer analogy can be found between Pacheco's *St. Sebastian nursed by St. Irene* (page 28), of 1616, and the later Velásquez' *bodegón*-like biblical compositions. In Pacheco's painting (destroyed by fire in 1936) St. Sebastian is seen in an interior, the blood-stained arrows hanging on the wall; a window shutter is open revealing a landscape with St. Sebastian tied to a tree and the archers aiming their arrows at him. Unlike Pacheco, however, Velásquez does not represent two moments of the same narrative in either *Christ in the house of Mary and Martha* or in *The Supper at Emmaus*; indeed, in these two works, the foreground and the background scenes concur in point of time. Velásquez' composition, moreover, differs as much from Pacheco's as from Aertsen's or Beuckelaer's. His is a different sense of space. Indeed, the stare of Martha—and for that matter, the gaze of the mulatto servant—suggests an outlying space which encompasses the viewer and together form an integrated whole.

Early portraits and religious works

A few likenesses of the people, who sat to Velásquez or whom he portrayed from memory in his early years in Seville, have come down to us: two drawings, both of a young girl, both datable to about 1618 (pages 10, 11); a posthumous full-length portrait of the priest *Father Cristobal Suárez de Ribera*, godfather to Velásquez' wife, Juana Pacheco, probably painted in 1620 (page 30); the two full-length portraits of *Mother Jerónima de la Fuente*, both dated 1620 (page 31), and the bust length portrait of *A Man with a Goatee Beard*, datable to 1620-1622 (page 37). In each of these portraits, Velásquez brings out the sitter's character, letting the individual expression accent age and status.

The commission for the portraits of *Mother Jerónima de la Fuente* apparently called for the inclusion of a scroll with a Latin text to curve around the crucifix held by the sitter. It must have been a challenge to Velásquez' sense of composition since this was a convention more of the sixteenth century. However in the two portraits the scroll around the crucifix originally had an almost architectural quality, framing the effigy of Christ on the Cross. In the version at the Prado, the scroll was erased soon after its acquisition by the Museum on the random assumption that it was a later addition.

THE TRIUMPH OF BACCHUS (THE TOPERS)
Oil on canvas; 165 × 227 cm. (64 ¾ × 88 ½ in.)
Probably begun in 1628; finished before 22nd July, 1629, the accurate date of payment.
Madrid, Prado (1170)
Damaged in the fire that destroyed the Royal Palace in Madrid in 1734.
Detail: *pages 54-55*

Velásquez' compelling rendering of the mundane and transient, whether a rind of melon, a few drops of water trickling down the side of a jug, or a human face on which age and character have been stamped, exists side by side with his portrayal of the divine in *The Adoration of the Magi*, dated 1619 (page 23). This work is rather different from the *bodegón*-like biblical paintings which Velásquez painted just before and after that year. In a rather traditional vein, he centered the composition around the vivid depiction of the divine nature of the Virgin and the Infant Christ. Indeed, light models the faces of the Virgin and the Child into unblemished shapes while the facial characteristics of the non-divine persons, St. Joseph, the three Kings and their manservant, are accented by lively contrasts of light and shade.

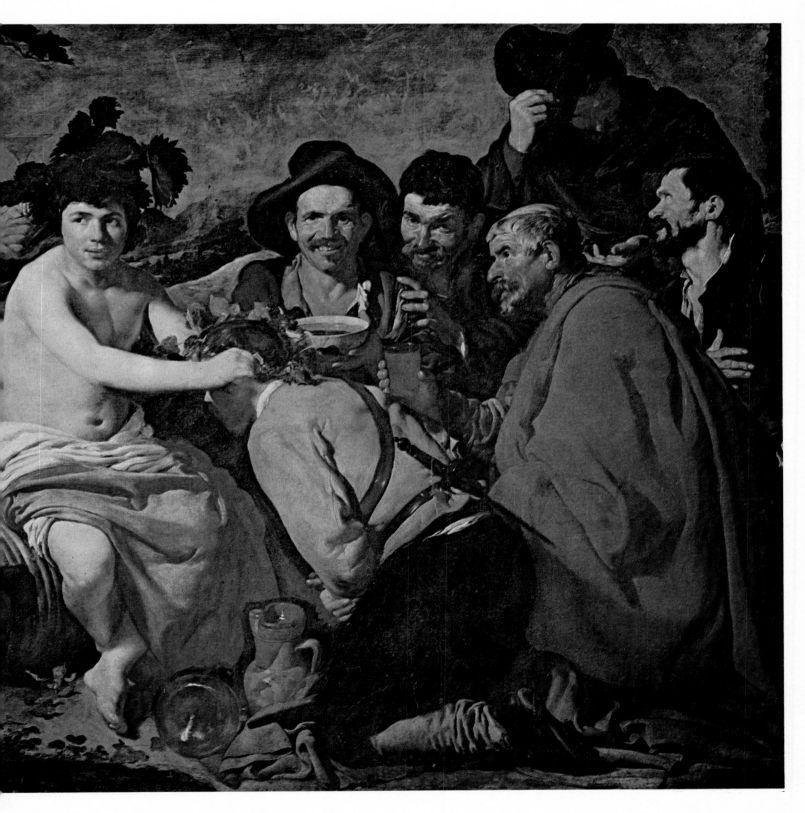

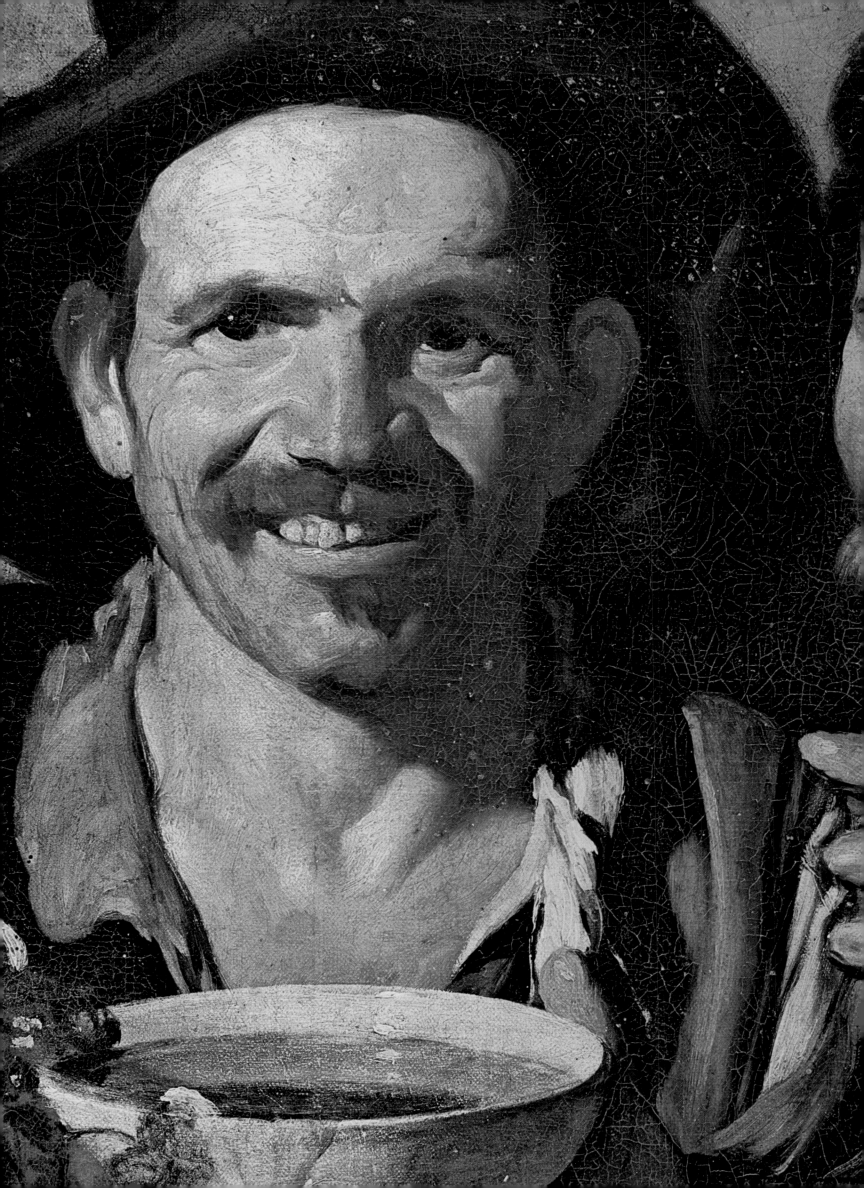

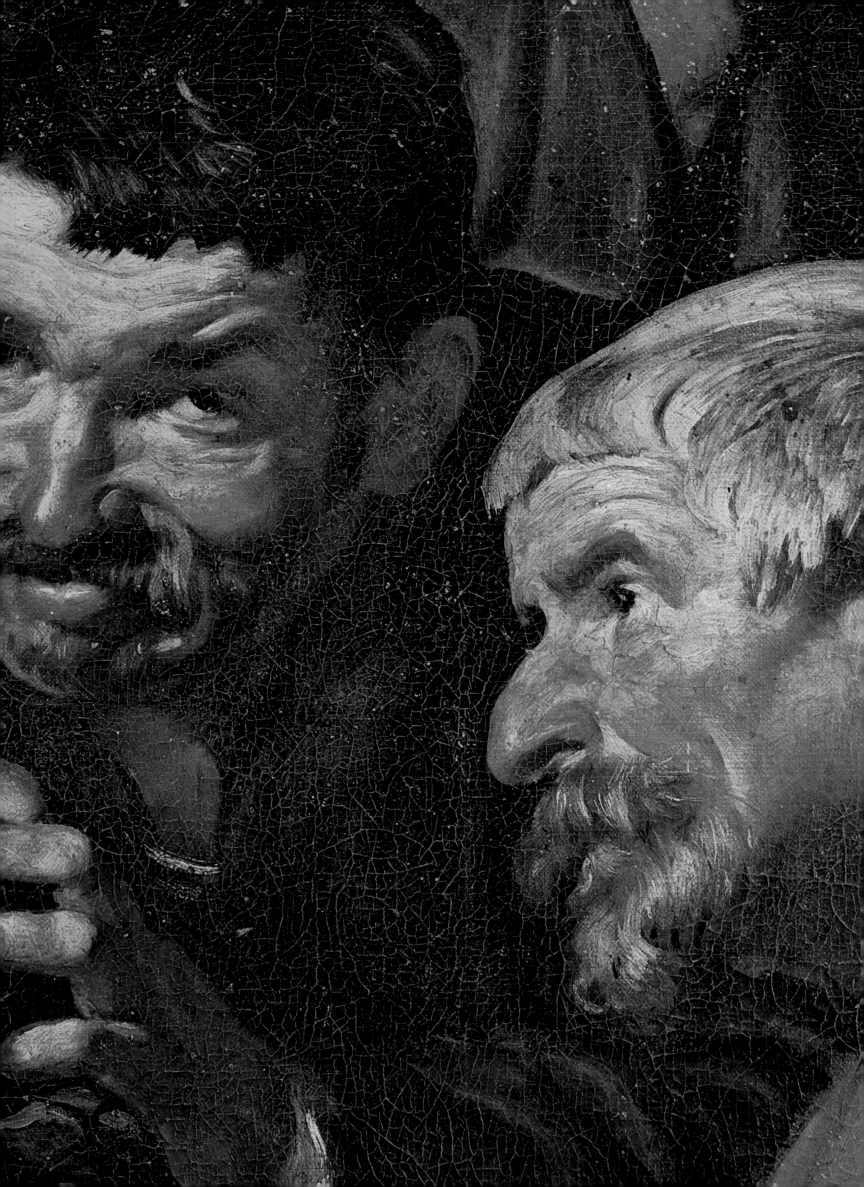

The same distinction in the depiction of human and divine persons is evident in *The Immaculate Conception* (page 22) and *St. John on Patmos writing the Apocalypse* (page 21) seeing the vision of the woman followed by the dragon, datable also to about 1619. The subjects are closely related, and they are of the same size and provenance (from a Carmelite convent in Seville); yet the difference in the scale of the figures indicates that they were not intended to be on the same wall or altar, or at least not at the same level.

The belief that the Virgin had been born without taint of original sin, a subject of debate for several centuries, aroused a great deal of feeling among its upholders, especially in Seville, where at least thirty-eight treatises debating the point were published between 1615 and 1620. On 1 January 1620, Pacheco completed a paper on the subject. Although Pacheco's paper did not touch upon matters of iconography, such matters must have been discussed at his workshop while he was writing it, all the more so since at precisely that time Velásquez undertook to paint the two companion pieces on the subject. Later, in *Arte de la Pintura*, Pacheco discussed the iconography of the Immaculate Conception of the Virgin as related to the vision of the woman chased by a dragon described in the *Apocalypse*. He advised the painter that, though the youth of St. John when he joined Jesus as his disciple signifies his perpetual virginity, pictures of him writing the *Apocalypse* ought to represent him as the old man that he then was. As for *The Immaculate Conception*, Pacheco says that the Virgin ought to look twelve or thirteen years old, have twelve stars round her head, and wear an imperial crown on golden hair; she must be dressed in a white tunic and blue mantle, and her feet should rest.on the moon, depicted with its points downward; she must also be represented against the ochre and white oval shape of the sun.

Velásquez' *The Immaculate Conception* is earlier than any of the pictures of the same subject painted by Pacheco or than the latter's formulation of his iconographical views on the matter. In Velásquez' painting the Virgin wears no crown but has twelve stars around her head; her white tunic is shadowed with purplish tints as she stands against the sun, painted in ochre within luminous white clouds, with the moon under her feet, and the symbols of the litanies built into the landscape below. It is a masterpiece, alive both with naturalism and symbolism.

Velásquez represented *St. John writing the Apocalypse* as a young, dark-haired man, in a white tunic and deep rose-colored mantle, his shape roughened by shadow and hand poised to write emphasised by the uneven impasto. The vision of the winged woman and the three-headed dragon is depicted in the upper left-hand corner, as the Saint with his half-open mouth and the quill suspended over the page, embodies the wondrous experience of the Revelation and the contemplation needed to put it into words.

Throughout his life, Velásquez differentiated between the portrayal of the divine and the human, which, as we have just seen, extends to the textural quality of the brushwork and is to be found not only in companion pieces, such as *The Immaculate Conception* and *St. John writing the Apocalypse*, but even within a single work, as in the case of *The Adoration of the Magi*.

Velásquez made use not only of a variety of hues but also of the variety of textures that the paint itself afforded to express pictorially the polarity of the divine and the human. He used paint with a fullness of meaning which we can grasp today only if we understand the reasons which prompted the artist to work in the way he did.

Velásquez and the art world of Madrid in the 1620s

Most of the prominent painters in Madrid in the 1620s had been brought up in the tenets of Mannerism which, from the 1570's until the early 1600s, had as its centre the Escorial. Vincencio Carducho (1570-1633) came to Spain from his native Florence in 1585, together with his elder brother Bartolomeo (1554-1608). The latter was an assistant to Federico Zuccaro at the Escorial, and unlike his brother remained in Spain after Zuccaro returned to Italy. Eugenio Caxés (c. 1577-1611) was trained by his father Patricio (c. 1544-1611) who in his twenties had come from Rome to Spain, where he was active in the service of the King till his death.

THE SUPPER AT EMMAUS
Oil on canvas; 123 × 132.6 cm. (48 ½ × 52 ¼ in.)
1628-1629
New York, Metropolitan Museum of Art
(14.40.631)

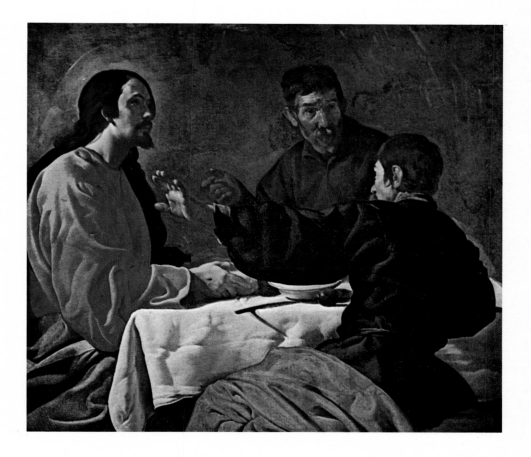

Vincencio Carducho and Eugenio Caxés became prominent during the reign of Philip III (1598-1621), who appointed both to the position of Court painter. However neither found favour with King Philip IV.

Carducho, however, remained influential in Madrid as a painter, writer on art and even as a dealer. In his later years, he hovered between the Mannerist tenets, learned in his youth, and the Baroque concepts acquired from his literary friends. He was truer to his prejudices then to the ideas that he borrowed from others, and he never departed from the conviction that drawing was the core of painting while colour was rather its 'coating'. In *Diálogos de la Pintura* (dated 1633, though actually published in 1634), he asserted that painting could only be mastered by dint of 'drawing, analysing, and more drawing'. Such views conditioned the cautious approach to naturalism noticeable in some of his works, even in the *Colossal Head of a Man* (246 × 205 cm.), presumably painted before the 1620s, in which line and shading define the individual features without in the least aiming at a transient expression of the moment such as Caravaggio and like-minded painters achieved with their striking use of light. Indeed, Carducho was in earnest when he chastised Caravaggio as being 'anti-Michelangelo'.

Carducho's views must have carried weight in Madrid during the 1620s, even

though by then painters and connoisseurs generally followed a trend towards naturalism, nurtured since early in the century by such painters as Orazio Borgiani (1575-1608), who spent some years in Spain, and by the Spaniards Pedro de Orrente (1588-1645) and Antonio de Lanchares (died 1630), who both continued the Bassanesque tradition. Even Eugenio Caxés occasionally tried, and failed, to give a more naturalistic cast to his Michelangelesque figures. The other Court painter, Bartolomé González (1564-1627), though older than either Carducho or Caxés, was more attuned to the times, trained as he had been to follow Titian in the tradition of his master, Juan Pantoja de la Cruz (1553-1608) and was later attracted to Caravaggism.

Also quite influential at Court was Juan Bautista Maino (1578-1641), who had learned the art of painting at Toledo during El Greco's last years, and probably spent some time in Italy around 1611. He had been drawing master to Prince Philip, who on ascending the throne kept him in his service; his paintings show an awareness of Caravaggio's use of light and colour, though his art appears more generally orientated to that of the Caracci.

The Madrilenian Juan van der Hamen (1596-1632), three years older than Velásquez, was truly creative. Though he painted portraits and other figure-compositions, his contemporaries rightly admired him mainly for his still-lifes. The work of Juan Sánchez Cotán (1561-1627), whose activity as a still-life painter came to an end in 1603, obviously had a vital influence on van der Hamen. His still-lifes are unique for the architectural quality with which he endows the spaces between the various objects depicted, fruits, sweetmeats or tableware—thus bringing order to seeming disarray (page 12).

JOSEPH'S COAT BROUGHT TO JACOB
Oil on canvas; 217 × 285 cm. (85 $\frac{3}{4}$ × 112 $\frac{3}{4}$ in.)
1630
Salas Capitulares, Palace of the Escorial.
The canvas has been greatly cut down.

THE FORGE OF VULCAN
Oil on canvas; 223 × 290 cm. (87 $\frac{3}{4}$ × 114 in.) (additions included)
1630
Madrid, Prado (1171)
A strip of canvas about nine inches (22 cm.) wide was added on the left-hand side, and another piece, about four inches (10 cm.) wide, to the right-hand side. It seems fairly certain that these additions were made during the eighteenth century, before 1772.
Detail: *pages 60-61*

This was the art world which, as Pacheco recorded, 'much praised' Velásquez' portrait of the poet Góngora, painted during his first stay in Madrid in 1622. Early in the century Giambattista Marino in Italy and Hortensio Félix Paravicini in Spain had expressed the view that the highest achievement of a portrait painter was to create a true-to-life image that would cause the sitter to doubt whether he or the painted image was his true self,[3] this view was current in intellectual circles in Madrid, even though Carducho did not share it, favouring rather the use of conventional attributes to make plain the preeminence, deeds or achievements of the sitter.

In the portrait of Góngora (page 38) the sitter was initially represented wearing a laurel wreath as Pacheco's portraits of poets generally did. Yet, before completing it, Velásquez painted over the wreath and achieved a striking naturalistic image. The sitter, half his face in light, half in shadow, stands out against the plain background, his strength of character made evident. The wreath, which none of the extant copies reproduces, is still visible under X-ray. Neither the portrait of Fonseca, which opened the way for the success of Velásquez at the Palace, nor that of the Prince of Wales, which was probably taken to England, has been identified.

STUDY FOR THE HEAD OF
APOLLO IN THE FORGE OF VULCAN
Oil on canvas; 36 × 25 cm.
(14 $\frac{1}{4}$ × 10 in.)
1630
New York, location unknown

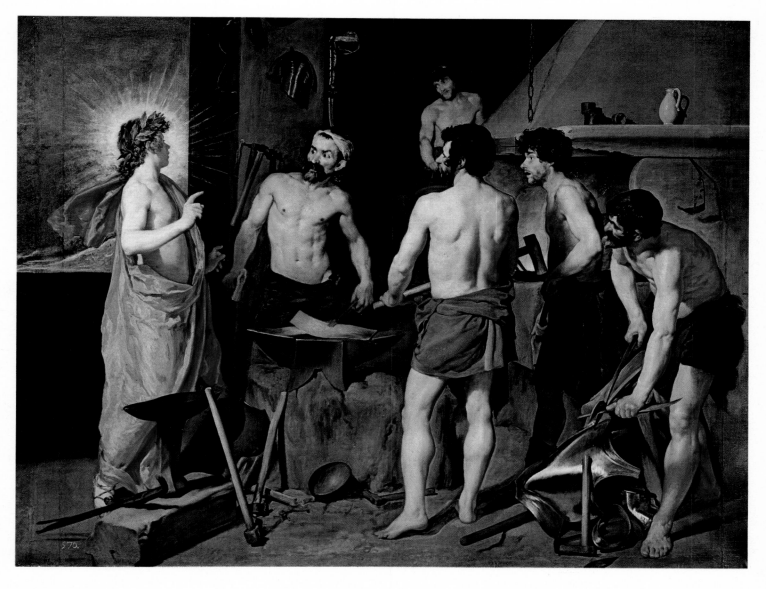

The portraits of the King

The portrait of the King that won for Velásquez the appointment of Court painter has been preserved, though only underneath another likeness of the Sovereign painted by Velásquez a few years later. In fact, X-rays show, if only in black and white, what appears to be the first portrait of Philip IV painted by Velásquez: the King is standing by a table, in his right hand is a petition, while his left hand rests on his sword hilt. He has a flabby face, roundish chin, and a short neck, which from all we know corresponded to his actual appearance (page 41). Yet Velásquez soon became dissatisfied, and in 1626-8 he painted out that true-to-life likeness, substituting for it another in which the august nature of the King rather than his physical characteristics were his primary consideration (page 41, right).

Probably in 1623, surely no later than 1624, Velásquez painted the earliest portrait of Philip IV which has come down to us intact. It is a bust-length portrait in which the broad outline of the shoulders emphasises the monumentality of the figure, a quiet light bathes the King's countenance, thinning the shadows to the faintest veil, and the blue-grey eyes appear as still as the highlights on the crimson lips (page 40).

By early December 1624, Velásquez had completed a full-length portrait of Philip IV and another of the Count-Duke Olivares (page 42, 43) both of which were commissioned, or at least paid for, by the widow of a high-ranking royal servant. It is unlikely that the portrait of the King was painted from life. It seems that Velásquez painted the head after the bust discussed above, while he

VIEW FROM THE VILLA MEDICI IN ROME
Oil on canvas; 44 × 38 cm.
(17½ × 15 in.)
1630
Madrid, Prado (1211)

used the full-length portrait of 1623 for the rest of the figure, now visible only under X-rays.

Unfortunately, the portrait is in poor condition. Yet, it is still noticeable that Velásquez shaped the head and hands by dint of light, using shadow very sparingly. There is no emphasis on Philip's physical characteristics; his kingly power is embodied in an effortless gesture, one hand on his sword hilt and the other holding a petition, the quiet rhythm of the figure underscored by the gold chain which falls in a long curve across his chest from his shoulder and by the order of the Golden Fleece hanging from a black ribbon (page 42).

In 1625 Velásquez achieved another resounding success at the Court with an equestrian portrait of Philip IV, now lost, painted entirely 'from nature, even the landscape', which was publicly displayed at a favourite spot of the Madrilenian cognoscenti, a public walk across the convent of San Felipe.

In the bust-length portrait of 1623 or 1624, as well as in the full-length of the latter year, Velásquez had still depicted Philip's chin as round and his neck as short. Yet, in those painted after 1624, he made the King's chin look more pointed and his neck longer. Later, probably between 1626 and 1628, Velásquez repainted the full-length portrait of the King which he had executed in August 1623 and which, as X-rays show, had been somewhat damaged. It was not a restoration, though, that Velásquez undertook. He repainted the whole composition, substantially altering the King's pose, introducing changes in his costume, and, more significantly, endowing him with distinctly different features, which could hardly correspond to actual changes in his physique. In the resulting new portrait, there is no floor line and the sense of space is

VIEW FROM THE VILLA MEDICI IN
ROME
Oil on canvas; 48 × 42 cm.
(19 × 16½ in.)
1630
Madrid, Prado (1210)

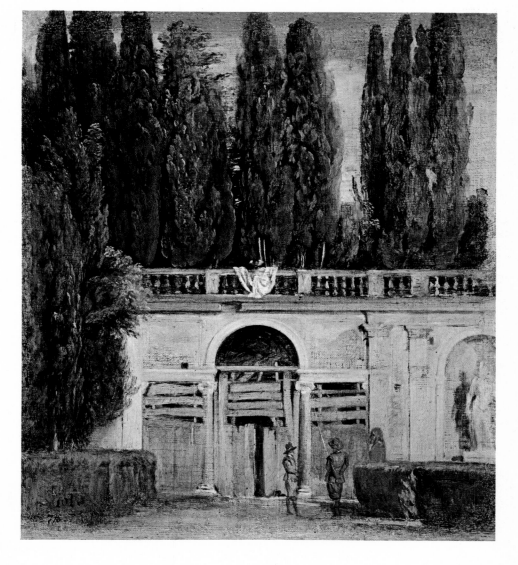

achieved by a subtle interplay of light and shade. The King's face and hands are undefined by shadows; his chin is pointed, and his neck quite long; the verticality of his figure has been somewhat enhanced by the change in his stance and the omission of the looped gold chain, yet his gesture is as effortless as that in the earlier portrait.

Similar devices had been used for the purpose of improving a sitter's appearance long before Velásquez' time. For him, they became another means to refine the likeness of the King. Flattery could hardly have been his motive, as he had won his first and astonishing success at Court precisely with a true-to-life likeness of Philip IV. Moreover, if the portraits of Philip IV executed throughout the years by other painters, even in the workshop of Velásquez, are any indication, the

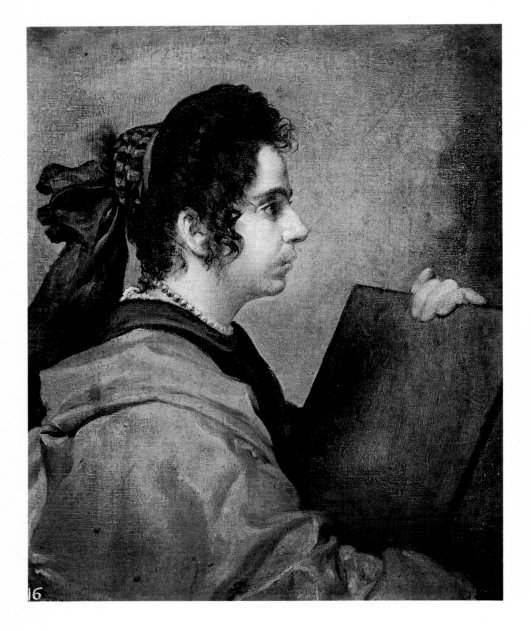

PORTRAIT OF A WOMAN AS A SIBYL (?)
Oil on canvas; 62 × 50 cm. (24½ × 19¾ in.)
1630-1631
Madrid, Prado (1197)
It is by no means certain that the identity of the sitter is Velásquez' wife, as was suggested in 1746.

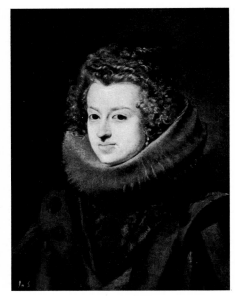

prevailing taste at Court continued to favour likenesses of the King which were truer to life, a preference that Philip himself apparently came to share in his melancholy last years. It seems that Velásquez always left it to his assistants to meet this requirement.

Diego de Saavedra Fajardo (1584-1648), a leading intellectual who was a keen judge on the matter of artistic creativity and on the 'theory' of the monarch and the monarchy, described an imaginary city where artists, all from the past except for Bernini and Velásquez, were seen at work. Bernini was in the act of completing the statue of Daphne being changed into a laurel tree, which kept

THE INFANTA MARIA, QUEEN OF HUNGARY
Oil on canvas; 58 × 44 cm.
(23 × 17¼ in.)
1630 (?)
Madrid, Prado (1187)
Infanta Maria (1606-1646) was Philip IV's sister. In 1629 she was married by proxy to Ferdinand III, King of Hungary.

the viewer in suspense, waiting for the bark to entirely cover the nymph's body and for the wind to stir the leaves into which her hair was turning. As for Velásquez, he was portraying Philip IV, endowing the likeness of the King with such a graceful air and achieving so compelling an expression of the 'majestic and the august' in the depiction of the face that Saavedra felt overwhelmed and knelt down, lowering his eyes, in an act of reverence.[4] This fictional episode reflected a deep-seated sentiment. It was not uncommon, indeed, for some of the best minds of the time to regard the King as a quasi-divine person, as a 'deity' or 'God's representative on earth' as was occasionally suggested. The portraits of Philip IV suggest that Velásquez shared that view.

Velásquez' portraits of Philip IV and of the Count-Duke Olivares painted in

PORTRAIT OF A YOUNG MAN
Oil on canvas; 89.2 × 69.5 cm. (35 $\frac{1}{4}$ × 27 $\frac{1}{2}$ in.)
1630-1631
Munich, Bayerische
Staatsgemäldesammlungen (518)

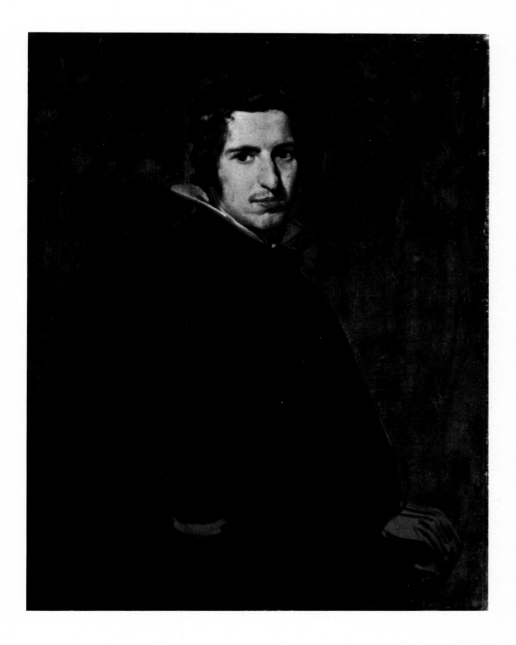

1624 differ significantly from one another as paintings. Olivares' black clothes, in contrast to the King's, are sharply highlighted. His corpulent figure is made rather ponderous by the vivid display of the red cross of Calatrava, the black sash, the heavy gold chain drawn firmly across the chest, instead of falling in the light curve of the King's, the other symbols of his high offices dangling from his belt. His forceful gesture emphasizes the nature of his power, and a strong light falls across his face, accentuating the wrinkles and leaving the left side in deep shadow.

The differences between these two companion portraits are so obvious that they

have led some scholars to cast doubts on the authenticity of one or the other, or even of both pictures. Such doubts arise from the idle assumption that Velásquez' sense of composition and handling of paint was unvaried at any given time, and that dissimilarities in execution between two of Velásquez' paintings indicate either that they were painted at different periods, or that one of them is not by him.

Dissimilarities in execution appear quite early in Velásquez' art, not only in companion pieces, as has been indicated with *The Immaculate Conception* and *St. John writing the Apocalypse*, but also within a single picture, as in *The Adoration of the Magi*. Velásquez made use of dissimilarities in the treatment of light and shade, or in the quality of the brushwork, for various expressive purposes, often to emphasize the artistic reality of the images that he put on canvas. He consistently used the dissimilarities to express the polarity of the human and the divine, or the contrast that he saw between the King as the embodiment of a divine right and the King's minister as the personification of worldly power. In the *Portrait of a Young Man*, datable to approximately the same period as that of Olivares, Velásquez also makes use of contrasts of light and shade to accent the individuality of the sitter (page 40).

Around 1628, when Velásquez re-painted his early full-length portrait of Philip IV (page 41), he portrayed the Infante Carlos, who was two years younger than his brother, the King. The portrait of the Infante, though, is quite different from that of the monarch: the light on his face is intermingled with shadows which make somewhat weightier his character traits, and highlights emphasize the textural qualities of both face and costume (page 48).

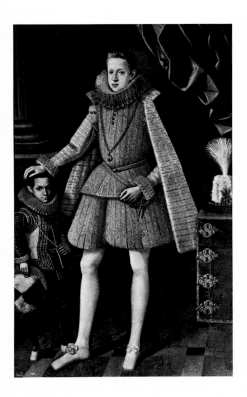

Rodrigo de Villandrando
PHILIP IV AND THE DWARF
SOPLILLO
Oil on canvas; 204 × 110 cm. (80 ½ × 43 ½ in.)
c. 1618
Signed bottom right:
'R.° de Villandrando F.'
Madrid, Prado (1234)

PRINCE BALTASAR CARLOS WITH A DWARF
Oil on canvas; 136 × 104 cm. (53 ½ × 41 in.)
1631
Boston, Museum of Fine Arts (01.104)
Baltasar Carlos was born in 1629 and died in 1646.

Naturalism

Velásquez must have finished his painting of *The Triumph of Bacchus* (page 53, 54-55) (commonly known as *The Topers*), sometime between 9 February 1629, when he agreed to a financial settlement covering all the works he had painted for the King up to that time, and 22 July of the same year, when the King ordered that he be paid one hundred ducats for 'a picture of Bacchus which he has done in my service'. It is likely though that he had started work on so large a composition much earlier, probably in 1628.

The picture was damaged in the fire that gutted the Royal Palace in 1734; as a result it has darkened considerably and unevenly; the canvas was, moreover, cut down on both sides. The vine-leaf crowned man sitting in the left foreground has blurred into a brown shape that hardly fulfills its intended *repoussoir* function and fails to add to the dynamic intersecting of diagonals, now mainly supported by the man being crowned and the nude youth holding a glass. The intersecting diagonals emphasise the heads of Bacchus and of the hatted drinker and also build a unifying rhythm which runs from the roomy area where the god officiates, across the huddle of topers, up to the standing beggar, identified as such by his open palm, at the back of the group.

As the reveller clad in a yellow jacket and dark breeches kneels, his face sinks away in shadows under the vine wreath with which Bacchus is crowning him. Blotches of shadow make more rustic both the flabby god and his muscular nude

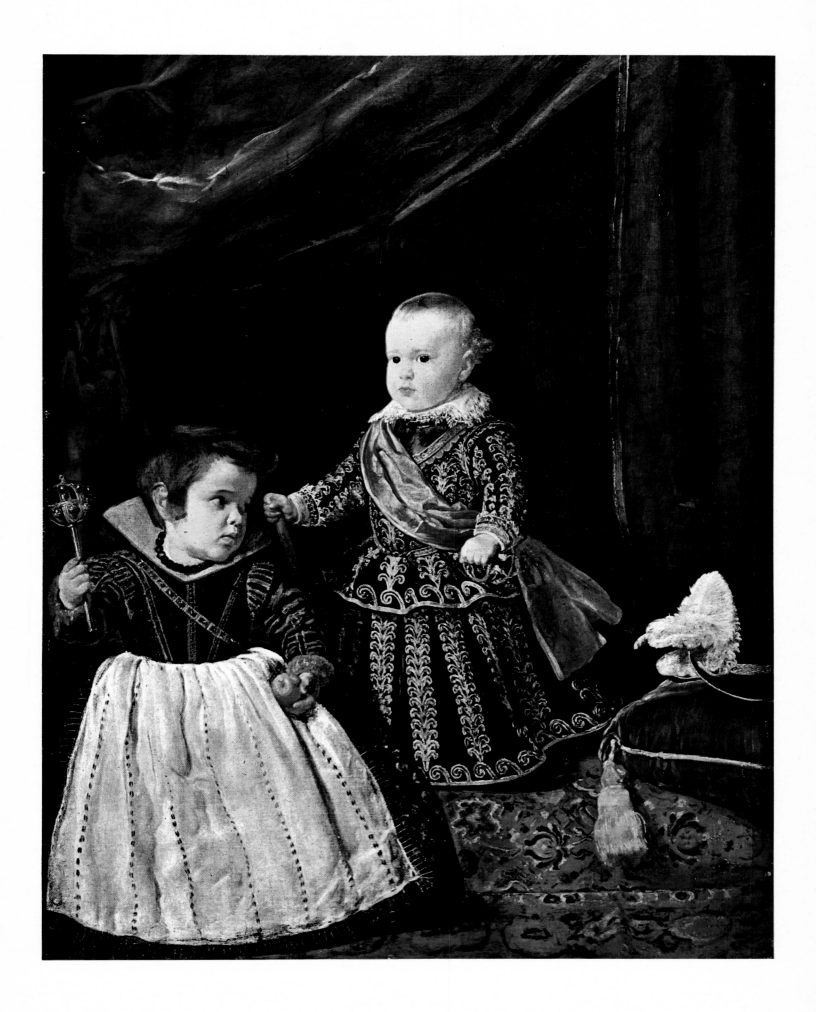

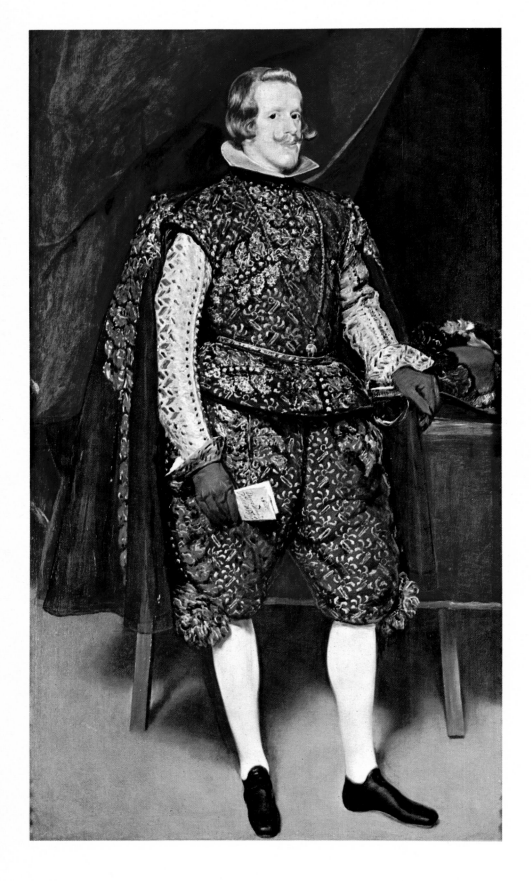

PHILIP IV IN BROWN AND SILVER
Oil on canvas; 199.5 × 113 cm. (78½ ×
44½ in.)
1631-1632
London, National Gallery (1129)
Probably painted over an extended
period of time. In 1936 it was cleaned,
although it was not possible to remove
all traces of the old and discoloured
varnish. Nevertheless recriminations
ensued as certain experts claimed that
the canvas had been ruined: a somewhat
exaggerated criticism. The King holds in
his hand a piece of paper bearing the
inscription *'Señor...Diego Velázquez,
Pintor de V. Mg.'*, set out in the form of
a petition.

attendant. Similar shadows and rather rougher impasto highlights emphasise
the features of the four carousers bunched together on the right side, in contrast
to the face of the standing beggar which Velásquez has left in shadow. The
composition is made more dynamic by the counterpoise of the vine-leaf crowned
Bacchus to the toper in the shapeless hat, and by the white bowl of red wine,
which by its vivid textures and reflections marks the centre of the *bodegón*-like
composition.

The picture is of course, a Baroque, double-edged parody of the world of the

QUEEN ISABELLA
Oil on canvas; 203 × 114 cm.
(80 × 45 in.)
1631-1632
Zurich, Private Collection
Painted over another portrait of the
Queen, also painted by Velásquez in the
last part of the decade 1620-1630.
Isabella de Bourbon was born in 1602;
she was married at the tender age of 13
to Philip IV in 1615 and died in 1644.

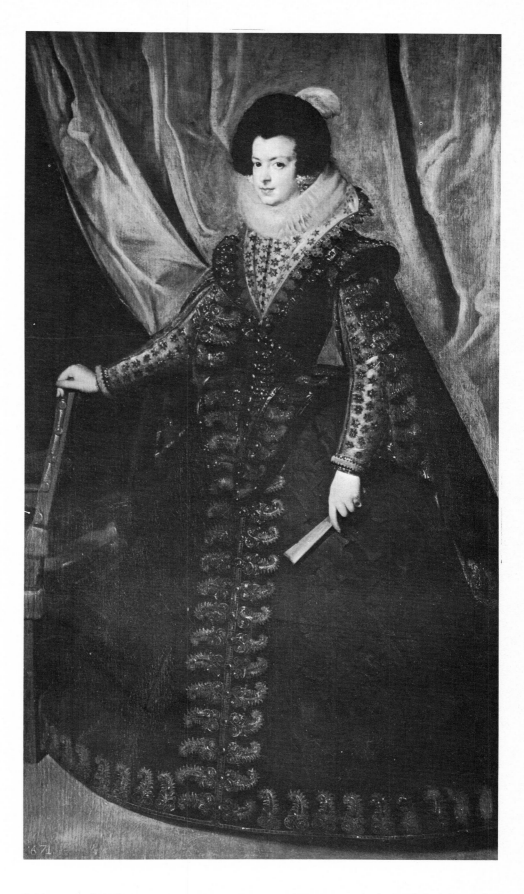

fable and of sinful human ways, as the clowning topers vie in their bearing with
the loutish nudes of Bacchus and his attendant; the underlying moral sentiment
is in the figure of the beggar who, lightly sketched in, looms in the background
òver the drunkards who ignore him. The virtue of Charity, readily identified
with alms-giving, almost invariably led the Catholic mind to the contemplation
of the Cross where Jesus shed His blood for the redemption of Mankind. In
Velásquez' burlesque of Bacchus and his fellows, the beggar underplays his part,
while Bacchus emphasizes his, as does his counter-figure, the hatted drunkard,

DOÑA ANTONIA DE IPEÑARRIETA Y GALDÓS
Oil on canvas; 215 × 110 cm. (85 × 43 ½ in.)
1631-1632
Madrid, Prado (1196)
Doña Antonia was born sometime between 1599 and 1608. Some of the scratches, mainly around the right eye of the child, have been restored. Forms a pair with the portrait of her husband (see page 73).

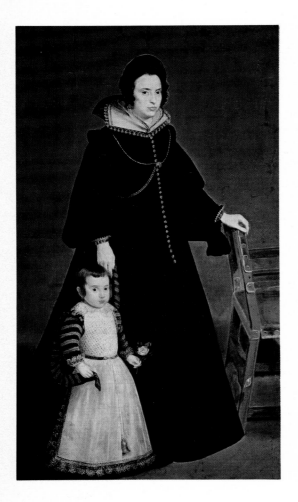

who holds up a bowl, his senses only responsive to the wine's potency, his mind obviously blank to its symbolic meaning of the Eucharist.

The Supper at Emmaus (page 57) is also datable to the late 1620's, before Velásquez' departure for Italy. It represents the moment when Christ breaks the bread and His divine nature is revealed to His astonished companions. Once more Velásquez is rendering the difference between the divine and the human. Luminous tints and smooth brushwork model the figure of Jesus, whose humanity, which connotes His humility, is expressed by weightless shadows on the faint rose flesh tones of His face. A rosy glare that lights up His pink tunic sets Him apart as an unearthly presence from the realism of His gesturing companions, whose coppery-brown flesh tones harmonise with the yellows, dusky browns and darkish blue of their surroundings and heavily-textured costumes. The natural characteristics of age and expression are depicted on the disciples' faces, modelled by energetic strokes and shadows though without the heavy impasto which weighs down the faces of the topers, one of whom, incidentally, resembles the disciple in the background.

Christ After the Flagellation Contemplated by the Christian Soul (page 47) appears to have been painted by Velásquez also before leaving for Italy, some time between 1626 and 1628. The execution of the torso of Jesus, with His arms stretched toward the column, is similar to that of Bacchus, with his hands extended to the kneeling reveller, both are modelled with a similar interplay of light and shade. However, in contrast to Bacchus, Christ dominates the composition, appearing quite monumental in relation to the other figures in the composition, the Christian Soul and the guardian angel.

It was also about 1628 that Velásquez painted out the true-to-life portrait of Philip IV with which he had won his signal success of 1623, and substituted for it, on the same canvas, a new image of the King, making his round chin more pointed, elongating his short neck, and depicting his face and hands as almost luminous shapes. This image of Philip IV was to remain Velásquez' own. Indeed no other painter seems to have grasped it and certainly none imitated it (page 41).

About 1629 Francisco de Quevedo (1580-1645), an uncompromising intellectual, noted that Velásquez did not merely aim at the by then familiar true-to-life image, but that, indeed, in his depiction of human sentiment, he could endow the depiction of human flesh with meaning by the use of 'distant blobs of colour' which 'are truth', not merely likeness.

'... el gran Velázquez ha podido, / diestro cuanto ingenioso, / ansí animar lo hermoso, / ansi dar a lo mórbido sentido / con las manchas distantes / que son verdad en él, no semejantes, / si los afectos pinta.......'[5]

Velásquez' Italian works

From what Pacheco reported, obviously on the basis of Velásquez' own account, and from what Palomino wrote on the basis of data collected from one of the master's pupils, Velásquez spent much of his time in Italy drawing or painting after the works of Tintoretto, Raphael and Michelangelo and trying his hand at studies in oils.

Velásquez used sketchy brushstrokes in *The Forge of Vulcan* (page 59) and in *Joseph's Coat Brought to Jacob* (page 58) and more markedly in the two small studies of the *Villa Medici*, probably painted during his stay there in the

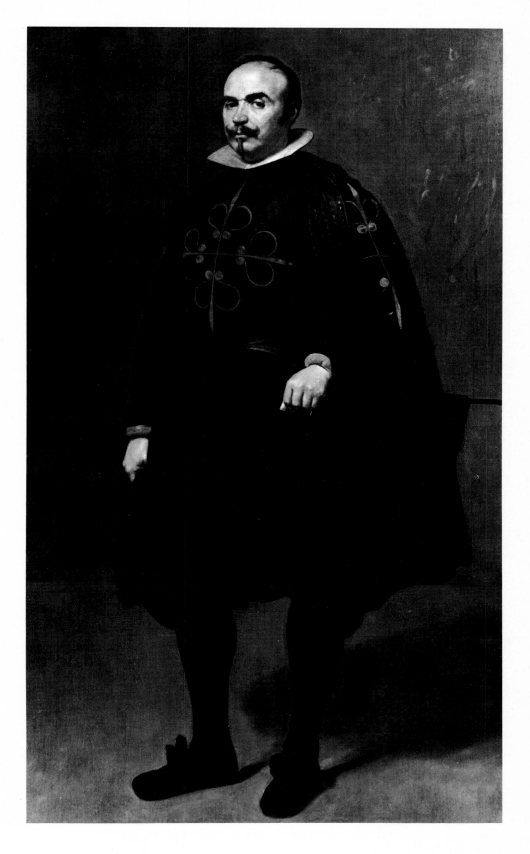

DON PEDRO DE BARBERANA Y
APARREGUI
Oil on canvas; 198.2 × 111.8 cm. (78 $\frac{1}{4}$
× 44 $\frac{1}{4}$ in.)
1631-1632
New York, Private collection.
Don Pedro (1579-1649) became a knight
of the Order of St. John in 1631;
Velásquez portrays him with the red
cross of the order on his breast.

summer of 1630 (pages 62, 63). In execution there is a similarity between these studies, fluidly painted, with impasto used for luminous accents of form, and the landscapes in the two large compositions, particularly the one in *The Forge of Vulcan*. There is a vivid contrast between the well-drawn and the sketchier figures in both *The Forge of Vulcan* and *Joseph's Coat Brought to Jacob*. Such contrast exists also in *The Triumph of Bacchus* (pages 53, 54-55), painted earlier in Madrid. There are, however, outstanding differences between the works executed by Velásquez before his Italian journey and those which he painted in Rome. In these the space in which the action takes place is deeper and more

assured and the colouring richer. Another difference brings tantalizingly to mind Velásquez' lost studies after Raphael, whom he later came to dislike: the proportions of the figures in both *Joseph's Coat Brought to Jacob* and *The Forge of Vulcan* are more slender than in either *The Triumph of Bacchus* or *Christ after the Flagellation*, painted by Velásquez before he left Madrid. The same is true of the *Crucified Christ* datable to 1631 or 1632, shortly after the master's return from Italy (pages 75, 76-77).

In Madrid the young Velásquez had learned to admire the work of Titian and other Venetian masters. This admiration was necessarily heightened as he saw the enthusiasm and freedom with which Rubens made copies after Titian's works at the Spanish Court, and later by the copies after Tintoretto that he himself made at Venice. In Rome, he finally faced the achievements of Raphael and Michelangelo, whose greatness Pacheco had impressed on him, and came to grips with them. It is a great pity that the drawings he made from them are lost, for they might have revealed to us something of the interplay of his understanding of those great masters and his own creative disposition.

Joseph's Coat has been substantially cut down on both sides, which has resulted in a distortion of the original composition. It is plain though, that Velásquez cleared the space around the figures by emphasising the geometric pattern of the brown and white floor tiles, a perspective device that he used in just one other painting, the portrait of the jester *Don Juan of Austria* (page 86), painted soon after his return to Madrid. Gerstenberg has plausibly suggested that this perspective rendition closely conforms to the manner discussed and illustrated in Daniello Barbari's *Pratica della Prospetiva* of 1568, a copy of which was in Velásquez' library at the time of his death. It may, however, be that Velásquez learned the use of such a perspective device for dramatic effect from Tintoretto's works in Venice and that it exercised his imagination during his Italian journey and for a while after his return to Spain. Yet, in *The Forge of Vulcan* he achieved a convincing spatial effect without recourse to the use of a geometric design on the floor.

In both *The Forge of Vulcan* and in *Joseph's Coat* the build of most of the figures is strongly accented by a raised light source coming from outside the composition. In both a sense of aerial depth is achieved by the fluid landscapes in the distance and by the sketchiness of the background figures: the shadowy figures of the two youths standing beside Jacob against a light coloured wall in the biblical scene, or the strongly lit, half-length nude seen against dark shadow at the chimney corner in the mythological painting.

Velásquez, who made many studies in Rome, must have made several for these large paintings. Unfortunately only one, a colour sketch for the head of Apollo (page 59), has come down to us. Painted in full light, it shows the god's youthful countenance contoured by a filmy shadow which, in the final composition, spreads over the whole face.

The figure of Apollo, clad in an reddish-yellow mantle, is as fleshy and dappled with shadow as that of Bacchus in the earlier and considerably less spatially competent composition. The shadowed face is seen against a thick-textured yellow light as he discloses Venus' and Mars' infidelity to Vulcan, who stops his work, the surprise on his face made the more bumpkin-like by his bushy moustache and by his fast grip on the hammer. The gesture of surprise is echoed by the three assistants and by the intense stare of the man in the background.

HAND OF AN ECCELESIASTIC
Oil on canvas; 27 × 24 cm.
(10 $\frac{3}{4}$ × 9 $\frac{1}{2}$ in.)
1630-1640
Madrid, Royal Palace
Fragment of a full- or three-quarter length figure, which has not yet been identified with any certainty.

DON DIEGO DEL CORRAL Y ARELLANO
Oil on canvas; 215 × 110 cm. (85 × 43 $\frac{1}{2}$ in.)
1631-1632
Madrid, Prado (1195)
The sitter (c. 1570-1632) was the second husband of Doña Antonia de Ipeñarrieta, whose portrait, of identical size, was also painted by Velásquez (see page 70).

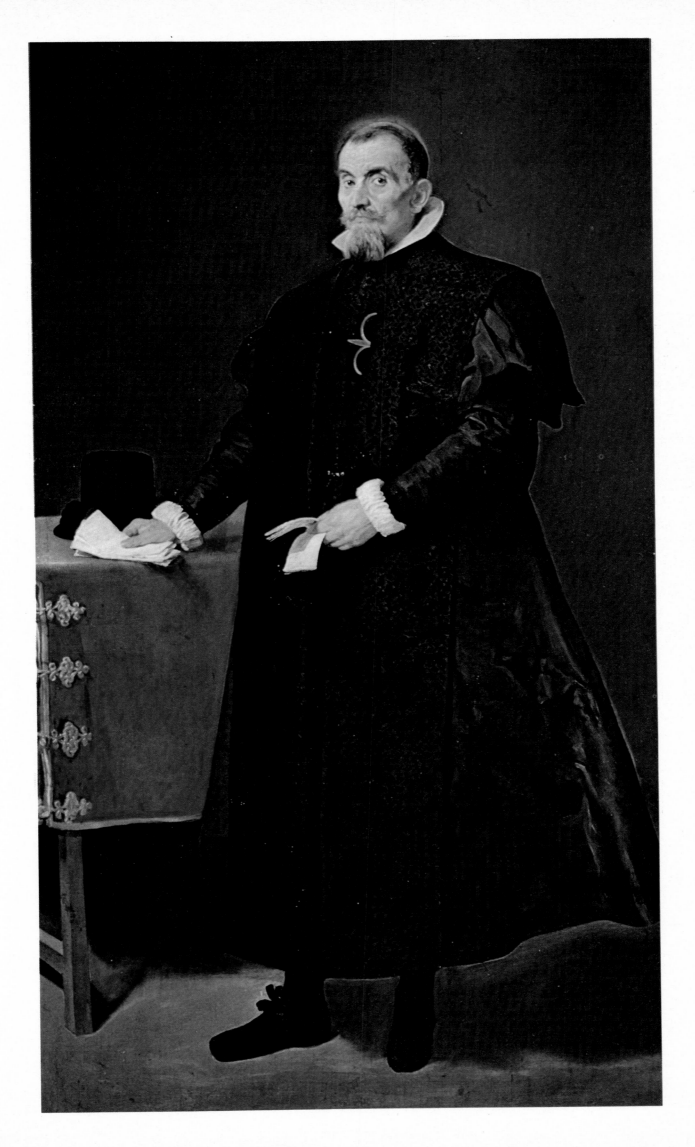

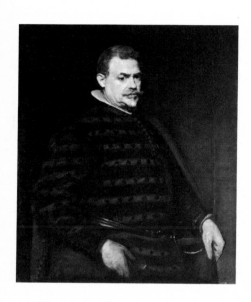

DON JUAN MATEOS
Oil on canvas; 108 × 89.5 cm. (42 ½ ×
35 ¼ in.)
c. 1632
Dresden, Staatliche Kunstsammlungen,
Gemäldegalerie (697)
The sitter, born in about 1575, was
Philip IV's Master of the Hunt.

CRUCIFIED CHRIST
Oil on canvas; 248 × 169 cm. (97 ½ ×
66 ¾ in.)
c. 1632
Madrid, Prado (1167)
Detail: *pages 76-77*

Portraits of the early 1630s

In March 1631 Velásquez finished the portrait of *Prince Baltasar Carlos with a Dwarf* (page 67). The sixteen-month-old Prince, dressed in gold-embroidered, dark green stands majestically on a dais, his right hand on a baton and his left on his sword hilt. In the foreground, to the left, there is dwarf in a dark green dress holding a silver rattle in one hand and an apple in the other, and who in turning her head back towards her charge directs the viewer's attention to the Prince. The smooth modelling of the Prince's luminous face and the uneven handling of the shadowed face of the dwarf contrast, as do their bearing and pose. The Dwarf's glance and gesture is subservient: the Prince towers over everything around him—in gesture and gaze a miniature version of his father.

Painters in Spain and elsewhere had for a long time included dwarfs in some of their royal portraits, even when there was only one royal sitter. As we know, in 1619 or soon after, Villandrando had represented Philip IV, then still a Prince, resting his right hand on the head of Soplillo, his favourite dwarf (page 66). In Villandrando's portrait, there is no contrast, except in stature, between the figure of Philip and that of Soplillo, not even in stance or gesture, much less in the brushwork used to depict them. Indeed, the dwarf quietly merges, as one more attribute, into the Prince's regalia. As for Velásquez' portrait, where the Prince and the dwarf are about the same height, he produces a contrast of stance and gesture, and, more significantly, by the handling of paint. It is mainly this contrast that makes the dwarf appear as a foil to the majesty embodied in the figure of the child Prince.

The only other time Velásquez represented dwarfs in the entourage of a royal person was in *Las Meninas* (page 165). He did portray them, however, individually. A comparison of these individual portraits of dwarfs with those of the Prince or the King painted by Velásquez at roughly the same time discloses the same kind of differences in the brushwork which distinguish the person of Baltasar Carlos from that of his dwarf in the portrait of 1631.

Equally interesting is the contrast offered by two works executed by Velásquez at approximately the same time: the portrait of *Doña Antonia de Ipeñarrieta and her Son* (page 70), of about 1631, in which the child's face, like the mother's, is finely modelled in light and shade, and that of *Baltasar Carlos* (page 79) painted in 1632. In the latter, the three-year-old Prince is seen alone, resting his right hand on a baton and the left on his sword hilt, his face as smoothly executed as in the portrait of 1631; it is an attractive portrait of a child, but imbued with a compelling sense of majesty.

Sometime after March 1631, when Velásquez completed the portrait of *Prince Baltasar Carlos with a Dwarf*, possibly in 1632, he painted out a likeness of Queen Isabella executed several years earlier, and substituted for it, on the same canvas, a new portrait of her (page 69). He did much the same as he had done, before leaving for Italy, with his earliest portrait of Philip IV. In the case of the Queen's portrait, though, the main changes did not concern the sitter's physical appearance but rather her costume. As the portrait has come down to us, it shows Velásquez' absolute mastery of light and texture, not only in the flesh

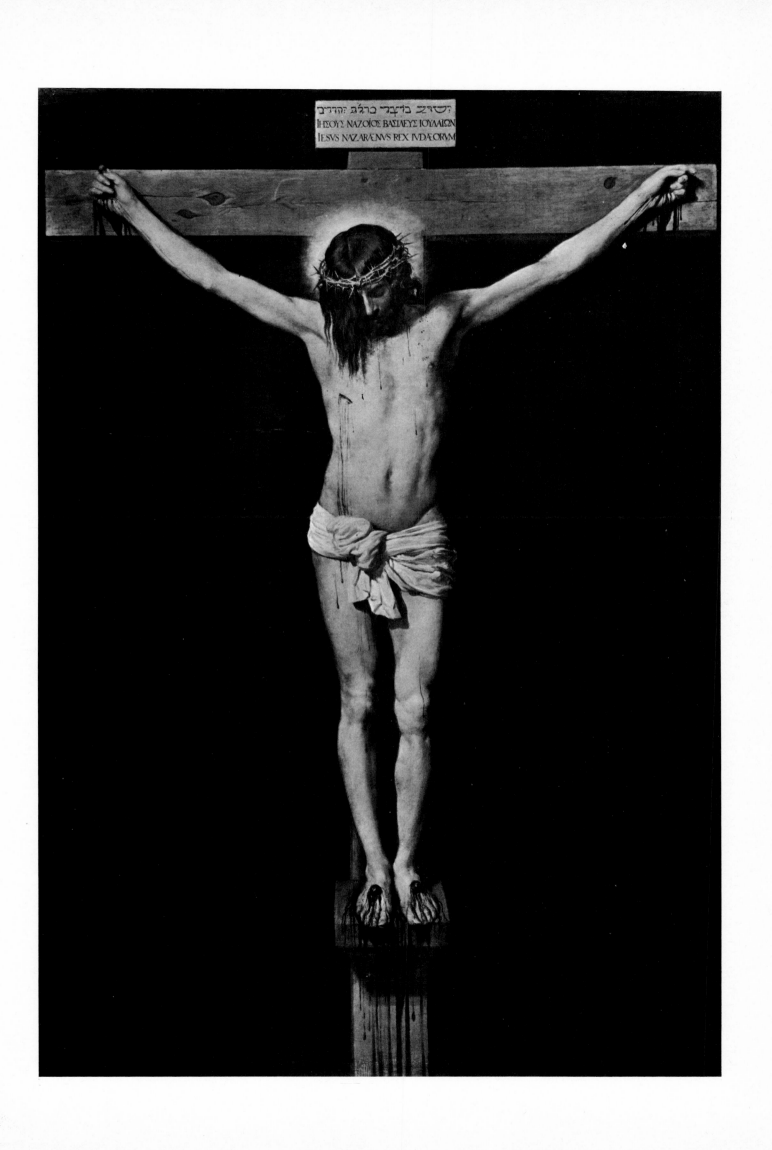

tones of the face but also in the black silk of the sitter's costume; the luminosity of the blacks matched by the highlights on the pinkish-red curtain behind her. A replica of the Queen's face appears in another portrait of her, now cut down to three-quarter length, painted by Velásquez and an assistant no later than September 1632. Again when, in 1634 and 1635, Velásquez extensively reworked the equestrian portrait of Queen Isabella, begun about 1628, he painted afresh the head and most of the dress, from the waist up, after his portrait of the Queen of 1631-2.

Stevenson, one of Velásquez' most perceptive critics, has pointed out that it took Velásquez some time to really mxster the 'chromatic nuances' of light upon black. He describes the blacks in the portrait of the *Infante Carlos*, datable to 1628, as 'hard' and 'scarcely obedient to the light'. The remark, though a trifle exaggerated, could as well apply to other works painted by Velásquez before 1631.

Velásquez, in fact, achieved his absolute mastery in the depiction of light upon black only after his return from Italy. This, however, cannot be explained as the result of any specific Italian influence since no particular painter or work can be mentioned as a likely source. Nor do any of the works which he painted in Italy disclose a penchant for luminous black hues. There can, however, be no doubt that Velásquez, while in Italy, reflected on the works of art which he saw and admired there, and perhaps too about those, including Titian's, El Greco's and Ruben's, which he had seen and admired elsewhere. It is also likely that he reflected on the works which he had painted so far, and the challenges that he had encountered, and about what he intended to achieve from then on. He must certainly have been open to new impressions and at work throughout the journey. We know that he studied Michelangelo, Raphael and Tintoretto, and that his admiration for Titian increased. However, he did not 'borrow' anything from other artists' works. Yet, he achieved new, wider scope for his own work. For one thing, his palette, notably his blacks, became more luminous, as can be seen in the portraits of the royal family which we have just discussed or in the portraits of *Doña Antonia de Ipeñarriete with one of her Sons*, of 1631-2 (page 70), *Don Diego del Corral*, of the same date (page 72), and *Don Pedro de Barberana* (page 71), of 1631-3.

The portrait of *Doña Antonia de Ipeñarrieta* has been somewhat marred by restoration, but still shows stylistic similarities with the other two mentioned above, notably in the quality of the blacks used in the dress, the fluid contours, rather luminous quality of the sitter's head and the interplay of light and shade which models her face.

Don Diego del Corral and *Don Pedro de Barberana* do not resemble each other as individuals, and yet their portraits are superficially alike. Both sitters stand with casual aplomb, their faces are made unquiet by broad brushstrokes, light and shadow; they are similar in the configuration of the forehead and temple, the bridge of the nose, and the eyesockets, all shaped by dint of light and shade. The purposeful play of light on black brings out the variety of shades in both portraits, disturbing the surface of the sitters' garments. Velásquez' mastery of the nuances of light on black is evident throughout the rest of his career. It is, indeed, a touchstone of his art, as shown by the portrait of *Philip IV* (page 157), of 1652-3, which, for all its apparent simplicity, none of his pupils, followers, or assistants could convincingly imitate.

Velásquez probably painted the portrait of *Philip IV in Brown and Silver* over an extended period of time from 1631-1632. The painting has suffered from the uneven cleaning and restoration that it underwent in 1936, but it is still plain that, as Beruete suggested, it could not have been painted significantly later than the portrait of Prince Baltasar Carlos which Velásquez completed in March 1631.

Velásquez obviously regarded this work as of particular importance; it is one of only two portraits of Philip IV that he is known to have signed with his title, 'Painter to Your Majesty', appended to his name, the other being the lost equestrian portrait of 1625. Several *pentimenti*, now quite noticeable, indicate, moreover, that Velásquez was not immediately satisfied with this work.

PRINCE BALTASAR CARLOS
Oil on canvas; 118 × 95.5 cm. (46½ × 37¾ in.)
1632
London, Wallace collection (12)

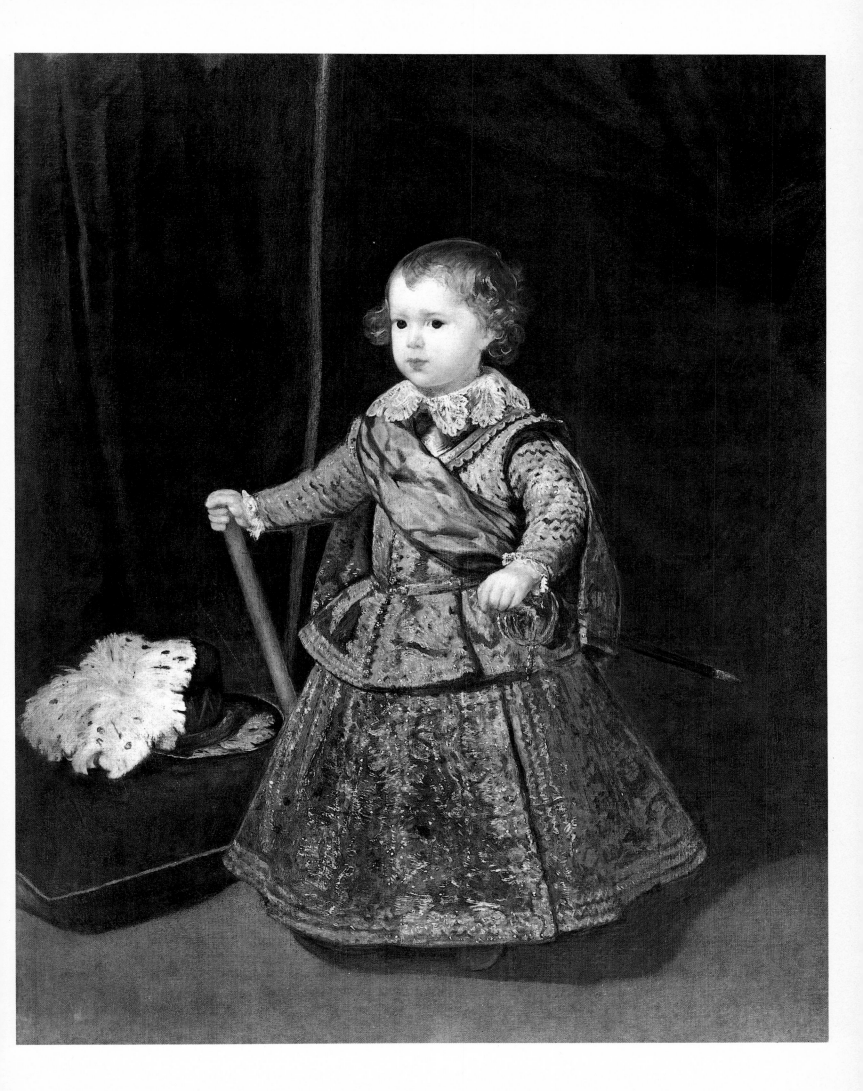

As in earlier portraits by Velásquez the likeness of Philip, though keen and quick, but does not reflect the march of time in the King's face. The same is true of later portraits of the sovereign, such as those in hunting dress (page 83), or on horseback (page 98), of the mid-1630s, the one in the uniform of Commander-in-Chief painted in 1644 (page 133), or the bust-length portrait dating from the early 1650s, when, although Philip was rather infirm, Velásquez portrayed him without emphasising the flaws of age or illness (page 157). This subtle depiction of the august person of the King was not grasped by Velásquez' assistants, followers and imitators; they, in fact, more often than not, emphasized the flaws of age and appearance in their copies or derivative portraits of Philip IV. We have already compared the portraits of Philip IV and his brother, the Infante Carlos both painted in 1626-8. Equally interesting is a comparison of the

QUEEN ISABELLA
Oil on canvas; 132 × 106.5 cm. (52 × 42 in.)
1632
Vienna, Kunsthistorisches Museum (731)
Probably originally a full length portrait, later cut down. Apart from the Queen's head, much of this portrait must have been painted by assistants: this can be deduced from the monotonous and uneven areas noticeable over much of the picture.

portrait of *Philip IV in Brown and Silver* (page 68) with either that of *Don Diego del Corral y Arellano* (page 73) whose face is roughened by broad brushstrokes and vivid highlights and shadow. The portrait of the Master of the royal hunt is similarly executed. Juan Mateos' (page 74) character is accented by the nervous modelling of the face with shadow, while the hands, sketched in with rough

impasto, are made more emphatic. Similarly, if we look at the portrait of *Philip IV* (page 83), the *Cardinal Infante Fernando* (page 85) and *Prince Baltasar Carlos* (page 104), all in hunting dress, painted between 1632 and 1636, it becomes obvious that the King's face, as well as that of the heir to the throne, is more smoothly luminous than that of the Infante. Examination of Velásquez' three outstanding equestrian portraits gives further support to this view.

PHILIP IV
Oil on canvas; 127.5 × 86.5 cm. (50 $\frac{1}{4}$ × 34 $\frac{1}{4}$ in.)
1632
Vienna, Kunsthistorisches Museum
(314)
Probably originally a full length portrait, later cut down. The rather inaccurate execution, particularly as far as the clothing is concerned, suggests that Velásquez entrusted most of this work to an assistant.

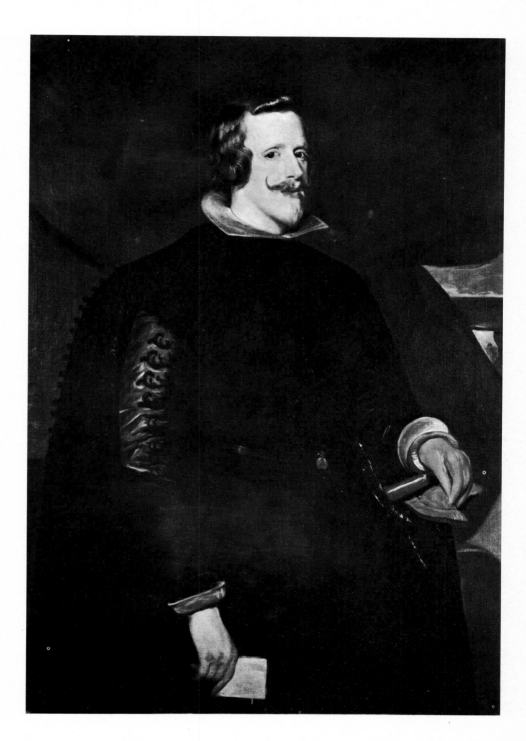

The equestrian portraits

The equestrian portraits of *Philip IV* (page 98), *Queen Isabella* (page 97), his parents *Philip III* (page 92) and *Queen Margarita* (page 95) and *Prince Baltasar Carlos* (page 99) hung in the ceremonial hall of the Buen Retiro. Those of Philip IV and the Prince are entirely by Velásquez, who probably completed them in 1634 or at any rate before April 1635, when they were in position in the Great Hall of the Buen Retiro. We know from a book of poems of 1635 on the paintings which decorated this hall, that the portraits of the reigning sovereign and the heir to the throne were the focal points of the display of Spanish monarchs that the *Salón* contained.

It is generally held that Velásquez began the other three portraits before his journey to Italy, leaving them to be completed in his absence by another painter, and it was only years later that Velásquez decided to repaint them. Quite naturally it was the portrait of Isabella de Bourbon, the reigning Queen, that he himself extensively reworked, repainting her head and upper part of her body after the likeness he had painted of her in 1631-2. He also painted afresh the white horse and made important changes in the landscape. In the portraits of *Philip III* and *Queen Margarita*, most of the repainting was done by assistants, though some passages suggest that Velásquez touched up both portraits, notably the Queen's.

On undertaking these equestrian portraits, or, for that matter, any of his major works, Velásquez must have called to mind similar compositions by other artists, which he was by then familiar with. There is reason to believe that on his way from Venice to Rome in 1629, he stopped in Florence, where he could not have missed seeing the two paintings of *condottieri* by Uccello and Castagno in the Cathedral. Nor could he had failed to look at Verrochio's *Colleoni* in Venice and at the famous horse of Marcus Aurelius in Rome. In the Royal Palace in Madrid there were several outstanding equestrian compositions including *Charles V at the Battle of Mühlberg* (page 99), in which Titian achieved a masterful likeness of the Caesar-like warrior, without a depiction of the battle, troops or allegorical figures. Four other paintings of horses, probably unfinished works by Ribera and other painters, were also at the Royal Palace. Shortly before leaving for Italy, he had seen Rubens painting the equestrian portrait of the reigning *Philip IV* (lost) and of *Philip II* (page 130), both of them allegorical compositions. Moreover, Velásquez himself had won acclaim as early as 1625 with a portrait of *Philip IV* on horseback, now lost. The portrait of *Philip III*, little more than sketched by Velásquez shows certain similarities with Rubens' manner, particularly in the posture and modelling of the horse: yet it reveals, like the others, that Velásquez, unlike Rubens, had no penchant for allegory.

The equestrian portrait of *Prince Baltasar Carlos* was intended to hang high up, above a door, in the Hall of the Buen Retiro; this explains the exaggerated curve of the pony's barrel-like body (page 99). Velásquez made use of the restrictions imposed and achieved a monumental perspective setting for the equestrian figure of the young Prince, now impossible to judge at the present hight at which the picture now hangs in the Prado.

The likeness of the fair-haired, blue-eyed Prince, is achieved with no emphatic modelling of his features. Even the shadow cast by his hat is diaphanous. The greens and blues of the sloping landscape deepen the space around and below the figure of the Prince as his mount paws the air above the brownish foreground, heightening the effect of monumentality of the composition.

In the portrait of *Philip IV* (page 98), it is plain that Velásquez did not turn, for the composition of this portrait, to any of the works familiar to him. Unlike Rubens he made no use of allegory; nor did he represent the King, as the Flemish master had done with Philip II, on a scale made colossal by the low horizon and the diminutive figures that fill the middle distance. Monumental though it is, there is nothing colossal about Velásquez' composition, and in this respect is closest to Titian's *Charles V at the Battle of Mühlberg*.

In Velásquez' *Philip IV* the accent is not on character, action or time; the surface texture, fluidly brushed in, is unruffled. Horse and rider are in full profile with

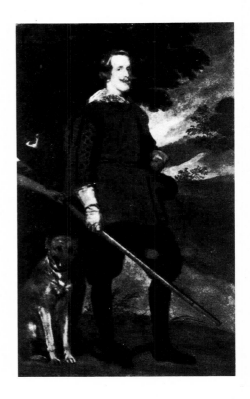

Studio copy
PHILIP IV DRESSED AS A HUNTER
Oil on canvas; 200 × 120 cm. (79 × 47 $\frac{1}{4}$ in.)
c. 1632-1633 (?)
Castres, Musée Goya

the exception of Philip IV's head which, slightly turned to the right, contributes to the effortless pose in which he holds the baton in one hand and the bridle in the other, while the spirited horse rears back in mid-gallop, momentarily arresting his own movement and that of the King. Lit from an invisible light source in front of him, the figure of Philip outshines the radiant expanse of countryside around him, a vivid image of the absolute monarch.

The painting conveys a sense of monumentality unadorned by either allegory or architectural pomp; the person of the King is at one and the same time vividly real and yet not of this world. We know from seventeenth century sources, other painters' portraits of Philip IV, including copies of this one, and even from the first likeness of him which Velásquez put on canvas in 1623 and later painted out (page 41), how divergent from all others, how compelling and inimitable was the image of the King achieved in the portraits by Velásquez. The ultimate image of the King it remains, to the point indeed, that what may have been

PHILIP IV DRESSED AS A HUNTER
Oil on canvas; 189 × 125 cm. (74¾ × 49¼ in.)
c. 1632-1633
Madrid, Prado (1184)
At an earlier stage, Velásquez painted the King holding his hunting cap in his left hand, as can still be seen with the naked eye, and as shown in a studio copy (preceding page) made before the artist removed the cap from the King's hand.

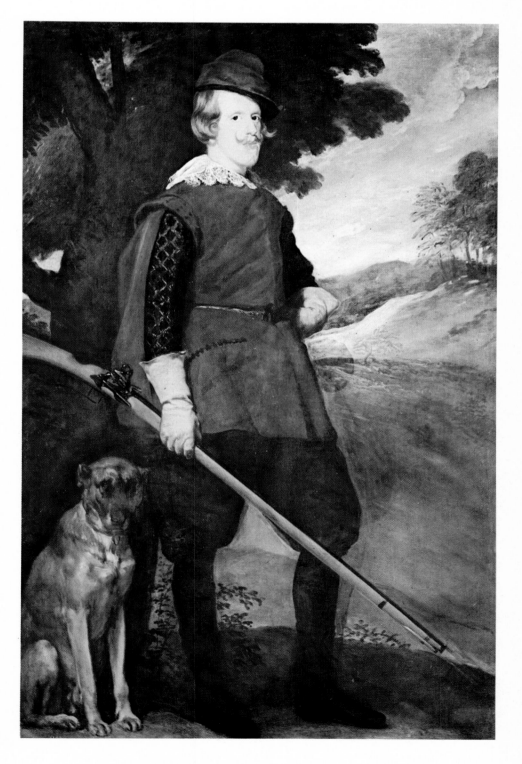

closer likenesses of Philip appear today as of little more than anecdotal significance.

The portrait of *Count-Duke Olivares on horseback* (page 89) is as fluidly painted as those of Philip IV and Prince Baltasar Carlos, although it is less luminous than either. The chief minister, wearing black ceremonial armour inlaid with gold, is on a chestnut horse at the edge of a cliff against a cloudy sky made sombre by the blue-grey smoke which rises high from a burning town in the background. Both his commanding gesture, with the baton in his right hand, and his high-spirited mount are directed towards the battle raging below in the middle distance; yet the Count-Duke faces the spectator. No specific military action is depicted. In fact, Olivares was never really militarily minded though, as chief minister, he was held to be responsible for the monarchy's military victories, a role which he enjoyed playing and for which the King rewarded him with great honours.

The bold rhythm of the composition is carried by lively diagonals, the horse, the sword, the baton, the smoke, the cliff, which are tied in to Olivares' pose. Bright highlights enliven the modelling of the horse, and the textures of the rider's costume and of the mount's trappings look rich and heavy. Olivares' head is painted vividly; it is, indeed, the focal point of the picture; yet the shadows on it are deep and the character traits are incisively rendered. The Count-Duke embodies with his gesture of command and self-assertion both the turmoil of the bloody battle depicted below and the bustle and glow of victory, a vivid image of worldly success far removed from Velásquez' portrayal of the King's absolute power and untouchable grandeur.

Velásquez' portrayal of military victory

The Surrender of Breda (pages 101, 102-103) represents Ambrosio Spínola (1569-1630), one of the ablest generals in the service of the Spanish monarchy in the course of the Thirty Year's War, receiving from Justinus of Nassau the keys of the conquered city of Breda. Spínola, a Genoese descended from an old and wealthy family of merchants, had served in the armies of the Spanish king since his youth. He made a military reputation for himself in Flanders where, in 1604, he conquered Ostend. Later, in 1621-2 he successfully besieged the city of Jülich. In August 1624 he undertook to conquer Breda, the key fortress of Antwerp, which was defended by Justinus of Nassau (1559-1631).

The siege of Breda was a momentous test of strength between the Netherlands and Spain; it was also a decisive contest between two famous generals who had their reputations at stake. Observers from various countries were attracted to Breda where Spínola, reputed to be the finest engineer of his time, matched wits with Nassau, counteracting time and again his ingenious schemes for breaking the siege. Finally, hunger forced Justinus to seek honourable surrender. Spínola, although the victory was already his, granted unusually generous terms.

The formal surrender took place on 5 June 1625. The citizens who so wished were allowed to leave the city with their possessions and the defeated army were granted the privilege of marching out carrying their arms and colours. Spínola's

chivalry was gratifying to the Spaniards, and even though some held that he had been overgenerous, the terms were ratified. Magnificence and magnanimity were then not only cognate words but kindred sentiments as well, and the Christian belief in the fleeting nature of human splendour and glory made them more so, even in the course of bitter religious wars.

None of the accounts of the surrender published before Velásquez depicted it on canvas says that Justinus delivered the keys of the city to Spínola nor that the

CARDINAL INFANTE FERNANDO DRESSED AS A HUNTER
Oil on canvas; 191 × 109 cm. (75 ½ × 43 in.)
c. 1632-1633
Madrid, Prado (1186)
The Cardinal-Infante was born in 1609 and was made a cardinal in 1619 when he was only ten years old. He was Governor of Flanders from 1634 to 1641, the year in which he died.

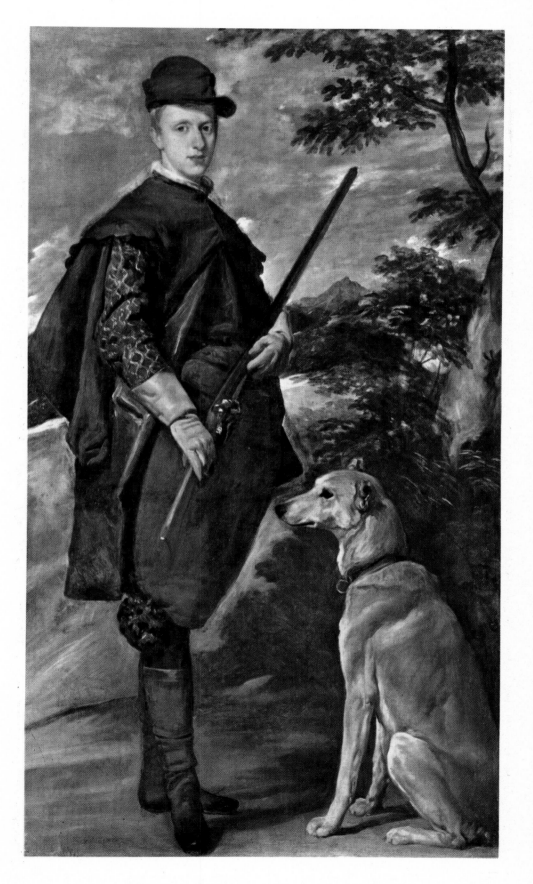

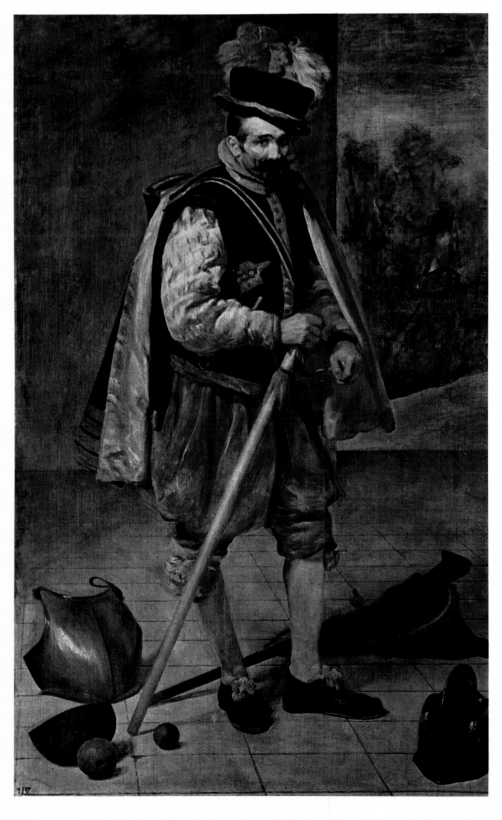

THE JESTER DON JUAN OF AUSTRIA
Oil on canvas; 210 × 133 cm. (73 × 52½ in.)
1632-1633
Madrid, Prado (1200)
Juan de Austria was probably the name given to the jester either by the King himself or by another member of the Royal family. Documentary evidence shows that this jester occasionally served at the Court in Madrid during the period 1624-1654.

victor embraced the defeated general. However, Spínola's success and unusual clemency obviously lent substance to the imagination of some such episode. *The Surrender of Breda* differs essentially from the other extant pictures of military victories which hung at the Buen Retiro. Nearly all of them - the exception being Maino's *The Recapture of Bahia* - resemble one another in their compositional pattern; whether their subject is a battle or an act of surrender, the victorious Spanish general is at one side on a rise above an area where a land or a sea battle is depicted on a markedly smaller scale, as if on a backdrop. Only two drawings (page 100) related to this compostion are extant though Velásquez probably made more. The overall composition, however, appears to have been 'drawn in paint' on the canvas, to use an expression applied at the time of Velásquez' death to a painting left unfinished by him. As he then went on with his work, he would paint out some of the shapes that he had brushed on the canvas, often with light strokes which now allow the original form to come through. He then brushed new shapes on the canvas, occasionally perhaps with the help of preparatory drawings or sketches. X-rays reveal the many changes hidden to the naked eye. For instance, the lances in *The Surrender of Breda*, which were to become a cardinal compositional element, were not initially included in the composition.

The sense of aerial perspective which pervades the whole composition articulates the essentials of the narrative from the trenches, waterworks and blockhouses in the background, the light-coloured uniforms of the defeated army who march past with their arms and colours in the middle distance, watched by a scattering of Dutch soldiers, to the foreground, where the Spanish officers, bareheaded for the solemn occasion, are massed around their flag, behind their leader, while the troops, their lances silhouetted against the sky, look on.

The gesture and bearing of the Dutch and Spanish soldiers are keenly expressive of a variety of emotions. There are faces which are sharply lit and modelled in the round; the features of others are distinctively shaped by the use of graduated shadow, while others are more sketchily painted. The imaginative handling of light and paint enhances the sense of depth and airiness of the composition.

The victorious and the defeated generals meet in a sort of clearing bounded by the massed Spanish and Dutch troops and a slight elevation of terrain in the foreground. Justinus of Nassau steps out from his troops to present the key of the city to Spinola whose outstretched arm, contrasting and cutting across the bright colours of the defeated troops marching past, bridges the gap between the two, a courtly smile on his pale, intelligent face. The figure of the conquered general acts as a foil to that of Spinola but Spínola's compassionate gesture of putting his hand on Justinus' shoulder draws the eye back to the defeated general. Their mutually noble bearing enhances the Christian sentiments of the scene of charity, humility, and the heroic sense of mercy, and hence of greatness.

It is possible that, as has been suggested, Velásquez painted from life some of the officers, who ten years before had participated in the actual event. Yet none of the Spaniards or Dutchmen in the composition has been convincingly identified, with the obvious exceptions of Justinus of Nassau and Ambrosio Spínola. Some of the Spaniards indeed resemble one another, as if they were variations of the same image. The same is true of the two young Dutchmen seen in profile. Similarities, are also noticeable between some of the figures in *The Surrender of Breda* and those in other Velásquez' works. For instance, the head of the young man holding the reins of Spínola's horse seems to have originated from that of one of the blacksmiths in *The Forge of Vulcan* (page 59), painted by Velásquez in 1630; both are indeed of much the same build, particularly in the shape of the forehead, the emphatic eyebrows, and the nose. Even though, unlike the dark-haired blacksmith, the blond young man does not have a moustache, their mouths appear rather similar. Likewise, the head of the chestnut-haired Spanish officer immediately behind Spínola, built up of contrasting rough and smooth impasto and of shadow and highlight, appears similar in proportion and features to *Don Pedro de Barberana* portrayed by Velásquez in 1631-2 (page 71). This is most evident in the distinctive shape of the forehead and temple,

even in the drooping left eyelid. It is plain though that Velásquez did not represent exactly the same individual in both works for he gave a different shape to the Spanish officer's eyebrows and nose. As before, there are variations in execution in the figure of the Spanish officer. The contrast between rough and smooth impasto is more vivid and the contour of the head is somewhat broader. Yet, the balance between the rough and the smooth and between light and shade is comparable in both heads. It is as if Velásquez had used his likeness of Don Pedro de Barberana as a starting point for the representation of the Spanish officer in furtherance of his naturalistic intent, but without aiming at duplicating the likeness.

General Spínola died in 1630 and thus could not have sat for the painting.

Juan Bautista Martinez del Mazo
STAG HUNTING IN ARANJUEZ
Oil on canvas; 249 × 187 cm. (98 $\frac{1}{4}$ × 73 $\frac{3}{4}$ in.)
c. 1636
Madrid, Prado (2571)

However, Velásquez had travelled to Italy with him in 1629, and, though there is no documentary reference to any portrait of Spínola done from life by Velásquez at that or any other time, it is reasonable to assume that Spínola's features and character were alive in Velásquez' mind when he undertook to paint *The Surrender of Breda*.

As for Justinus of Nassau, Velásquez had never seen him in the flesh, nor is it likely that he had to hand a portrait of him. In fact, at the time of the surrender, Justinus was sixty-five years old and was described as 'venerable' on account of his white hair. However, Velásquez represented him as a vigorous man, with slightly greying hair, certainly not older than Spínola (who was in fact ten years his junior) and whom Velásquez represented with silvery grey hair. Therefore, the image of Nassau that Velásquez painted must have been imaginary, based on verbal description or perhaps based on an unknown portrait executed by another artist long before 1625, the date of the surrender. And yet both Nassau and Spinola, appear as vivid in gesture and expression as any portrait that Velásquez did from life. As I have long suggested, this fact should be taken into account by those who wish to decide, on the basis of the life-like quality of Velásquez' portraits or figure compositions, whether or not he painted them from life.

Nor was Velásquez ever in Breda. However there were maps, descriptions and engravings of the city, the battle-field and the surrender available to him. The background view in the painting reveals familarity with, and freedom from, the details they provided. *The Surrender of Breda* is dedicated not to the physical

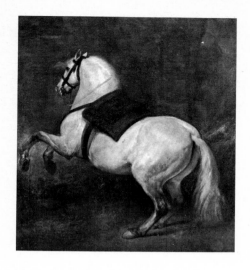

WHITE HORSE
Oil on canvas; 310 × 245 cm. (122 ¾ ×
97 in.)
c. 1634-1635
Madrid, Royal Palace
Heavily restored.

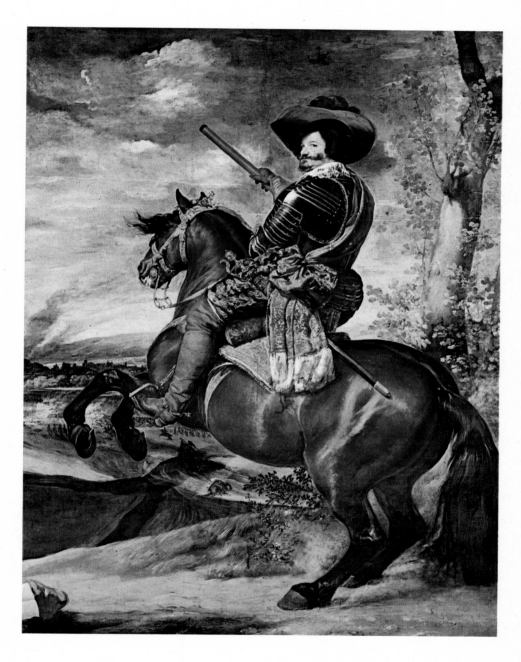

COUNT-DUKE OLIVARES ON
HORSEBACK
Oil on canvas; 313 × 242 cm. (124 ×
95 ¾ in.)
1634-1635
Madrid, Prado (1181)
Detail: *pages 90-91*

appearance of the various participants or to the location, circumstances or
trappings of the occasion but rather to the play of sentiments that the painter
discerned in the event. It portrays both the misery and the splendour of the
surrender, a luminous whole with accents of bright colour, the dusty colours
sparingly used in the depiction of the field and the defeated.
Velásquez painted in a lively, naturalistic manner what he had seen, or
imagined, whether in a sitter or a story either popular, historical, mythological,

or religious. Certainly, he was steeped in a live pictorial tradition rooted in Spain and Italy, and in a Catholic attitude to life which was then particularly keen and forceful in Spain. Although circumstances need not necessarily have turned him into the artist that he was, still his works bring them to mind. Nor should we assume that this is so because he worked to a fixed programme, which no true artist ever does. Yet the consistency of his *oeuvre* reveals the polarity of the religious and the worldly which is peculiar to the Baroque mood of his day but also creatively his own, and it is for this reason that his work is unique in the context of his own or any other time.

The sentiments that Velásquez embodied in *The Surrender of Breda* are unlike those which other painters of his times depicted in works of a similar nature. A case in point is Jusepe Leonardo's *The Surrender of Jülich* (page 96) also painted for the Great Hall of the Buen Retiro.

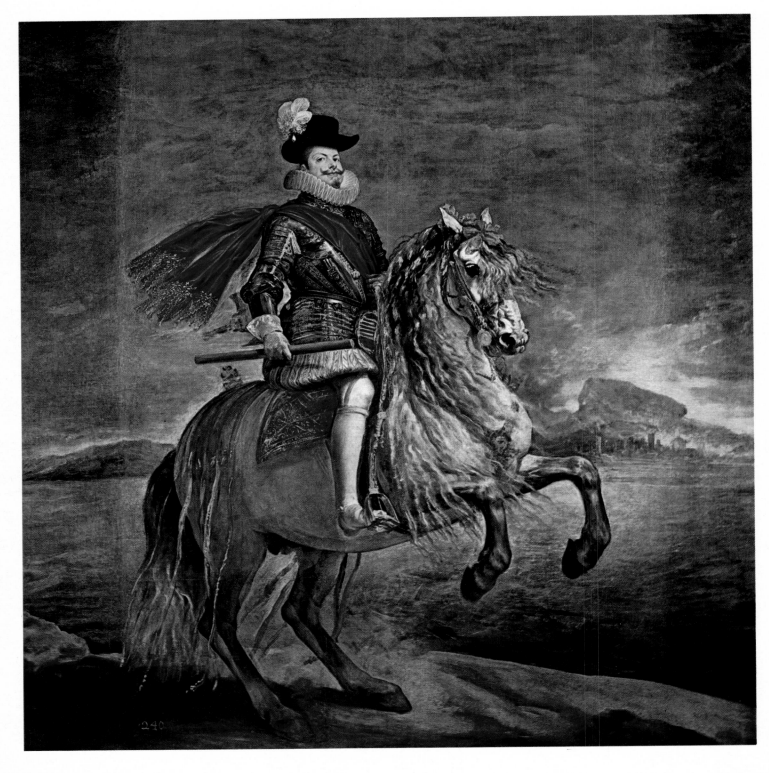

PHILIP III ON HORSEBACK
Oil on canvas; 300 × 314 cm. (118 $\frac{1}{2}$ ×
124 in.) (including additions)
1628, 1634/35
Madrid, Prado (1176)
This portrait of Philip IV's father
(1578-1621) was probably started by
Velásquez in 1628, and finished by a
lesser painter in 1629-1631. The artist
then went over it with the help of an
assistant in 1634-1635 when it was
decided that the picture should be hung
in the Great Hall of the Palazzo del Buen
Retiro. Before 1772 the canvas was
greatly enlarged by the addition of strips
on both sides.
Detail: *right*

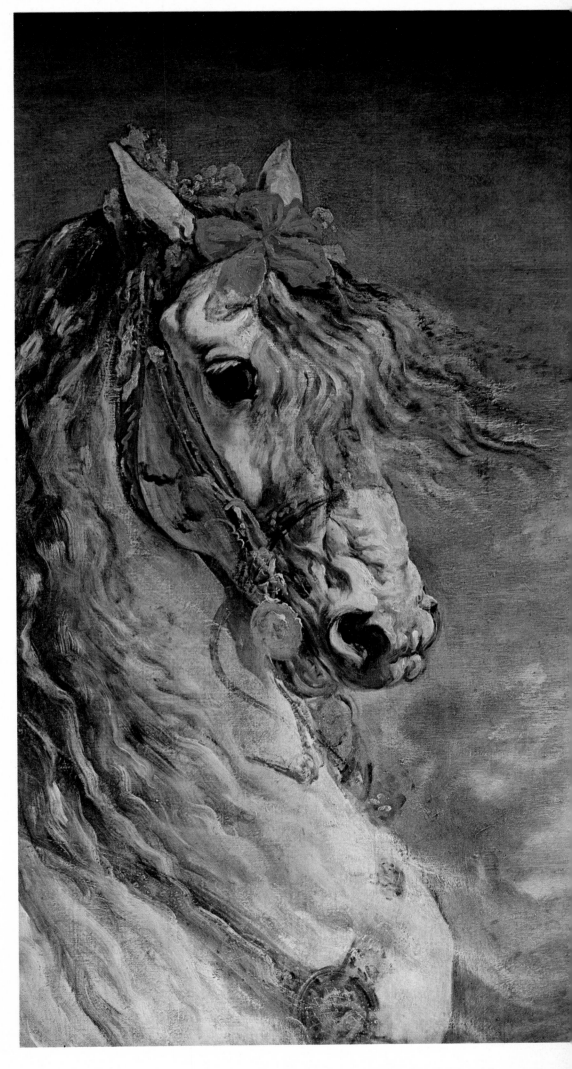

Jusepe Leonardo (1601-1642/3) was of approximately the same age as Velás-quez; he studied under Eugenio Caxés, and like other painters active in Madrid in the 1630's, he tried without success to appropriate Velásquez' stylistic traits, though he never cared for, or understood, his sense of composition or came close to his way of fashioning a form and its ambient air.

In *The Surrender of Jülich*, Spínola is again seen receiving the keys of the city from a vanquished Dutch general, while the defeated troops march past with their arms and colours in the distance. The surrender takes place on a rise above a view of the battle-field, and the city is depicted on a much smaller scale as if a backdrop, with no attempt made to blend the two planes. This was Leonardo's, and many others', manner of emphasizing the main episode and detailing at the same time other incidents of the narrative. In the foreground scene, the Dutch general, fear showing on his face, kneels as a Spanish officer directs him to surrender the keys to Spínola who, sitting on a restless horse, bends slightly to receive them. The victorious general is the apex of a pyramid which has as its sides the diagonal which leads to the kneeling Dutch general and that leading to the Spanish officer on the left. The contrast between the victors and the con-quered is heightened as the two Dutch soldiers by their general's horse recoil at the hurt and shame of the surrender. It is a narrative of victory, with the emphasis on incidentals, dramatised for the victor's sake.

QUEEN MARGARITA OF AUSTRIA ON HORSEBACK
Oil on canvas; 297 × 309 cm. (117 $\frac{1}{4}$ × 122 $\frac{1}{4}$-in.) (including additions)
1628, 1634/35
Madrid, Prado (1177)
As in the case of the portrait of *Philip III on horseback* on page 92, this painting also was probably started by Velásquez in 1628 and finished by a lesser painter during his absence from Spain in 1629-1631. Later repainted by the artist with the help of an assistant in 1634-1635, it was greatly enlarged before 1772 by the addition of strips of canvas on both sides of the original. Queen Margarita, was the wife of Philip III, born in 1584, and died in 1611.

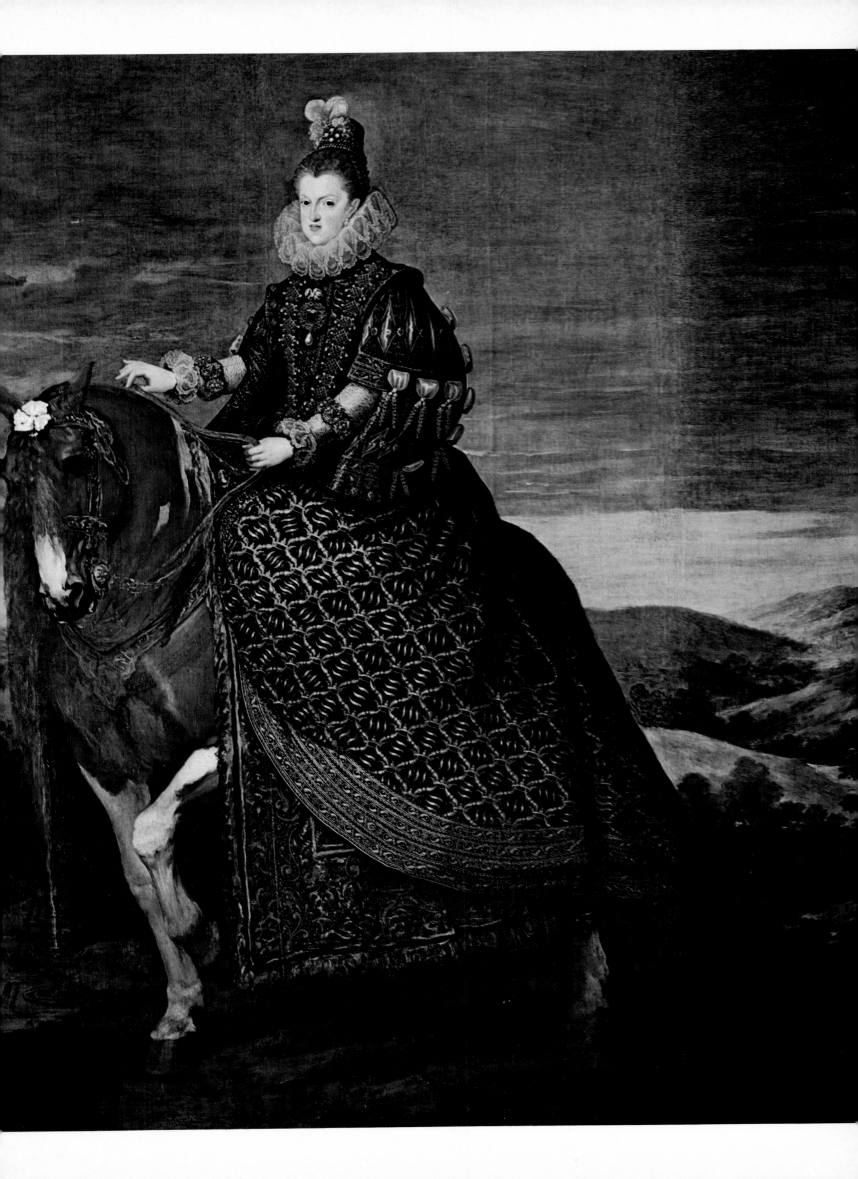

The royal hunting portraits

Sometime between 1632 and 1636 Velásquez painted the portraits of *Philip IV* (page 83), the *Infante Fernando* (page 85) and *Prince Baltasar Carlos* (page 104), all three clad in hunting dress; ultimately these three portraits decorated the hunting lodge, the Torre de la Parada, near Madrid. The portrait of *Baltasar Carlos* bears the inscription *Anno aetatis suae VI*. Since he was born on 17 October 1629, the portrait must have been painted either late in 1635 or in the following year.

The dating of the portraits of Philip and his brother is rather more problematic. The head of the King, who was originally bareheaded, is quite close to that in the portrait which Velásquez painted soon after his return from Italy, in 1631 or 1632. *Pentimenti* and major corrections are visible to the naked eye in the painting. Something of their sequence can be gathered from an early workshop copy in the Museum of Castres (page 82). Velásquez, after sketching the figure on the

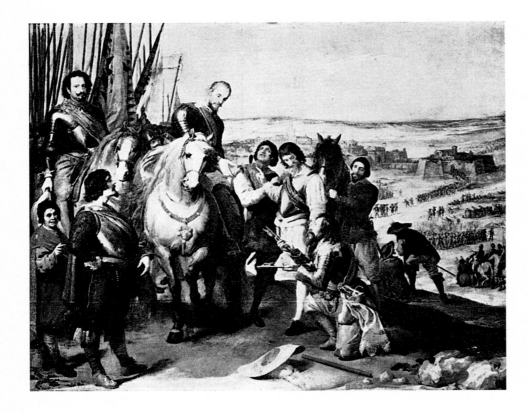

Jusepe Leonardo
THE SURRENDER OF JÜLICH
Oil on canvas; 307 × 381 cm. (121 × 150 $\frac{1}{2}$ in.)
Before 1635
Madrid, Prado (858)

canvas, altered the pose considerably, as revealed by the substantial *pentimenti* running from the waist to the feet. At that point the King was represented holding his cap in his left hand, as he appears in the copy in the Museum of Castres (page 82). Later on Velásquez painted out the cap, the shape of which is now seen overlaying the earlier *pentimenti* around the waist, and depicted the King wearing his cap. The execution of the painting suggests a date close to the London portrait of *Philip in Brown and Silver* and that of *Baltasar Carlos with a Dwarf* (pages 67, 68), and consequently could not have been painted much later than 1632 or 1633. As for the copy at the Museum of Castres, it must have been executed by an assistant before Velásquez had entirely finished the original.

The portrait of *Infante Fernando* (page 85) is executed in much the same manner as that of his brother except for the pictorial handling of the face which, as always with Velásquez, is smoother in the case of the King. Infante Fernando was not quite twenty-three years old when he left Madrid on 12 April 1632 with the King and his other brother, the Infante Carlos, on a journey to various Spanish cities, including Barcelona, where Philip left him as Governor; two years

QUEEN ISABELLA ON HORSEBACK
Oil on canvas; 301 × 318 cm. (119 × 125 ½ in.)
1628, 1634/35
Madrid, Prado (1179)
Very probably started by Velásquez in the autumn of 1628 and finished by another painter during the artist's visit to Italy in 1629-1631. Originally the Queen was depicted wearing a little French-style collar. Around 1634-1635, the artist painted a bust-length portrait and a head of the Queen, based on a portrait of the Queen done in 1631-1632, which in its turn had been painted over a previous portrait (see page 69). Velásquez also repainted the white horse and most of the landscape.

later he was sent from there to Flanders, also as Governor. He died in Brussels in 1641 without ever having returned to Madrid.

Velásquez, in his capacity as Usher of the Chamber, might have accompanied the King on that journey, in the course of which he could have portrayed Infante Fernando in Valencia, Barcelona, or any other city where the royal party stopped. That Philip, even before his decision to refurbish the Torre de la Parada, would have liked to have a portrait of his brother Fernando in hunting dress, would seem natural since hunting was the favourite sport of both.

Velásquez' intial success at Court came when he was commanded to paint the portrait of the Cardinal Infante, though, to his greater advantage, it was then decided that he should first portray the King. It is in consequence likely that Velásquez made a portrait of Infante Fernando before the one in hunting dress, which, as the broad brushwork indicates, and the sitter's appearance confirms, must have been painted, not necessarily from life, in 1632 or 1633.

If the portrait was painted at this time, Infante Fernando does not look older

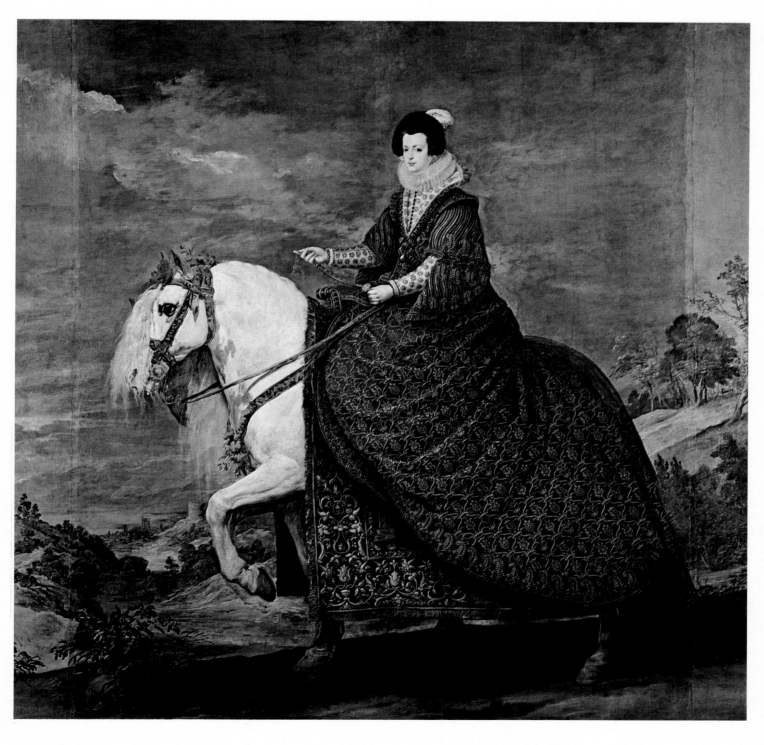

than his twenty-three years. Therefore, if Velásquez painted it later, he may have worked from memory or from a sketch made at about that time. As with the portrait of Philip, there is, however, no stylistic reason to suggest a date later than 1632 or 1633. If we compare the landscape in either picture with that in the portrait of *Baltasar Carlos in Hunting Dress*, painted late in 1635 or in 1636 (page 104), we realise that the depth of the latter sets it apart from the others, and links it rather with the equestrian portraits painted by Velásquez for the Buen Retiro no later than 1635. It could thus be suggested that the hunting portraits of Philip and his brother were executed around 1632 or shortly after, and that some four years later, they were taken to the Torre de la Parada.

In the portrait of *Infante Fernando*, the prevailing tints are grey and ochre, which contrast with some light green strokes and with the vivid, almost saturated, blue of the mountain in the background. In that of *Philip IV*, ochres, used in a wide range of tones, dominate the greys and greens, filling the whole composition with an amber warmth which enhances the luminous face of the King. The portrait of *Baltasar Carlos*, now cut down on the right and extensively restored, is lighter in tone and the greys and greens of the landscape are keyed to the blues of the sky.

PHILIP IV ON HORSEBACK
Oil on canvas; 301 × 318 cm. (119 × 125 $\frac{1}{2}$ in.)
1634-1635
Madrid, Prado (1178)

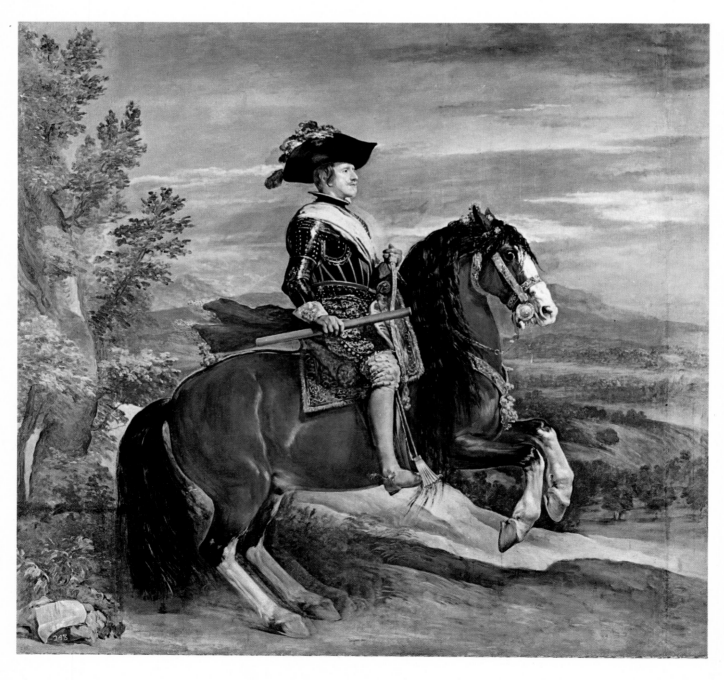

PRINCE BALTASAR CARLOS ON
HORSEBACK
Oil on canvas; 210 × 175 cm. (82¼ ×
68 in.) (including additions)
1634-1635
Madrid, Prado (1180)
Strips of canvas were added to the upper
and lower edges before 1772.

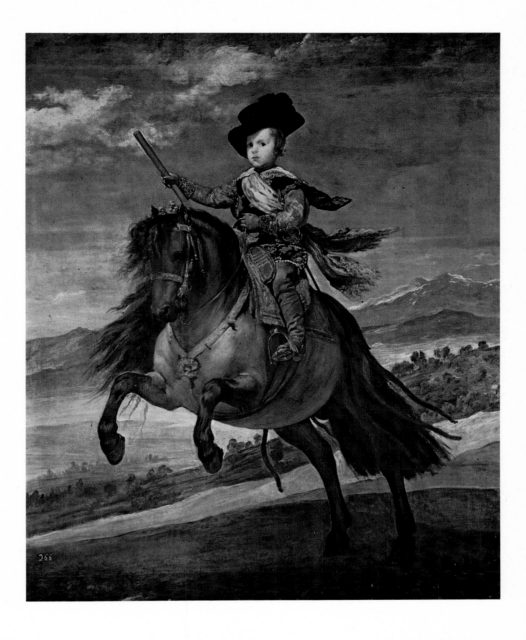

Titian
CHARLES V AT THE BATTLE OF
MÜHLBERG
Oil on canvas; 332 × 279 cm. (131¼ ×
110 in.)
1548
Madrid, Prado (410)

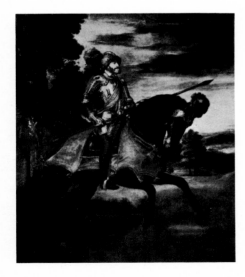

Velásquez rendered in a different pictorial manner the face of the King. Only
the subtlest of shadings have been used in the modelling of Philip's face, which
is lit by a light coming from a source other than that which falls on the dog by
his side and finer than that on the landscape. Shadows, however, are used to
accent the features of Infante Fernando in much the same manner as in the
portrait of the *Infante Carlos* of 1628 (page 48); moreover, the light on his face
has the same source as that which falls on the dog beside him, and shows the
same vivacity of touch as that which illuminates the landscape.

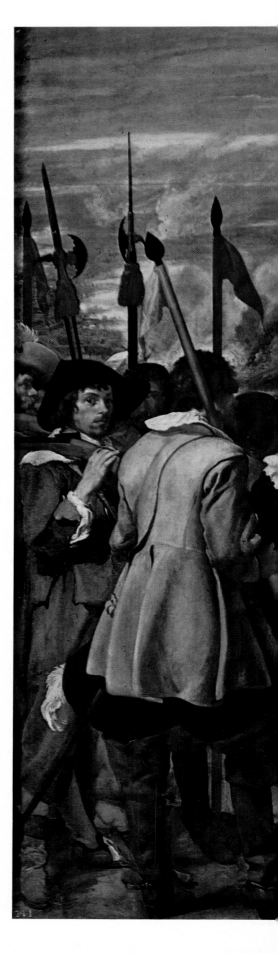

STUDIES FOR THE SURRENDER OF BREDA
Black pastel on yellowish paper; each
26.2 × 16.8 cm. (10 ½ × 6 ¾ in.)
1634-1635

The portrayal of antiquity

The life-size pictures of *Mars* (page 127), *Aesop* (pages 123, 124-125) and *Menippus* (page 123) were apparently painted for the Torre de la Parada. All three are tall and narrow, their height, though not their width, coincides either exactly or within one or two centimetres, with a dozen or so of the paintings executed by Rubens and other Flemish painters for the Torre de la Parada, which lends additional support to the theory that they too were painted to hang on the walls of the hunting lodge.

In pictorial treatment, and inherent meaning, *Aesop*, *Menippus* and *Mars* are analogous with the second portrait of the jester *Calabazas* (page 112), which there is no reason to suppose was painted after his death in 1639 and with that of the dwarf *Francisco Lezcano* (page 128), of the early 1640s, which was at the Torre de la Parada.

It has been repeatedly suggested that *Mars* resembles an antique statue at the Villa Ludovisi, Rome, as well as Michelangelo's *Lorenzo de' Medici* in San Lorenzo, Florence, which Velásquez may have seen in 1629. It is conceivable recollections of one or other sculpture, or both, came to his mind when he was at work on the painting. However, the painting, in which an unheroic god of war sits on a couch propping himself on his staff, is essentially different from either sculpture.

Velásquez' *Mars* is a huge gawky figure, whose torso, framed by broad shoulders and brawny arms and legs, is shadowed and his uncouth, and quite human features, touched by light on the chin and tip of nose, emerge from under a glittering helmet. The god's loose pose is emphasised by the bright rim of the tilted helmet and the diagonal of the glistening shield which tops a heap of pieces of armour in the foreground.

The shining armour and the rich textures of the blue loin-cloth and red mantle which falls in folds to the floor stresses the weariness of the figure. The lightest part of the composition is the god's left hand, rather idolently supporting his head, while the other, hidden under the mantle, props his weight against the staff. It is a masterful scaling down of a god to a human form, and a worthless one at that, achieved by a pictorial play on his very attributes, without detracting from the plastic integrity of the nude. Indeed, Mars is made into a parody of mythological heroism by just the touches of light which, hitting his hand, chin and tip of the nose, underline his bushy moustache and stolid features.

Madrid, Biblioteca Nacional (16-40, 20, *recto* and *verso*)
On the study for the figure of General Spinola, right, *'Velásquez'*, written in ink, has been added at a later date.

THE SURRENDER OF BREDA
Oil on canvas; 307 × 370 cm. (120½ × 125 in.)
1634-1635
Madrid, Prado (1172)

The Spanish general, Ambrosio Spinola is portrayed accepting the keys of Breda from General Justinus of Nassau, on the 5th June, 1625.
Detail: *pages 102-103*

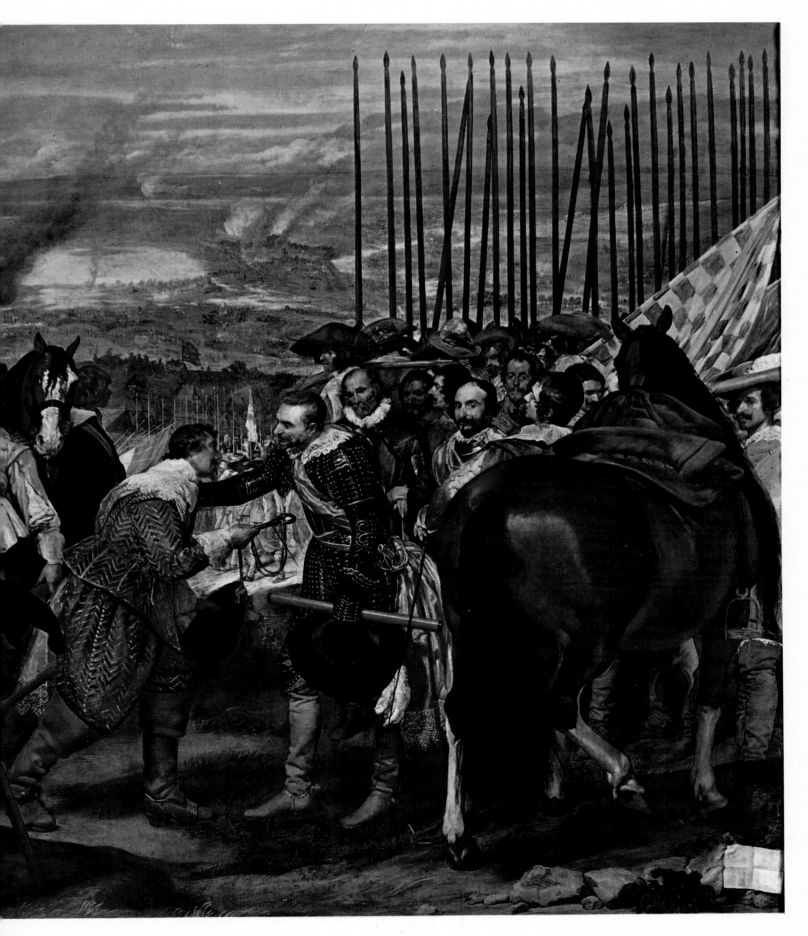

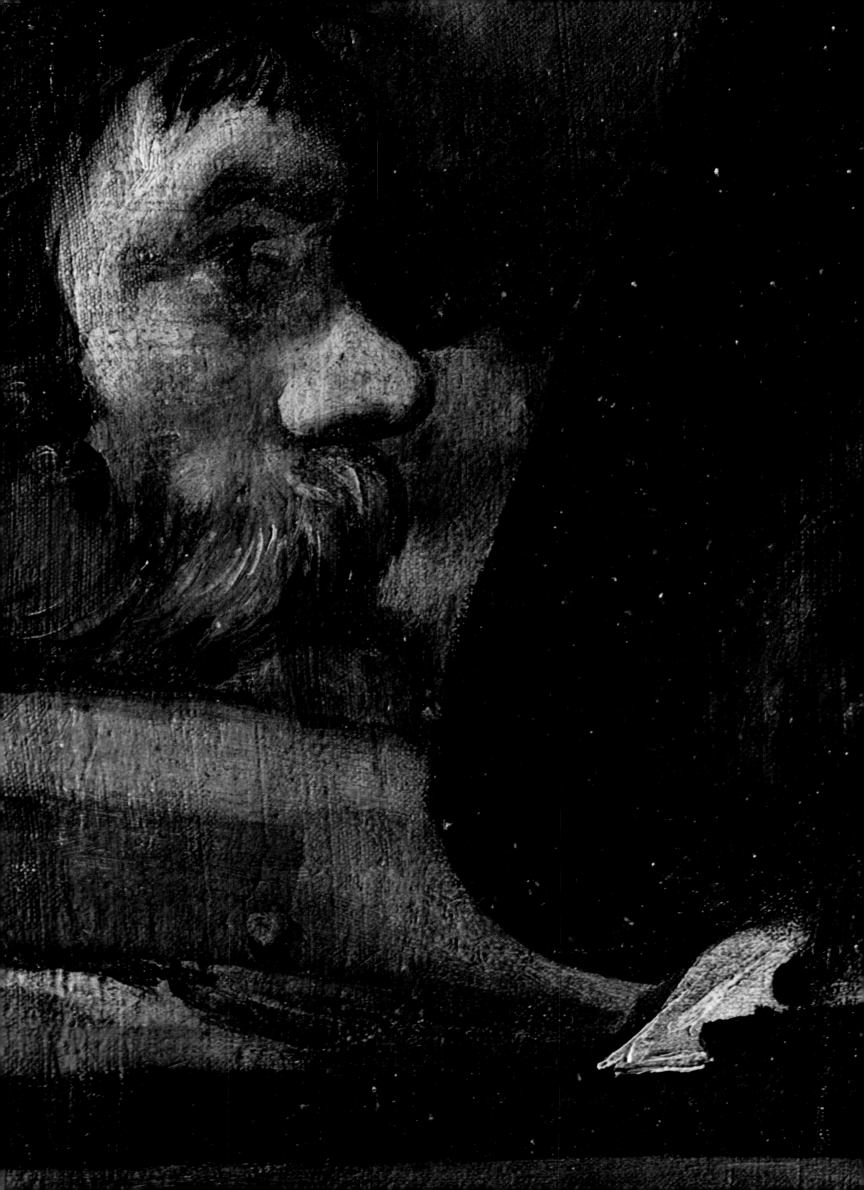

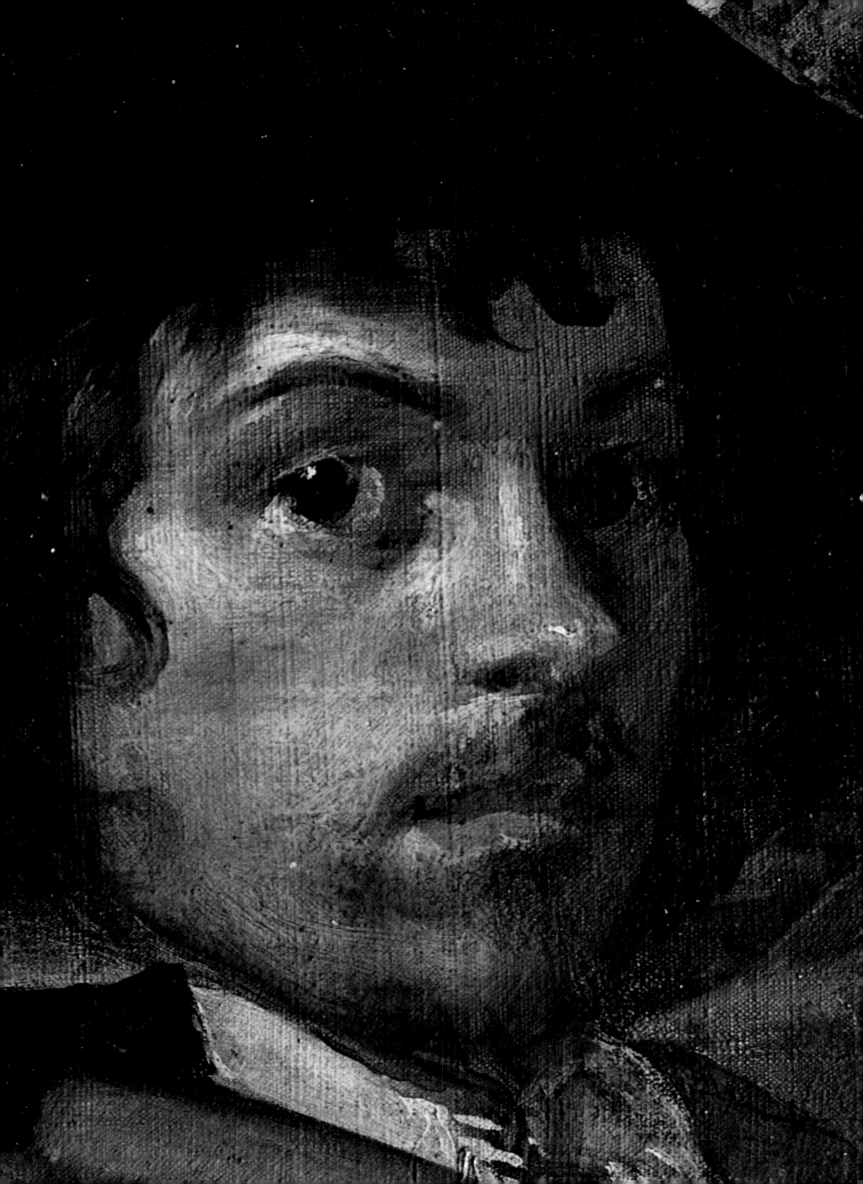

PRINCE BALTASAR CARLOS
DRESSED AS A HUNTER
Oil on canvas; 190 × 103 cm. (75 ×
40½ in.)
End 1635 or 1636
Madrid, Prado (1189)
The Prince was born on 17th October,
1629; an inscription on the canvas '*Anno
aetatis suae VI*' confirms that the Prince
was six at the time he was painted. Cut
down on both sides. Original composi-
tion probably included three dogs, as
shown in the two surviving studio copies.

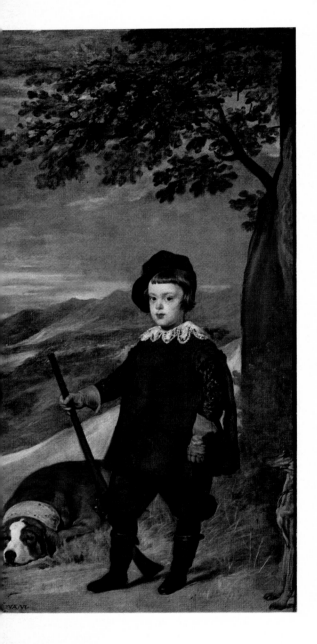

Scholars and other writers on the subject have seldom failed to emphasize the rascally traits of *Mars* and the beggarly appearance of *Aesop* and *Menippus*, the underlying idea being that Velásquez' zest for realism carried him away from his subject to be true to the knave or the wretch posing for it. Lately, however, Gerstenberg has convincingly shown that Aesop's lacklustre eyes, flattened nose, broad mouth and thin underlip correspond closely to an engraving illustrating Giovanno Battista Porta's physiognomical comparison of a man with an ox. The bucket with a piece of leather across its edge and the hide set up to dry on the ground are implements and materials of the tanner; they refer to Aesop's fable in which the rich neighbour begins by finding the stink coming from the tannery unbearable till he finally becomes innured to it—the moral being the need to reach equanimity by mastering discomfort. Likewise, the books and scroll lying on the ground at Menippus' feet in the companion picture point to his contempt for conventional knowledge and vested interests, and the water jug on a piece of board supported by two stones stands for his cynical philosophy of freedom from human wants. Hence, it is plain that Velásquez kept to his intended subject in each picture. However, the subject of a painting is not the same as its significance, which is embodied in the shapes brushed by the painter on the canvas.

Velásquez' *Aesop* wears a tattered brown robe, while *Menippus*, his legs also in brown rags, is snugly wrapped in a cloak, grey and tattered like his hat. Each of them stands against a neutral background, shadows narrowing the space marked by the line of the floor. Everything is subdued and fluidly painted except the wasted faces and gnarled hands, which are accented beyond mere description by vivid textures of rough impasto. Each is centered in the midst of the unemphatic symbols of his philosophy, looking intently out, his bovine or sharp eyes and his ruminating or knowing expression stressing the carnality of his features and, with it, the purely human nature of his knowledge.

Within the context of Velásquez' *oeuvre*, *Mars*, *Aesop* and *Menippus*, like his *Democritus* of the late 1620s, rank with his portraits of Court fools and jesters, in all of which the sitter's earthy qualities are vividly accented. Within a broader context, that of Velásquez' Spain, *Democritus*, *Aesop* and *Menippus* appear as pictorial counterparts to the *pícaro*, who appears in literature and who lives by his wits and sinks beyond salvation in his purely human and as such forever fault-finding knowledge, as age and accidents distort him into becoming a wretch. As for *Mars*, it has been pointed out more than once that it was not unusual in Velásquez' day in Spain and elsewhere to regard mythology as a merry farce. Yet, there is no caricatural distortion in Velásquez' pictures of subjects such as these, which are, on the contrary, endowed with the pulse of life. For instance, the caricatural traits, sharply defined in the engraving illustrating Porta's comparison of a man and an ox, are composed into a living human being in Velásquez' painting of *Aesop*.

Velásquez' humanistic knowledge is naturally woven into his compositions, but it ought not to be identified as their theme. What he appears always to be intent on depicting, in all its variety and deceit, is life, embracing both the divine and the human. Hence this vivid portrayal of the ephemeral human form and manner and which explains the lasting appeal of his naturalism.

Dwarfs and jesters

Velásquez had painted five of the six extant portraits of identified Court fools, dwarfs and other jesters by November 1648, when he left Madrid on his second Italian journey, and there is no reason to suppose that he painted any of his extant portraits of unidentified dwarfs later.

The sitters for four of the portraits, Calabazas, Pablo de Valladolid and Francisco Lezcano, died before Velásquez' departure from Madrid in November 1648 or long before his return, and neither stylistic nor documentary evidence suggests that any of the four portraits was painted posthumously. As for the portrait of *Don Juan of Austria*, there is documentary indication that it was painted in 1632 or soon afterwards, as the composition and execution of the painting suggest (page 86). Dwarfs and jesters had for a long time been a feature of European courts and aristocratic mansions, where their quirks or quips broke the icy formality of fashion and etiquette. Their portraits often decorated the palaces of their masters.

Velásquez' earliest portrait of any such court retainer is one of the jester

MARTINEZ MONTAÑES
Oil on canvas; 109 × 83.5 cm.
(43 × 33 in.)
1635-1636
Madrid, Prado (1194)
Between June 1635 and January 1636, Juan Martinez Montañes (1568-1649) made a clay sculpture of the head of Philip IV for the bronze equestrian statue of the King that Pietro Tacca was to create in Italy. Velásquez portrayed the sculptor at work on this project.

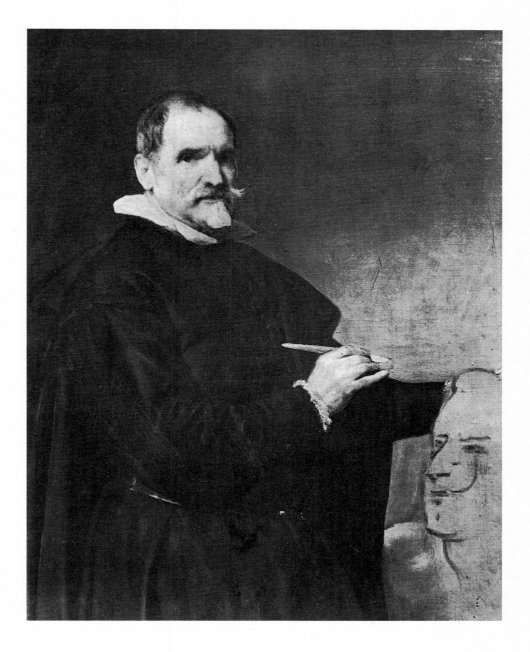

Calabazas holding in one hand a miniature of a woman, and in the other a pinwheel (page 50). This children's toy had long been regarded as an attribute of Folly. The nervous, somewhat tight modelling of *Calabazas'* face, the highlights on the nose and mouth, particularly at the corners of the lips, recall the figure of Bacchus in the large composition of 1628-1629, which leads to the belief that this portrait must also have been painted before Velásquez set out on his Italian journey in 1629. As in the face of Bacchus, the smallness of Calabazas' eyes,

LADY WITH A FAN
Oil on canvas; 93 × 68.5 cm. (36$\frac{3}{4}$
× 27 in.)
Middle of decade 1630-1640
London, Wallace Collection (88)

YOUNG WOMAN
Oil on canvas; 98 × 49 cm. (38$\frac{3}{4}$ ×
19$\frac{1}{4}$ in.)
Middle of decade 1630-1640
Chatworth, Duke of Devonshire's
Collection. Cut down on all sides.
The lower part is badly scratched.

vacuously looking somewhere outside the composition, is underscored by the light that broadens the sockets and his empty smile. This, together with his smallish head and torso and his gangling limbs with big hands and feet, confirms the impression of subnormality. This is, however, no caricature. Indeed, the likeness of the misshapen buffoon has the fullness of presence of any individual that Velásquez painted.

The dating of *Don Juan of Austria* to 1632 or soon afterwards is suggested by a clothier's bill submitted to the King's accounting office that year; it lists several pieces of different fabrics to be made into a costume complete with cape and cap for this jester, whose services at the Court from 1624 till 1654 were only occasional. The materials listed coincide, almost to the last detail, in the stuff, colour and quantity, with the velvet and silk attire, in black and rose which he wears in Velásquez' portrait.

The name Don Juan of Austria, probably given to this jester by Philip III or some other member of the royal family, was that of the hero of the naval battle of Lepanto (1571), Charles V's son, memories of whom were very much alive at the time of Philip IV, when the jester may have been encouraged or commanded to impersonate his illustrious namesake. Velásquez has represented him in a martial pose, one hand on his sword and the other on a baton.

The composition recalls the two large pictures painted by Velásquez at Rome in 1630. As in *Joseph's Coat Brought to Jacob* (page 58), the lines of the tiled floor emphasize the recession towards the battle and wall which form the background. Likewise, there is an analogy between the arrangement of the objects on the floor which in both the portrait of the jester and *The Forge of Vulcan* further the sense of spatial depth; moreover the face of Don Juan of Austria is akin, in execution, to that of Vulcan.

Velásquez turned *Don Juan of Austria*, as he later did with *Mars* (page 127), into a military simpleton, whose spiritless pose is emphasized by the splendour of his attire and the mock naval battle seen in the background, although the composition itself is articulated by the intersecting diagonals of the baton and cloak.

The portrait of *Pablo de Valladolid* (page 110), which Manet held to be 'perhaps the most astonishing piece of painting' ever done, has substantially deteriorated during the last twenty years; the background, originally of luminous grey tones, has turned ochre. Velásquez painted a full and yet substanceless shape of a man in black on grey, standing in a space void of definition, without even a floorline, enlivened only by the declamatory gesture and stance of the jester.

The portrait of *Don Cristobal de Castañeda y Pernia* (page 113) seems to have been conceived by Velásquez in a similar vein. This jester's claims to military ability had earned him the nickname of 'Barbarroja', a famous Algerian pirate in the preceding century. The painting, probably begun in the late 1630s, was left unfinished by Velásquez and has remained so, though another painter worked on it, mainly on the grey mantle draped over the sitter's shoulder. Velásquez' brushwork is unmistakable in the painting of the head and hands as well as in the lively outline of the whole figure. Barbarroja is clad in a red Turkish costume of sorts, which includes a hat not unlike a fool's cap; his pose of defiance is accented in an almost comic way by his hold on the empty scabbard, which is even stronger than his grip on the naked sword.

Not long before Calabazas' death, which occurred in October 1639, Velásquez portrayed him again (page 112). This time Calabazas was represented sitting on a low bench, flanked by two gourds, each of a different variety, a visual pun on his name and simple-mindedness since *calabazas* is Spanish for both simpleton and gourds. The high floor-line, gives an impression of recession into the corner which emphasises the short torso and gangling limbs encased in flowing green robes which are piled in a heap that occupies the foreground of the picture. His head is a shadowy, roughed out shape with thick highlights and framed by the lacy white collar; the smallish eyes are sunk in the sockets, made broad by dense shadows and stressed by a thick band of light which extends from across the nose to the cheekbones.

WOMAN SEWING
Oil on canvas; 74 × 60 cm.
(29 ¼ × 23 ¾ in.)
c. 1635-1642/3
Washington, National Gallery of Art (81)
Unfinished.

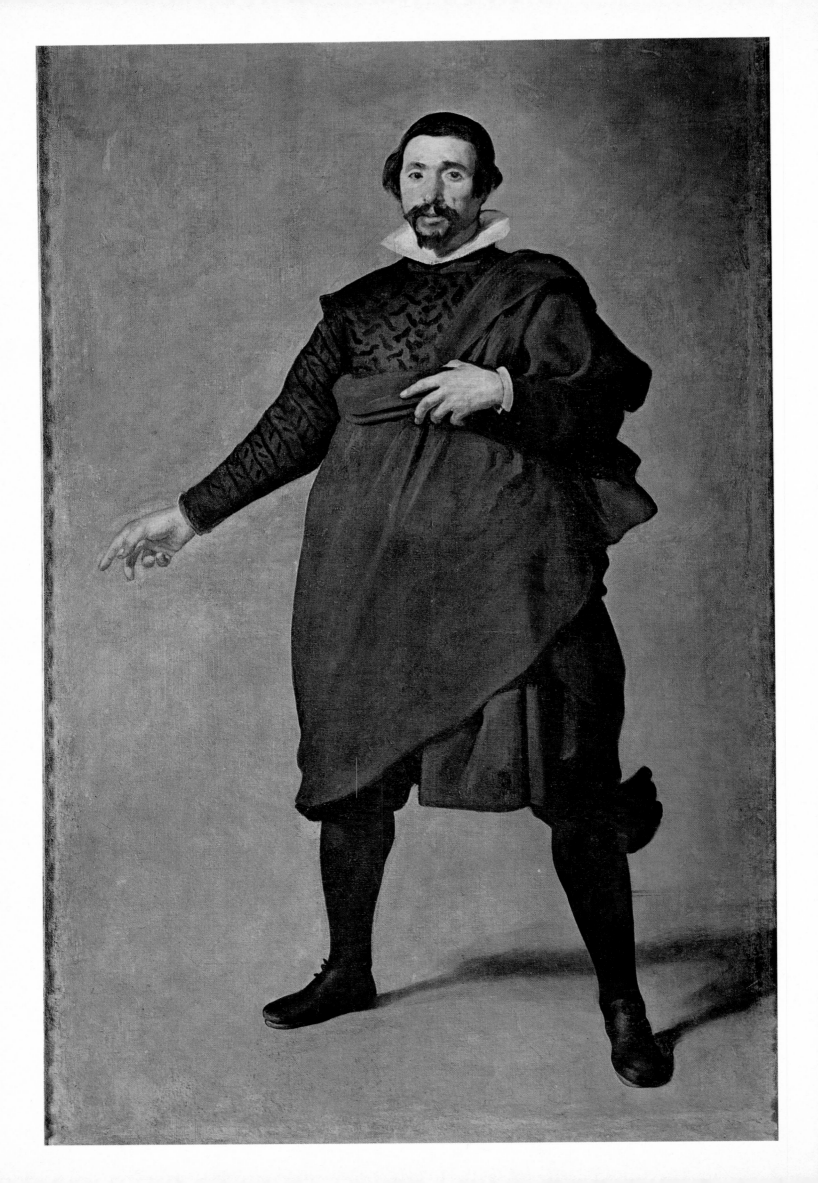

PABLO DE VALLADOLID
Oil on canvas; 209 × 125 cm. (82 ½ × 49 ¼ in.)
c. 1636-1637
Madrid, Prado (1198)
Records show that this jester served at the Court in Madrid from 1632 to 1648, probably the year of his death. The painting is in very precarious condition. The background, originally pale grey has become ochre, while the figure's white collar has darkened to a greyish colour.

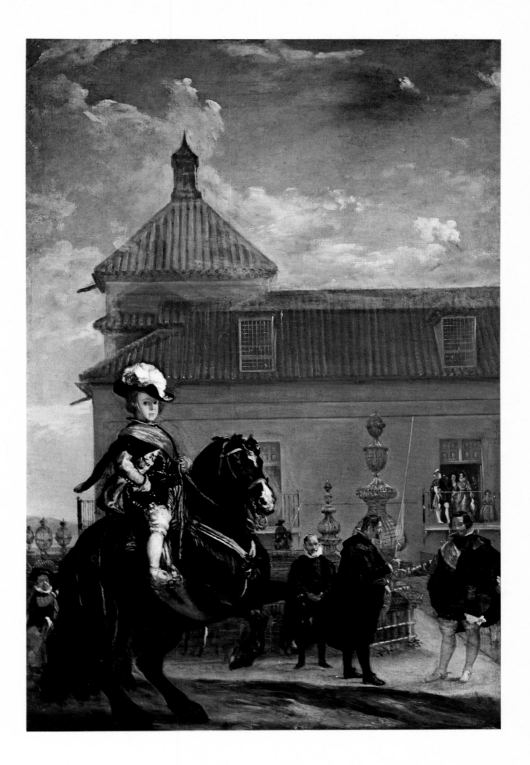

PRINCE BALTASAR CARLOS WITH COUNT-DUKE OLIVARES AT THE ROYAL STABLES
Oil on canvas; 144 × 91 cm.
(56 ¾ × 36 in.)
c. 1636
Eccleston (Chester), Grosvenor Estate
The irregular composition and uneven execution of this painting show that it is the work of several hands: it appears to be a studio painting, extensively retouched by Velásquez, whose intervention is apparent in the figures on the balcony and those in the middle distance. However the Prince on horseback is not Velásquez' work but a copy of the portrait shown on page 99.

The portrait of *Francisco Lezcano* (page 188), datable to 1643-5, represents the moronic dwarf picking at the edges of the playing cards that he holds in his hands; he sits against an overhanging cliff while on the right is a mountainous view; this setting lends a sort of monumentality to his stunted figure, while the, in relation, enormous hat that fills most of the foreground gives away his true size.

It is rather doubtful that the portrait of Don Diego de Acedo, nicknamed *El Primo*, known to have been painted by Velásquez in June 1644, is the *Dwarf Holding a Book on his Knee* as it has long been held to be. The date, however, is perfectly consistent with what the composition and execution of the portrait suggest: mid-1640s (page 132).

The well dressed dwarf is depicted holding a large book on his lap and surrounded by other volumes, perhaps a reference to his bookish disposition. These tomes emphasize the sitter's size, his heavy shoulders and big head out of proportion with the rest of his body. In his rakish hat, he strands out against a

mountainous backdrop. As X-rays show, Velásquez had initially depicted the sitter bareheaded and wearing a falling collar; the substantial changes that he made to both the hat and the collar help create a compelling pictorial image. This scaling up and down of the rather grotesque figure of the sitter allies this portrait to that of *Francisco Lezcano*.

A similar interplay is seen in the portrait of *A Dwarf Sitting on the Floor*, of which we have the original and a copy, also by Velásquez, the latter possibly with some workshop assistance (pages 134, 135). The original has been substantially cut down, particularly on the right. The copy, *A Dwarf Seated Near a Pitcher*, shows the sitter off centre, as was Velásquez' wont.

Velásquez represented the bearded dwarf in a green jerkin and gold-braided red

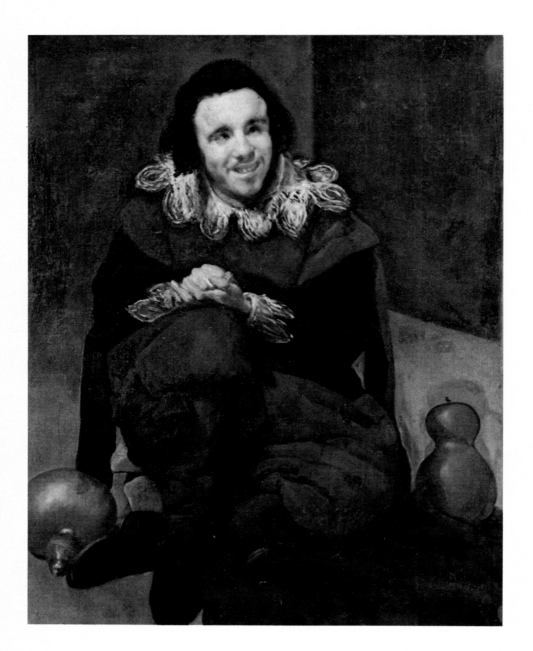

THE COURT JESTER CALABAZAS
otherwise known as Calabacillas.
Oil on canvas; 106 × 83.5 cm. (41 $\frac{3}{4}$ × 32 $\frac{3}{4}$ in.)
1637-1639
Madrid, Prado (1205)
Restored, mainly around the figures' right temple and in the area of the body where, as can be seen in X-rays, the painting has been defaced.

THE JESTER DON CRISTOBAL DE CASTEÑEDA Y PERNIA
Oil on canvas; 198 × 121 cm.
(78 × 47 $\frac{3}{4}$ in.)
1637-1640
Madrid, Prado (1199)
Records show that this jester served at the Court in Madrid between 1633 and 1649. Velásquez never finished the painting, and it remains unfinished, although another painter apparently added to the Turkish costume, probably between 1772 and 1794.

overgarment, sitting on the floor; his characterful face is rendered by the play of strong light upon shadow, which adds to the strength of his features. His pose, his foreshortened legs, with the upturned soles of the shoes on his little feet, and the low floorline make his torso look large, and the symmetric pull of his shortish arms give to his chest the appearance of a monumental bust, contrasting with the diminutive hands and feet, his red cloak hardly touching the floor. In the copy the area is wider, and the impression of space somewhat deeper. It seems that there was in the background, to the sitter's left, a sort of window

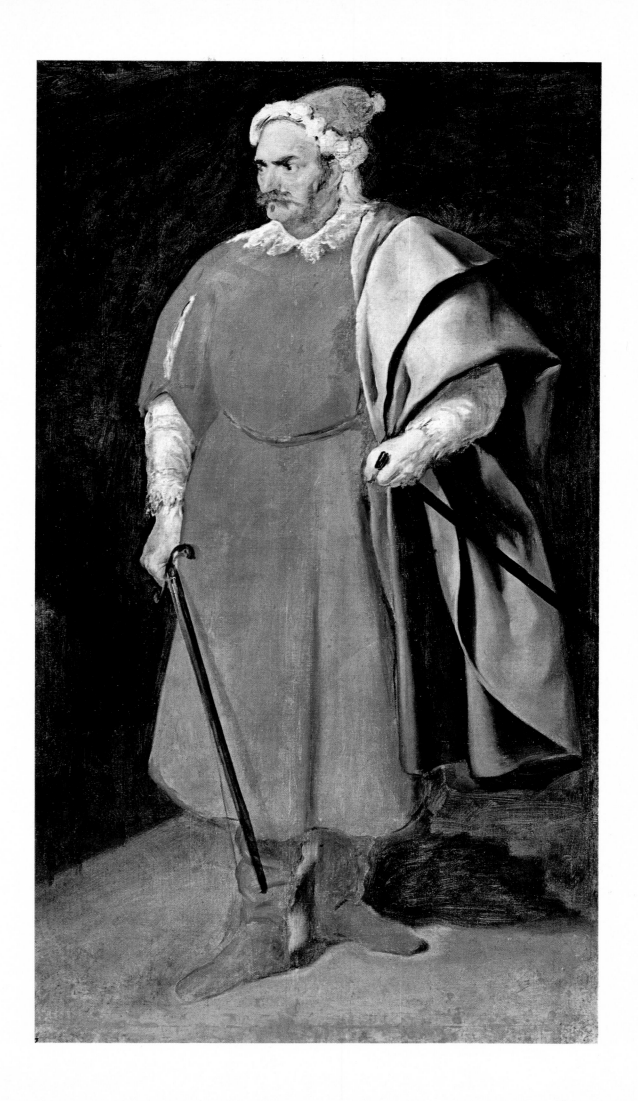

opening, which the original composition may also have included (page 135).
As in his pictures of pagan gods or men of antiquity, Velásquez used fore-shortening, highlights, and impasto to stress the earthiness of character of dwarfs and jesters, and as well as their comical or stupid traits and gestures, and the disfigurement, and accompanying individuality, brought about by passions, appetites, idiocy, and age. Yet, unlike Callot's works of similar subjects, these portraits are in no way caricatures or farcical. There is, in fact, neither irony nor melancholy in Velásquez' portrayal of men whose role it was to act out their feelings and proclivities, even their infirmities, for the King's and the courtiers' pleasure. He used light, shade and the texture of paint to make them into enduring images. Velásquez' approach to the clowning of dwarfs and jesters resulted indeed in a almost stoic depiction of the quirks of human nature.
In 1635 Pietro Tacca undertook to make, in Italy, a monumental equestrian portrait of Philip IV for the Buen Retiro. Juan Martínez Montañés (1568-1649) was commissioned to sculpt the head of the King in clay from life as a model

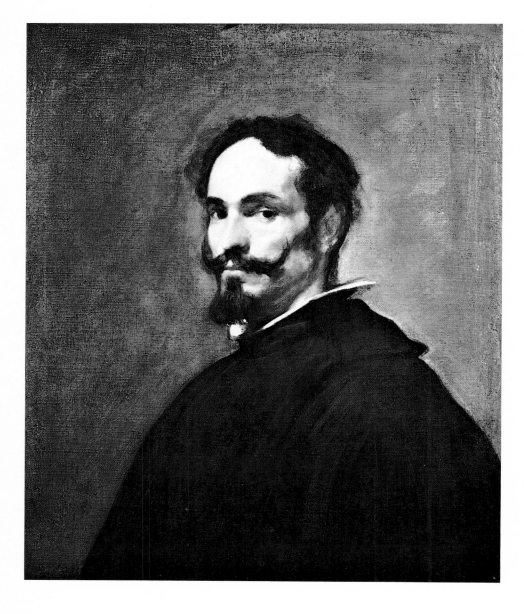

PORTRAIT OF A BEARDED MAN
Oil on canvas; 76 × 64.8 cm.
(30 × 25 $\frac{3}{4}$ in.).
End of decade 1630-1640
London, Wellington Museum, Apsley House (125)

from which Tacca could work.
Velásquez, in turn, painted Martínez Montañés at work on that clay head of the King (page 105). The sculptor is gazing concentratedly into the distance, obviously at his royal sitter, as he holds the modelling tool pointed at the likeness of the King roughed out in clay. Montañés' luminous head is modelled with a rich impasto and yet with a fluidity in the cheeks and eye sockets, from whose shadows the eyes, thinly painted, gaze out. There is a certain ambivalence

in the strength of the shape of the head and the serene countenance of the sculptor at work. Likewise Montañés' right hand, poised over the clay, is fully modelled, the sensitiveness of the fingers being heightened by the vivid quality of the paint subtly worked from a rich impasto to a thin film. As for the likeness of Philip, his features are sketched in directly on the grey priming of the canvas, and the sculptor's hand which props the shape of clay is just roughed out with a few strokes of heavy impasto.

These facts have led to suggestions that the picture is unfinished or that Velásquez completed it many years after Montañés' stay at Madrid, which, it is argued, would explain why he did not paint in more detail the sculptured head of the King, since with the passing of the years he would not have remembered it. Like many surmises made about other works by Velásquez, with few

SAINT ANTHONY ABBOT AND
SAINT PAUL THE HERMIT
Oil on canvas; 260 × 192 cm. (102 $\frac{3}{4}$ ×
75 $\frac{3}{4}$ in.)
Middle or end of the decade 1630-1640
Madrid, Prado (1169)
Detail: *pages 116-117*

exceptions, these have been based on assumptions as to how Velásquez might, or ought to, have painted rather than on a realisation of how he actually did paint.

There is an interesting analogy between Velásquez' early *St. John Writing the Apocalypse* (page 21) and the *Martínez Montañés at Work*. Each is represented at a moment of deep concentration on what he is shaping, whether words or clay, in both the hand is poised in readiness for the sentient stroke. There is a

difference too: the evangelist looks past the depiction of the vision that he is intent on describing towards an indeterminate point outside the picture, while the sculptor looks out of the picture to a determinable though invisible point —his royal sitter. Some twenty years later, Velásquez would portray himself at the easel in a similar attitude in *Las Meninas* (page 165).

Montañés' left hand is sketchy, though in quite a different manner to the head of clay that it supports; roughed out with heavy impasto, which is also used for the cuff, it contrasts with the filmy lights and broad strokes which sketch the likeness of the King. Thus an ambivalent, but by no means confused, image is created as the shape roughed out by the sculptor is in fact the painter's sketch. The monumental head of the King, moreover, blends with the background, allowing the three-quarter length figure of the sculptor dominate the composition.

Had Velásquez left this work unfinished, it would be necessary to conclude that he chose to do so at a point when he was satisfied that he had strikingly expressed on canvas the act of artistic creation. It appears, indeed, that Velásquez did not limit himself to superimposing, as it were, his own sketch of the likeness of the King in the representation of the head sculptured by Montañés. Actually he fashioned the portrait of the latter into a vivid image of the artist as a creator whose hands manipulate materials, whether clay or paint, to his expressive purpose. Thus accenting the superiority of the image achieved over the natural appearance that it portrays.

Woman sewing (page 109), datable to between the mid-1630s and the early 1640s, is a fine example of what a plainly unfinished portrait by Velásquez looks like. The head, well modelled in terms of light and shade, is the only finished part, as was noted at the time of the painter's death. The arms and hands, sketched in, have their rhythm masterfully indicated, though they fall short of the full modelling of the face, which results in a sort of distortion of space and of the limbs, particularly the left forearm. This painting, in its unfinished state, reveals Velásquez' felicity of grasping a simple gesture and the way he went about building a shape within a broadly brushed outline, blending the figure with its ambient air.

Several documents refer to the portrait of *Philip IV in the Uniform of Commander-in-Chief* (page 133) painted by Velásquez at Fraga in June 1644 during a halt in the campaign against the French. The room, or rather alcove where the King was to sit for the portrait is illuminated by three windows, and was reconditioned, a load of reeds was brought to cover the floor each day of the three days that Philip sat for the portrait, obviously to keep his feet warm. At the same time, the house where Velásquez was staying was repaired and a new window was opened up so that he could 'work and paint'. This reveals a procedure which probably was usual for Velásquez as a portrait painter: to work from the model first, and then to finish the portrait in his workshop without the sitter. At least that was the way he went about it in the only other instance for which we have a reliable account, from an eye-witness in this case. Jusepe Martínez, indeed, tells how Velásquez during one of his stays in Saragossa in the 1640s painted the portrait of a young lady, now lost or unidentified. He painted

COUNT-DUKE OLIVARES
Oil on copper; 10 × 10 cm. (4 × 4 in.)
c. 1638
Madrid, Royal Place

COUNT-DUKE OLIVARES
Oil on canvas; 67 × 54.5 cm. (26½ × 21½ in.)
c. 1638
Leningrad, Hermitage (300)

just the head from life, and then, 'in order not to tire' her, he took the canvas to Martinez' house where he finished the painting. In this instance, the sitter was disappointed, so much so that she refused to accept the portrait, mainly on the grounds that Velásquez had not depicted the collar of very fine point Flemish lace that she had worn at the sittings.

The portrait of Philip IV painted at Fraga in 1644 shows the royal sitter in the red and silver field uniform of Commander-in-Chief holding the baton in his right, and a black hat with a red feather in his left hand, his fair-skinned face and red and silver costume set off by the dark umber background. Light touches build the King's features, without wrinkles or weighty shadows (page 133).

This portrait, painted when the King was leading his troops in a campaign, might readily have suggested an allegorical composition to Velásquez if he had been allegory-minded. He obviously was not. Indeed there is no indication that Velásquez ever painted an allegorical portrait of Philip IV, although it is true that in 1627, he painted a large canvas with the portrait of the previous monarch, *Philip III and the Expulsion of the Moors*, he represented Spain as a matron in Roman armour carrying in her right hand a shield and arrows, and in her left, some waggons of grain. That picture (now lost) was, however, painted in competition with three other court painters at Philip IV's command, and most likely the allegorical figure of Spain was specifically included in the subject that the four participants in the competition were required to put on canvas.

FRANCESCO II D'ESTE, DUKE OF MODENA
Oil on canvas; 68 × 51 cm.
(27 × 20¼ in.)
Autumn, 1638
Modena, Pinacoteca
Cut down on lower edge.

The portraits of Philip IV by Velásquez which have come down to us show that he consistently made vivid the presence of the King by an effortless gesture of innate power instead of the paraphernalia of allegory. Allegories were, of course, quite in vogue in literature and the other arts, and allegorical portraits of Philip IV were painted in Velásquez' time. In fact, the portrait of *Philip IV* which he painted at Fraga, and which was greatly admired in Madrid, was soon worked into an allegorical composition.

Many of the noblemen who had returned to the Court after the King's banishment of Olivares had a sincere if ineffectual desire to bring back the glories of the past. The Marquis of Eliche, son of the new chief minister, decided to have a portrait of Philip IV which would spell out in an allegorical manner the glory and power of the Spanish monarchy. Velásquez let one of his assistants copy Rubens' allegorical portrait of Philip IV painted in 1628 and then still at the Madrid Royal Palace (now lost) and as documentary and visual evidence show, limited himself to painting afresh the head of the King (page 131) which, apart from the hat, is very much like that in the Fraga portrait.

As indicated before, many of the extant portraits by Velásquez have often been described as unfinished. Underlying such a view, and frequently mentioned to

PRINCE BALTASAR CARLOS
Oil on canvas; 128.5 × 99 cm (50 $\frac{1}{2}$ × 39 in.)
c. 1639
Vienna, Kunsthistorisches Museum
(312)
The Prince's face appears to be the work of Velásquez: the artist probably sketched the whole composition himself, but most of the actual excution was entrusted to an assistant.

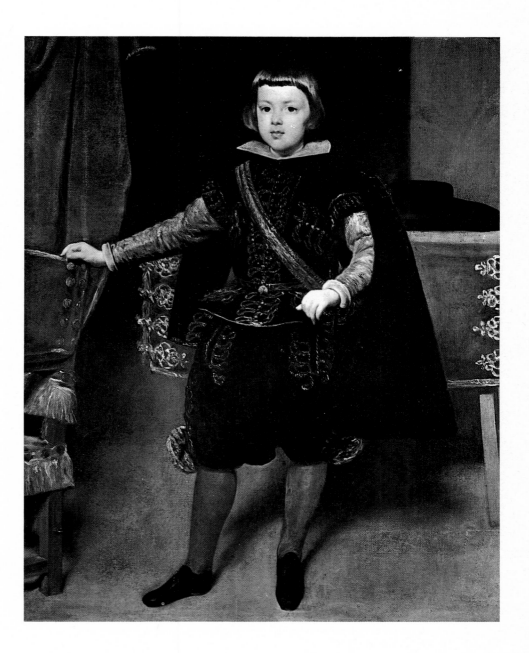

support it, are one or more of the following facts: an unevenness of texture resulting from the use of both fluid and rough brushstrokes, as in *A Knight of Santiago*, of the late 1640s (page 152); the sketchy painting of the sitter's hands found in *A Young Woman*, of the mid-1630s (page 107), in *Juan Mateos*, of about 1632 (page 74), and in *A Young Man*, of 1630-1 (page 65); or the seemingly chance strokes left by Velásquez in the background of some portraits as if he had wiped his brush on the canvas, an example of which is found in the *Portrait of a Bearded Man* of the late 1630s (page 114), where the flowing

contour line adds to the unfinished effect. Such 'chance' strokes, which the painter could easily have erased or painted out, had he regarded them as a flaw, are also noticeable in works which can hardly be considered as unfinished, including *Don Pedro de Barberana*, of 1631-2, and *Juan de Pareja*, of 1649-50 (pages 71, 149).

However, there are pictures such as *Woman Sewing*, *Don Cristobal de Castañeda* and *Portrait of a Girl*, (pages 109, 113; 148) on which Velásquez obviously stopped working before completing what he had intended to paint. There is in these paintings, even in the portrait of Castañeda which another painter tried to finish, a lack of the pervading aura which Velásquez achieved in his finished works.

Portrait of a Girl is a telling illustration of Velásquez' method, sharply criticized in his day, of brushing a figure on canvas from life, working out the composition as he went on painting. This work brings to mind Carducho's waspish rebuke addressed to 'some' painters who, dispensing with preparatory drawings or sketches, would just use a piece of chalk to block out on the canvas 'what they want to do, and go on painting it all at once, without erasing anything, painting or rather simply copying from life, and they may even perhaps completely finish half a figure without having determined how the other half should be'.

It seems that *Portrait of a Girl* was cut down on the right-hand side after Velásquez' time for the purpose of 'centering' the figure, as has been done with many of Velásquez asymetrical single-figure compositions. The girl's head appears almost complete, in Velásquez' terms, down to her shoulders, including the kerchief. Strokes of white paint, unevenly thick and with a faintly pinkish tinge, which highlight the face from the forehead to the chin, are distinctly unblended with the layers of skin colour. This, as well as the girl's chestnut hair, swiftly brushed in, brings this work close in manner of execution, to paintings by Velásquez from various periods, notably though not exclusively, *A Dwarf Holding a Book on his Knee* (page 132), *Menippus* (page 123), *Pablo de Valladolid* (page 110), and *Juan de Pareja* (page 149). The girl's body though is merely blocked out with broad black strokes on a dark greenish-brown ground, the left arm and what is visible from the waist down scarcely indicated.

Studies are, of course, a somewhat different matter since, however sketchy they may be, they are not likely to be impaired or made more challenging to the artist by want of further work. There are instances, though, in which it is difficult to decide whether a painting ought to be regarded as unfinished or just as a study. Such is the case with Velásquez' bust length *Portrait of a Girl* (page 128). The sitter's head is well modelled in terms of light and shade, while the neckline and sleeves of the grey-green dress are summarily indicated by strokes of brown; yet, the light that pervades the figure and permeates the background, painted in a grey-green tone darker than the dress, effects the kind of pictorial whole that comprises many studies.

The decision as to when a painting, whether sketchily or elaborately painted, is finished lies, of course, with the painter himself, yet, works of art, whether finished or unfinished, exist independently.

Sketchy passages often appear in portraits by Velásquez which seem quite finished otherwise. Their comparatively large number are of significance for the understanding of Velásquez' art, even if we are to conclude that he often simply put aside his portraits just as he was about to give them the final touches, leaving for instance, no more than one hand to be finished or a few chance strokes to be painted in. Sketchy passages, moreover, are also noticeable in some of his religious, mythological or historical compositions which have always been regarded as finished.

Velásquez' 'sketchy' passages are not distinctive of any particular period of his art, for he used them now and then throughout most of his life, presumably whenever the sitter, or whatever subject he was depicting, quickened him to do so; presumably, also, at the urge of the artistic reality that was taking shape on the canvas as his work progressed.

It is significant that the portrait of Martiñez Montañés at work is the painting which shows the widest range from the 'rough' to the 'finished' within

Velásquez' *oeuvre* (page 105). Plainly Velásquez has brought into it the theme, as distinguished from the subject, of the artist's mastery of his medium for his expressive ends. He has not only portrayed Martinez Montañés in the process of shaping the King's likeness out of clay, but he has also achieved an image of the very act of artistic creation, making vivid both the sculptor's and the painter's mastery of their media.

Baroque artists were intent on accenting the texture of their material, whether paint, clay, marble or bronze, while shaping it to their expressive ends. This, which evident in Bernini, the sculptor and architect, enhanced the superiority of the work of art over both the stuff it was made of and the natural appearances it portrayed; it often resulted in a brilliant display of resourcefulness, sometimes

MENIPPUS
Oil on canvas; 179 × 94 cm. (70 ¾ × 37 ¼ in.)
c. 1639-1641
Madrid, Prado (1207)

AESOP
Oil on canvas; 179 × 94 cm. (70 ¾ × 37 ¼ in.)
1639-1641
Madrid, Prado (1206)
Detail: *pages 124-125*

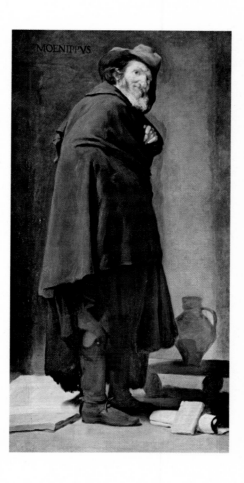 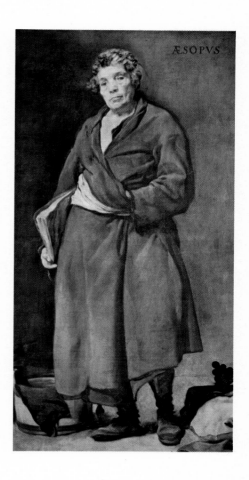

bordering on virtuosity, noticeable in so many works of that time. In a broader sense, such brilliant resourcefulness appears akin to that exhibited by creative writers of the period in their use of neologisms, conceits, puns and other word play, by which they underscored the very structure of words while building unique images with them.

Velásquez' sketchy passages in works which appear finished otherwise, whether a shadowy or light-permeated shape, a roughed out hand, a flowing contour, an unevenness between liquid paint and heavy impasto, or some strokes which smear the background without having a representational function, have in common that they make us aware of both the painter's medium and the way in which he goes about putting his images on canvas.

Velásquez, like any other painter, left unfinished a number of works, some of which were so listed in the inventory of his possessions drawn up after his death. It is also known that he had a penchant for retouching his own works, which often show *pentimenti*, but there is no clear indication that such changes were not generally made in what he regarded as the course of execution, which very likely was a long period of time given the overlapping of royal commissions for paintings, his other duties at Court, and what seems to have been his own sense

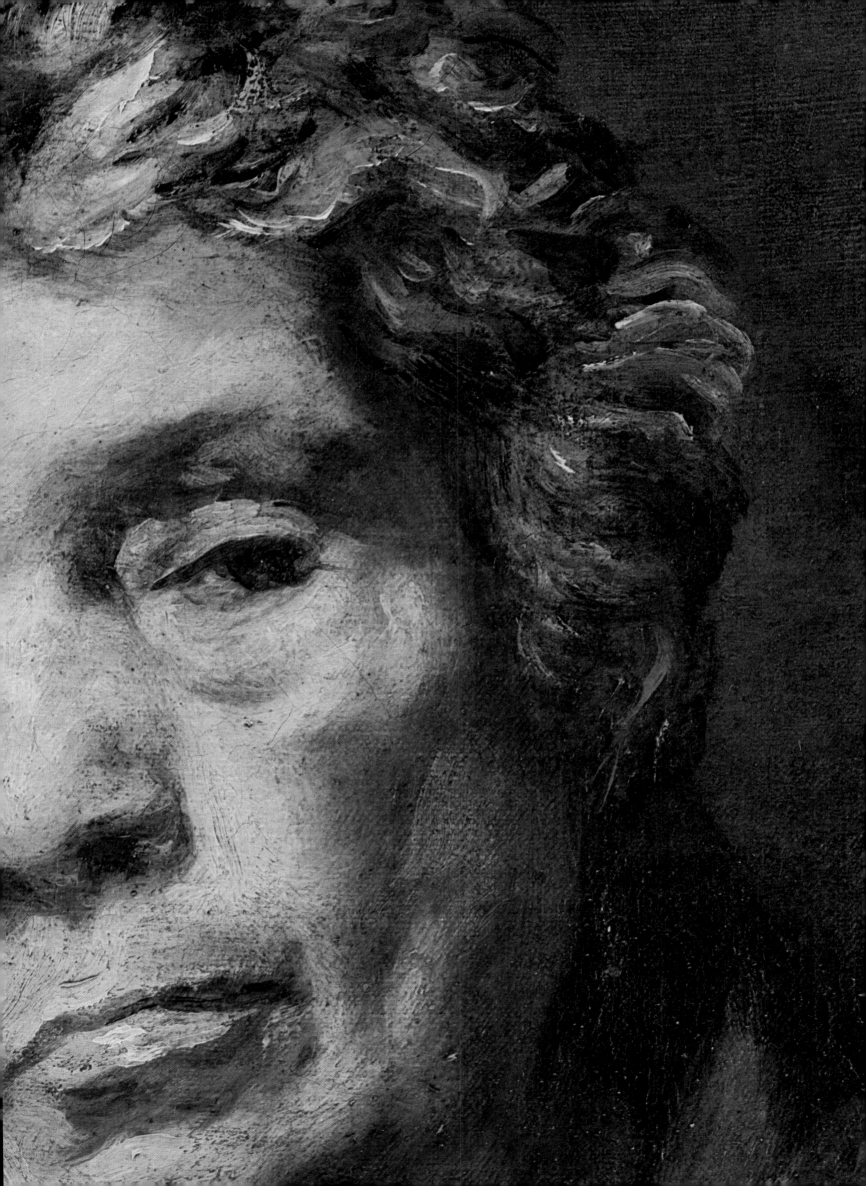

of leisure. It is well documented that he made many sketches, nearly all of which are lost. Sketches too exist independently, and do not necessarily depend for understanding on the work to which they ultimately led and whose process of composition they help to reveal. Unlike paintings on which the painter stopped working before fully putting on canvas what he intended to brush in, nothing can be missing in a sketch.

As for the works in which Velásquez used sketchy passages or nonrepresentational strokes in a pictorial whole, such as *Martínez Montañés at Work*, *Portrait of a Young Woman*, *Don Pedro de Barberana*, *A Knight of Santiago*, or *Juan Mateos*, if we compare any of them with *Portrait of a Girl*, *Woman Sewing*, or, for that matter, with *Don Cristobal de Castaneda*, we can see the difference

DON FRANCISCO BANDRES DE ABARCA
Oil on canvas; 64 × 53 cm.
(25 ¼ × 21 in.)
1637/39-1640/43
New York, Private collection
Fragment, very probably from a half-length portrait; restored. The heraldic shield, top left, and the red cross of the Order of Saint John on the sitter's doublet are later additions. Don Francisco (1595-1647) served King Philip IV and the Cardinal Infante Fernando and in 1645 became a knight of Saint John.

between a painting on which Velásquez stopped working, for whatever reason, before achieving a pictorial whole, and those images including sketchy passages for expressive purposes, be it to accent an expression of the sitter, to reveal the painter's mastery of his medium, or empahsise the superiority of the painted image over the natural appearance that it portrays.

MARS
Oil on canvas;
167 × 97 cm.
(70 $\frac{1}{2}$ × 37 $\frac{1}{2}$ in.)
c. 1639-1641
Madrid, Prado (1208)

Religious compositions

The only extant large composition with small figures unquestionably by Velásquez is *St. Anthony Abbot and St. Paul the Hermit* (page 115). It is also one of the few paintings by Velásquez for which there is an extant preliminary study, for the head of St. Anthony, executed in colour and life-size.

Velásquez set the two saints dramatically against an angular crag surrounded by a diaphanous view of a green valley and distant blue mountains. The composition includes several episodes of the visit of Abbot Anthony to Saint Paul the hermit. The narrative proceeds from the background along the curving line of the terrain and the river, giving at the same time prespective depth to the

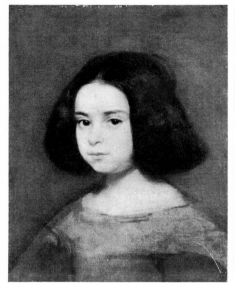

PORTRAIT OF A GIRL
Oil on canvas; 51.5 × 41 cm. (20 $\frac{1}{2}$ × 16 $\frac{1}{2}$ in.)
Beginning of decade 1640-1650
New York, The Hispanic Society of America (A 108)
Unfinished.

THE DWARF FRANCISCO LEZCANO.
Oil on canvas, 107 × 83 cm. (42 $\frac{1}{8}$ × 32 $\frac{3}{4}$ in.)
c. 1643-1645
Madrid, Prado (1204)
The dwarf served Prince Baltasar Carlos from 1634 to 1645; he returned to Court in Madrid in 1648, and died a year later in 1649.

landscape. Thus the various scenes are articulated in a linked sequence. In the far distance, Saint Anthony is seen asking the centaur the way to Saint Paul's cave; closer to his destination he meets the horned and goat-footed monster; then the action turns to the right where the holy man knocks at the door of the cave built in the crag; this scene is a sort of backdrop for the main one: the two saints, one making a gesture of prayer and the other one of wonder, are grouped together as the black raven, a small loaf of bread in its beak, flies down to them. To the left, in a barren area to the left of the foreground, the concluding scene,

second in scale, takes place: two lions dig the grave for St. Paul as St. Anthony prays over his body.

The paint is thin, with impasto used only for highlights, particularly on the faces and limbs of the two saints. A silvery light permeates the whole composition, bringing out the rich blues and greens of the landscape. The depiction of the hardships of the hermit, referred to in the Golden Legend's narrative, are embodied in the rugged crag on top of which rises a palm, the tree on whose fruit St. Paul lived for about twenty years, and in the barren ground where the lions dig the grave for him. The surrounding verdant landscape is not a departure from the narrative, rather it heightens the seclusion of the hermit's retreat from the luxuriant parts of the earth, where temptation lurks. It also provides a vast and luminous setting for the miraculous event: the heaven-sent loaf of bread. The diaphanous colouring and the upward rhythm of the composition, stressed by the ivy-covered birch tree which rises from the thicket in the foreground, past the forbidding crag, up to the sky all combine to stress the miraculous event.

The Coronation of the Virgin, of about 1644, is a lucid depiction of the widely held but much argued belief that the Mother of Jesus was born without original sin, on which her coronation was postulated (page 137). The Father and the Son, both clad in purple tunics and red mantles, hold a crown of roses and green leaves over the Virgin, whose white kerchief leaves her chestnut hair uncovered, and whose blue mantle contrasts with her red gown. The masterful opposition of luminous reds and blues, is made the brighter by the juxtaposition of purple in the tunics of the Father and the Son.

The Virgin lightly holds a hand to her breast, bathed in light, like her head. A highlight across her luminous face and along her hairline enhances the unblemished symmetry of her features and blends with the most brilliant ray of light coming from the Holy Ghost in the form of a dove above her. Her lids lowered, she looks down with an expression of modesty which compositionally accents the sense of distance from the earth as angels lift her to Heaven.

The face of the Son is modelled in translucent shadow and that of the Father is built up of fluid shadow and vivid highlights, and broad, radiant strokes emphasize the folds of the mantle across His shoulders. The Father and the Son hold the crown of roses over the ascending Virgin, her brightly-lit head becoming the centre of the composition, and her shadowless, unblemished features externalise her immaculate nature, her freedom from sin.

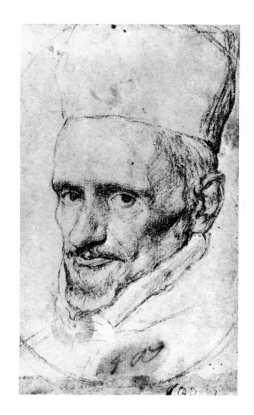

HEAD OF CARDINAL BORGIA
Black chalk on white paper glued onto another sheet of paper bearing an inscription dating from the middle of the nineteenth century: '*El Cardenal Borja, Arzobispo de Toledo, dibujado pʳ. d. Diego Velazquez*'.
18.6 × 11.7 cm. (7½ × 4¼ in.)
1643-1645
Madrid, Real Academia de Bellas Artes de San Fernando (72) The Cardinal was born in 1582 and died in 1645.

Mythological compositions

The earliest mention of *Venus at her Toilet* (pages 138, 140-141) occurs in the inventory of a Madrid aristocratic mansion drawn up on 1 June 1651, when Velásquez was still in Italy. This leads to the conclusion that, as stylistic considerations suggest, Velásquez painted it before November 1648, when he left Madrid on his second Italian journey. Late in the seventeenth century it decorated the ceiling of a room, not otherwise identified, in the same mansion. Though damaged by old scratches, rubbing, bad repainting and, in 1914, by a suffragette's knife, the painting could until recently be recognized at once as a masterpiece (page 138). One could readily grasp the masterful contrast of

smooth and rough impasto, essential to Velásquez' intent. One could also discern what was incidental to his way of painting, the *pentimenti*, tentative shapes that he quickly painted over and which with time became noticeable to the naked eye, without however, marring his achievement. The painting was drastically cleaned and implausibly restored in 1965. As a result, it now appears messily sketched in some areas and overworked in others.

As Velásquez painted it, the flowing shape of Venus, her back turned to the viewer, lay on leaden grey drapery with only some bluish reflections; her face was softly reflected in the black-framed mirror held by Cupid, and the blue of his sash, the red of the curtain and the lavender ribbons on the mirror frame acted as foils to her pale flesh tones. The mirror, with its straight sides tilted away from Venus, emphasises the curves of which the rest of the composition is made up. Nothing like this picture, exuberant with vivacities of textures and colour, could be found in any other painting of the same subject. Only in nuptial poems of the time, such as Marino's can one find a Venus-like image immersed in so sensuous an atmosphere.[6]

The reflection of the face of the chestnut-haired goddess in the tilted mirror corresponds quite closely with that of the Virgin in *The Coronation of the Virgin*, both have the same oval shape and their features are similar point by point. The head of the Virgin, however, is spotlessly luminous and her tresses accent the impeccable balance of her features. Venus' face however is to a large extent in shadow, which, together with the irregular frame provided by her untidy hair, alters the harmony of its oval shape and the symmetry of its features. Obviously, Velásquez worked in both cases, and, for that matter, in *The Spinners* and *Arachne* (pages 143, 144-145), from the same model, the same sketch, or just the same idea of a beautiful young woman. Yet, he put on canvas two totally different images, one of divine and the other of very earthly beauty.

The Spinners is another large mythological composition painted by Velásquez around 1644-8 and not intended for the King. The first mention of it occurs in the inventory of a Madrid private collection compiled in 1664, four years after Velásquez' death; the metrical equivalent of the size then recorded was approximately 167 centimeters in height and more than 250 centimeters in width (66 in × more than 98 in). Before 1772, it was in the Spanish royal collection, first at the Buen Retiro and then at the Madrid Royal Palace. By then, however, the composition had been substantially enlarged, and its true subject was not recognized; it was described as representing a tapestry workshop, and *The Spinners* is the title by which it is still commonly known.

The composition was enlarged by the addition of a large strip at the top of the original canvas, another, rather uneven, at the bottom, and a narrow one at either side. Without these additions, the size of the original canvas appears to be almost the same as that recorded in the cited 1664 inventory.

Unfortunately, the painting, which had for long been frayed and cracked, has lately been allowed to deteriorate into an appalling condition; its colours have undergone changes nearly everywhere, and the paint is flaking off in places.

The subject of the picture is thought by many to be the fable of Arachne. As told in Ovid's *Metamorphoses*, Arachne, a low-born weaver, had achieved so

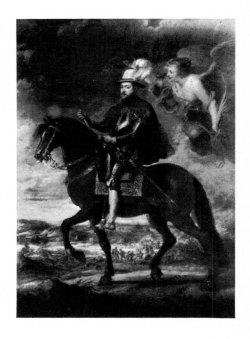

Peter Paul Rubens
PHILIP II ON HORSEBACK
Oil on canvas; 314 × 228 cm.
(124 × 90 in.)
1628
Madrid, Prado (1686)

ALLEGORICAL PORTRAIT OF PHILIP IV
Oil on canvas; 339 × 267 cm. (133 $\frac{3}{4}$ × 105 $\frac{1}{2}$ in.)
c. 1645
Florence, Galleria degli Uffizi
In this copy Velásquez painted only the head of the King; the rest is a studio copy from a portrait (now lost), also of Philip IV, painted by Rubens in Madrid in 1628-1629.

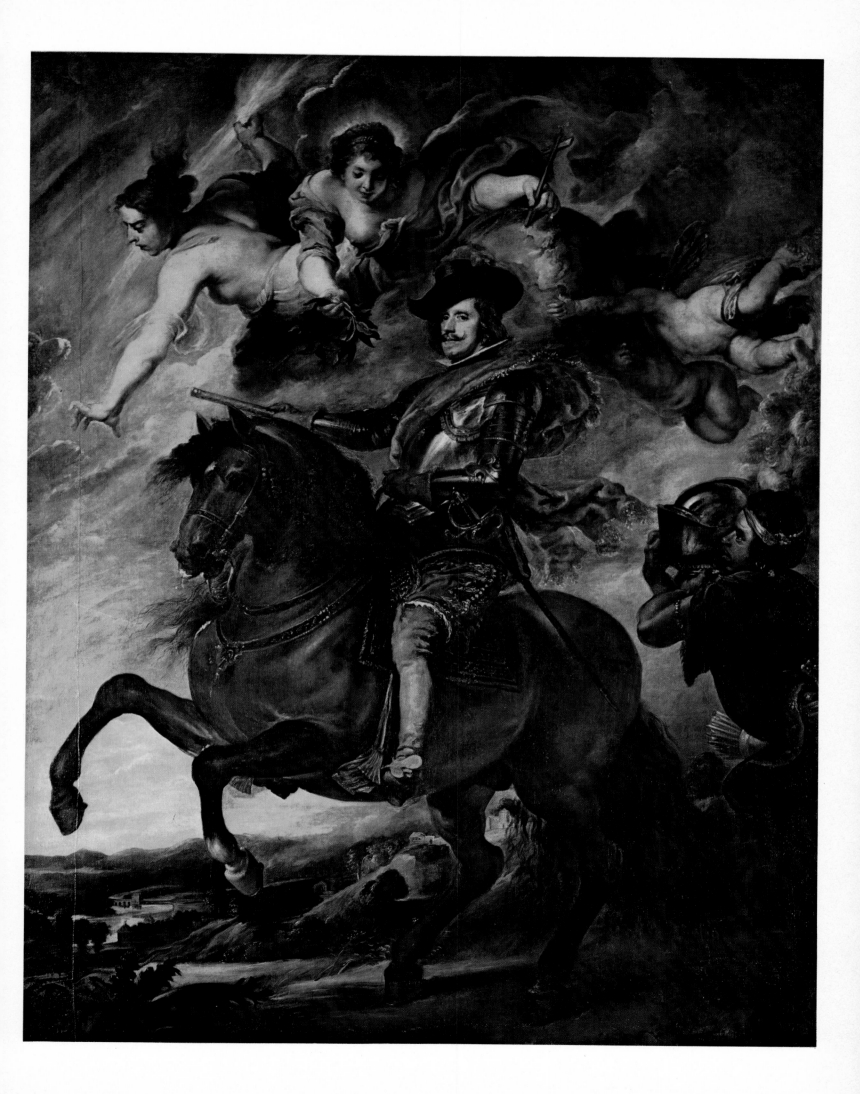

great a reputation that Lydian women came from distant parts to admire her work. Proud of her success, she boasted of having a skill superior to that of the goddess Pallas Athena. On hearing this, Pallas came, disguised as an old woman, and admonished her not to defy the gods. Arachne, however, repeated her daring words, whereupon Pallas discarded her disguise, showing herself in armour and helmet, and took up the challenge. A contest was arranged and Pallas wove a set of six tapestries depicting the fate of mortals who had dared to challenge the power of the gods. Arachne chose as her subjects six stories of mortals who had attracted the gods, beginning with Europa and the bull. Pallas won, and punished Arachne for her pride by turning her into a spider.

So much for Ovid's narrative. As for Velásquez' work, ignoring the extraneous

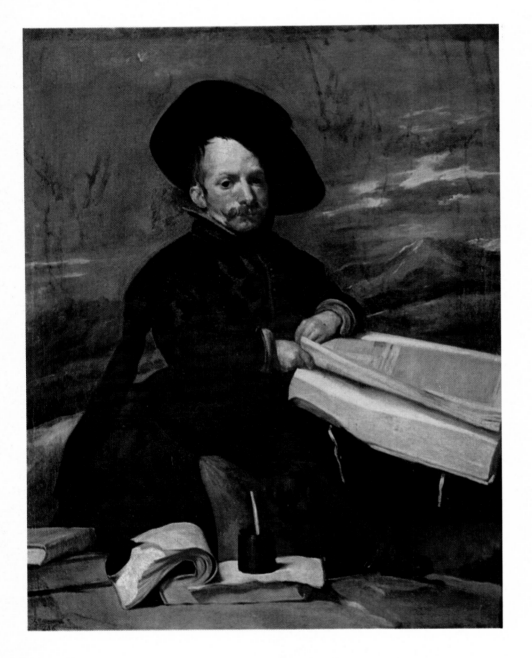

DWARF WITH A BOOK ON HIS KNEE
Oil on canvas; 107 × 84 cm. (42 $\frac{1}{4}$ × 32 $\frac{1}{4}$ in.)
Middle of decade 1640-1650
Madrid, Prado (1201)
There is no conclusive evidence that the figure portrayed is Diego de Acedo, a theory first put forward in 1872.

KING PHILIP IV IN THE UNIFORM OF COMMANDER-IN-CHIEF
Oil on canvas; 133.5 × 98.5 cm. (52 $\frac{1}{4}$ × 40 in.)
June 1644
New York, Frick Collection (138)
Painted in just three days at Fraga (and thus known as the 'Fraga Philip') during a pause in the military campaign against the French.

additions, it originally depicted the richly hued interior of a tapestry workshop, with vivid play of light and shade on the weavers, their tools, and the skeins, balls and tufts of wool scattered around and a brilliantly lit-up alcove in the background. To the right of the workshop, a girl in a white blouse and greenish-blue skirt is winding yarn as another young woman brings a basket to her side. To the left, a spinner in a white kerchief and brown costume works at a spinning wheel who, as she is dressed like an old woman, could be Pallas Athene,

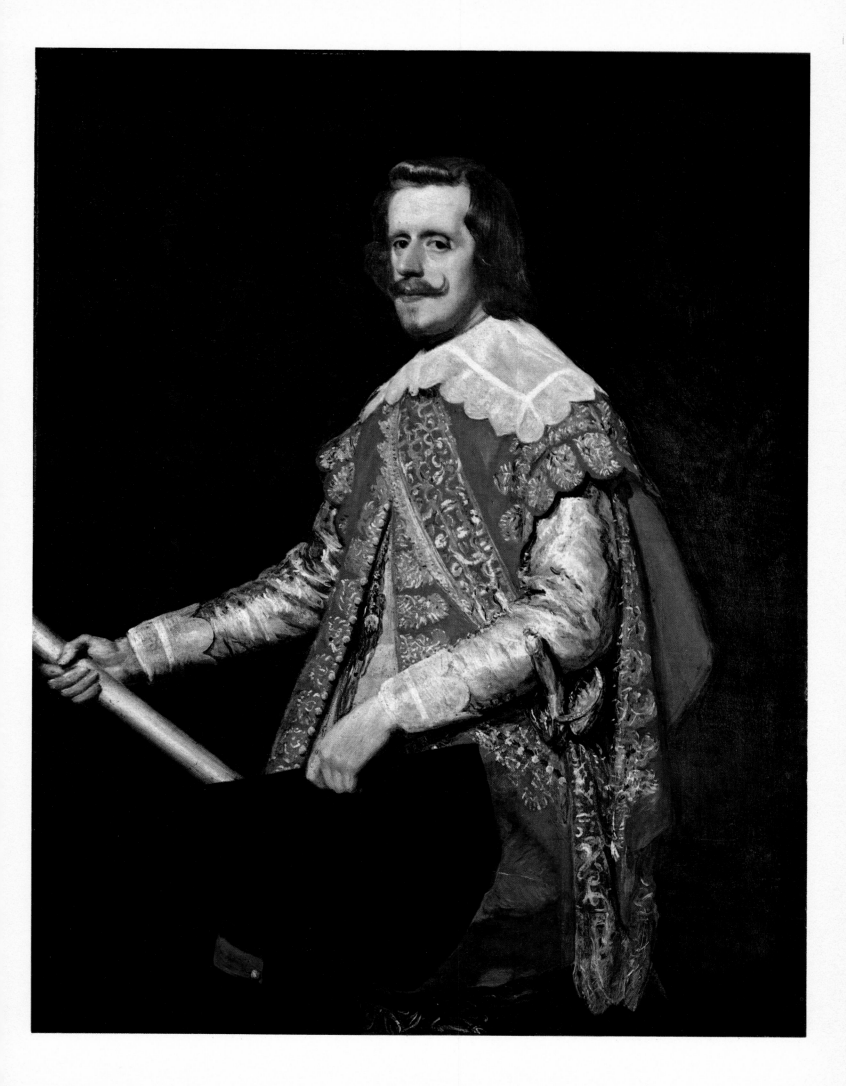

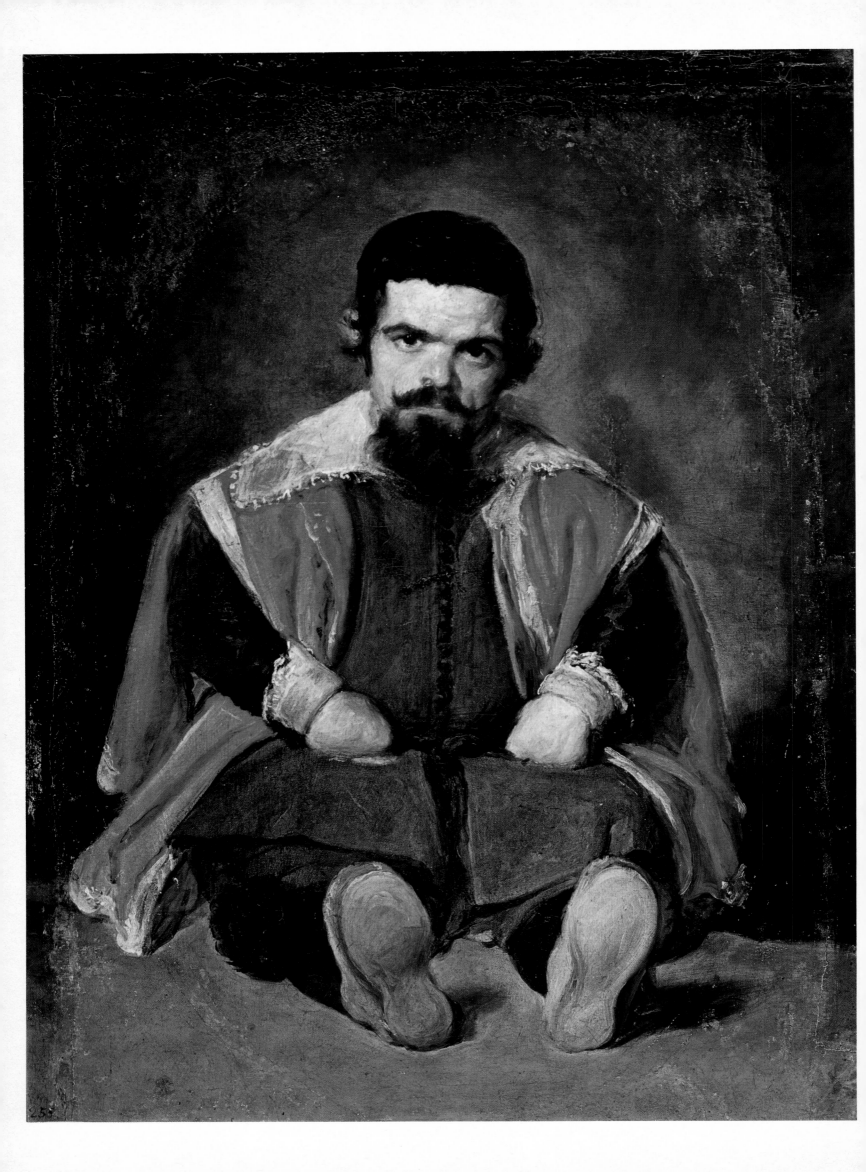

engaged in her contest with Arachne, the girl in the white blouse.

Set slightly back from the two spinners, there is woman carding tufts of wool that she picks up from the floor; her figure, a deep-shadowed, sketchy figure of white, brown and red, underlines the luminosity of the alcove behind, two steps above the workshop. The rear wall of the alcove is covered with a tapestry of *The Rape of Europa*. Three well dressed ladies in seventeenth-century costumes, one in rose, another in blue, and the third in yellow, stand there. The one in rose looks into the workshop, while the others look at Pallas, now in armour and helmet, and Arachne, now wearing a red sash over her white blouse and olive skirt, which, classical looking though it is, recalls the one she is seen wearing in the workshop.

A diagonal shaft of light fuses the space of the alcove with the composition

DWARF SITTING ON THE FLOOR
Oil on canvas; 107 × 82 cm. (41¾ × 31¾ in.)
Middle of decade 1640-1650
Madrid, Prado (1202)
There is as yet no conclusive evidence that the figure portrayed is Sebastian de Morra, a theory first put forward in 1872.

DWARF SEATED NEAR A PITCHER
Oil on canvas; 103 × 82 cm. (40¾ × 31¾ in.)
Middle of decade 1640-1650
New York, Private Collection
Copy of painting on preceding page, and probably executed by Velásquez with the aid of an assistant. In 1690 the work was listed as 'portrait of *El Primo*', that is Diego de Acedo.

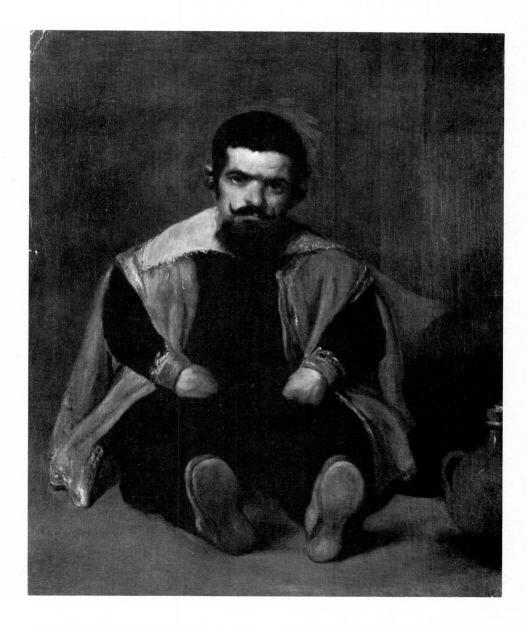

woven into the tapestry hanging on the rear wall: Titian's *The Rape of Europa*. To Velásquez, Titian was the greatest of the Italian painters. The Venetian master's *The Rape of Europa*, now at the Gardner Museum, Boston, was at the Royal Palace in Madrid in Velásquez' day. Rubens copied it there in 1628-9 (Prado, No. 1693) as other painters, including Mazo, had done before or were to do later. Velásquez must certainly have expected so well-known a composition to be readily identified by his contemporaries when he included it in *The Fable of Arachne*.

In spite of the painting's present condition, it is possible to realize that light was the dominant element in the composition of the masterpiece. Indeed,

perceptive critics have held it to be Velásquez' most brightly coloured painting, his greatest achievement in the rendering of light.

Some of the pictorial facts in *The Fable of Arachne* have been a puzzle to scholars. Are the figure of Pallas and Arachne in the alcove woven into the background tapestry or standing before it? The answer has been provided by the observation that Arachne casts a shadow, however slight, on the floor, and that consequently neither her figure nor that of Pallas can be regarded as woven into the tapestry. Even so, Velásquez does not make very explicit the spatial relations among the tapestry, the figures of Pallas and Arachne, and those of the three ladies. Indeed, the shaft of light that comes in obliquely from the left blends the space of the alcove with that of the tapestry and the perspective view of the floor does not allow certainty. The contrast of this light-coloured scene with the rich play of light and shade in the workshop must have been even more vivid in Velásquez' original composition, before it was altered by another hand intent on making the rendition of space more plausible by a rather trivial architectural device, the addition of the cross vault and the *oculus*. As for the shaft of light that blends the space of the alcove with that of Titian's composition woven into the tapestry, it obviously comes through the workshop. The window behind the red curtain at the left could be suggested as a source for it.

There are in this work, as in other Velásquez compositions, several layers of significance. The depiction of the contest between Pallas and Arachne, with the goddess still in disguise is certainly a departure from Ovid's text. The ordinary woman as whom Pallas is disguised and the three workshop helpers have their characters firmly stamped on their faces and their figures modelled in shadow. Not so Arachne, whose face is not visible but whose torso is lit from a light source on the left; her opulent figure breaking free of the shadows of the workshop, a luminous counterpoise to the dark figure of Pallas and creating a light/dark rhythm which is continued in the room and in the alcove. Contrasts of light and shadow and of colour also heighten the intensity of the foreground scene, where the spinners are seen plying the wool with deft fingers. Indeed, the shadowed figure of Pallas, set off by the radiance of the whirring spinning wheel, is in turn a foil to the light-bathed figure of Arachne.

Velásquez, well read as he was in Ovid and his commentators, gave a new interpretation to the fable of Arachne. In neither of the scenes which he depicted did he represent her punishment, as other painters and engravers had done in works with which he must have been acquainted. Rather he depicted in the background scene the bold spinner facing Pallas, the demonstrative gesture of her right hand opposing the threatening one of the goddess. He made the sky of Titian's composition considerably higher, freed the cupids of their bows and arrows, and stressed by strokes of light and shadow the course of their flight which appears to pass over the figure of Arachne. Light blends the space of the tapestry, readily indentifiable as such, with that of the alcove. The rich tones of the shadows of the workshop frame the whole background scene, a painting within a painting, and the foreground figure of Arachne is picked out from the shadows.

Velásquez was conversant with other artists' works on mythological subjects, and with Ovid's *Metamorphoses* and with Ripa's *Iconologia*, but did not feel chained to the language of metaphor nor to the traditional iconography of mythological subjects. He reduced the mythical characters to within the compass of human nature and conferred on them a human sensibility far removed from the usual iconography and for this reason the subjects are sometimes difficult to recognise.

This is the case with the picture of *A Young Woman* (page 146) who holds perhaps a canvas, over which she casts a deep shadow. There are stylistic afinities between this work and *The Fable of Arachne*, in particular the vigorous use of *chiaroscuro* in the two works, applied in many ways, emphasising the depth and dynamism of the composition and in the execution of the figure of Arachne, whether full or bust-length. Both have dark hair and wear rather crumpled white blouses. Both rough and smooth brushstrokes are used to build up the figures, the main highlight falling on the right shoulder of the young woman

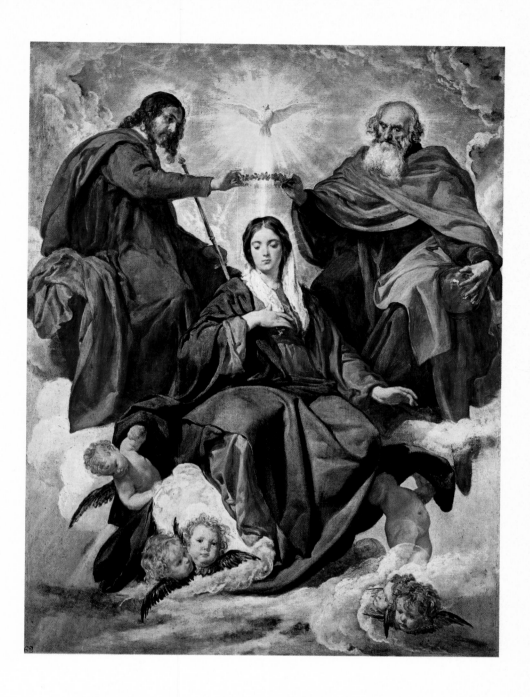

THE CORONATION OF THE VIRGIN
Oil on canvas; 179 × 135 cm. (69½ × 49 in.)
Middle of decade 1640-1650
Madrid, Prado (1168)

and on the left shoulder of Arachne. The light is uneven and is partly extinguished or cancelled out by the deep shadow.

The iconographical significance of the second painting is uncertain. Velásquez has not made it clear what the young woman holds in her hands. It could be a painter's canvas but its rather uneven shape makes it seem unlikely that it is nailed to a wooden frame to stretch it. It could be a piece of embroidery canvas held in an embroidery frame. The canvas and the dishevelled black hair are, according to Ripa, among the attributes of Painting, but the girl in this picture lacks any other such attribute, notably the paintbrush and palette.

The shadows on the canvas, or whatever it may be, held by the girl bring to mind the ancient legend, often mentioned during the Renaissance and still alive in the seventeenth century, according to which the art of Painting began with the tracing of a shadow on a lit-up surface. The girl's forefinger and the shadows which she projects on the blank surface might, indeed, allude to this legend, well known in Pacheco's and Velásquez' circle.

Some scholars have argued convincingly that Arachne stood for Painting in Velásquez' mythological composition on page 143, where she is seen working with her bare hands in the foreground. The resemblance between this figure of Arachne at work and that of the half-length figure of a girl holding a painter's canvas or a piece of fabric suggests that Velásquez had in mind the image of one

while he was painting the other.

Velásquez represented the girl, set off centre looking toward the canvas, or whatever it may be, on which she presses or rests her forefinger, which projects a large shadow as does the left side of her body. The shadows contrast with the light on the same surface, which is further enlivened by contrasts of texture and colour. This vivid surface is indeed an essential part of the composition. Whether meant as a painter's canvas or as a piece of weaver's material, it would fit, in Velásquez' terms, the image of Arachne, possibly once more as Painting, possibly an allusion to the ancient legend of its origin.

The Roman portraits

We know the names, or at least the profession, of ten of the sitters for the portraits which Velásquez completed during the times, on and off, that he was in Rome from May 1649 until the spring of 1651. We also know that he left several portraits unfinished.

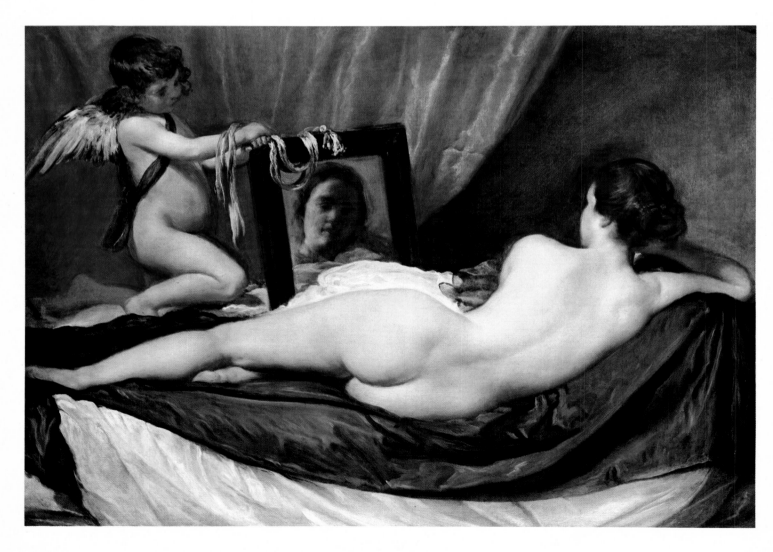

THE ROKEBY VENUS (THE TOILET
OF VENUS)
Oil on canvas; 122.5 × 177 cm. (48 ×
70 in.)
c. 1644-1648
London, National Gallery (2057)
Cut down on the left side. In 1914 the
figure of Venus was badly slashed in
seven places by a suffragette, however
the painting was restored. Cleaned and
extensively restored in 1966.
Detail: *pages 140-141*

Of the finished portraits, five, and a replica of one of them, *Innocent X*, (page 151) are extant. The only exact completion date we have for any of them is that of 19 March 1650, when the portrait of Pareja was exhibited at the Pantheon. Since Velásquez portrayed his assistant as an 'exercise' to prepare himself for the portrait of the Pope, it is safe to assume that Pareja's portrait was the first he painted and he could have done it any time between July 1649 and the date mentioned above.

Velásquez placed Pareja off centre on the canvas, turned three-quarters to the right, his head, raised and boldly highlighted, set off by the whiteness of the broad, and broadly painted, scalloped collar (page 149). The coppery flesh tones of the face are framed by bushy black hair, beard and moustache, and accented by the reddish stroke which models the lobe of the ear. The head stands out against a harmony of greys, permeated in parts of the background, as well as in the sitter's doublet, sleeves, shoulder belt and cape, by a subtle greenish tinge. The line of the dark cloak and shoulder belt across his chest set up a contrasting rhythm to that of the lifted head, heightening the roundness of the figure, as does the arm which crosses Pareja's body. Sketchy strokes around the figure carry the fluidity of the contour deep into the surrounding space. Hence atmospheric space and the way in which it is rendered are simultaneously enhanced, Pareja's coppery flesh tones and the blackness of his hair stand out against a grey background whose lighter area is made somewhat warmer by a slight greenish tinge.

Having 'got his hand in', Velásquez undertook the portrait of *Innocent X* (page 150). He created both a striking human likeness and an absolute harmony of reds, yellows and whites. *Innocent X*, wearing a white alb and red biretta and mozzetta, with broad scarlet highlights, sits in a chair whose gold braid and finials sets it off against the red curtain that is the background. The Pope's upright carriage is accented by the searching look in his blue-grey eyes and the bold highlights on the face. There is a tenuous shade of green in the varying greys of his hair, moustache and beard, as well as in the yellow of the braid to his left. The collar, painted in a slightly greyish white with the edges and folds highlighted with white, lets through a pale glow from the red underneath, while bluish-grey tints enliven the white of the alb and of the paper in the Pope's hand. Both hands are modelled with yellow lights and purplish touches, the latter being somewhat more vivid in the right hand, on which the stone in the pastoral ring gives off a blackish gleam.

The sense of depth is mainly achieved by the recession of tones, from light to dark, which flow into each other: the highlit crimson folds of the backdrop; the red chair; the deeper red of the shadow cast by the Pope's head on the back of the chair; the flashing scarlet stroke in the red mozzetta that outlines the sitter's right shoulder. The outlines are fluid everywhere, and the paint is laid on thinly, particularly in the area of the face, but for the heavy impasto used to brush in the highlights.

Although the sitter's features have been made vivid, his ugliness has not been stressed. It is, indeed, a marvellous likeness in reds, yellows and whites, in which Innocent X appears to embody papal splendour in his own characteristics. Certainly Velásquez depicted in this portrait a sense of earthly power, as he had done in his portraits of Olivares but never did when portraying the person of his King.

The supposed portrait of *Monsignore Michelangelo*, barber to the Pope, is one of Velásquez' outstanding works (page 151). As in the portrait of Pareja, the background is grey with a greenish tinge. The head is thinly painted, as is the background, with impasto used for the highlights on the face, the black hair and the edges of the transparent white collar over the black costume. The outlines are broad, and that of the right shoulder is made the more fluid by a stroke of white which, vivid and thick close to the sitter's neck, thins to become just a glimmer as it slopes down. Strong highlights on the forehead, nose, upper lip and neck are accented by the glints and flecks of impasto which give vivacity to his features.

Velásquez portrayed *Cardinal Astalli* late in 1650 or early in 1651. The portrait is

thinly painted but for the strokes of impasto that highlight the sitter's roseate flesh tones, which harmonise with the light red of the mozzettea and the biretta, smartly worn at an angle (page 152). Broad strokes around the top and right side of the biretta and along the sitter's left shoulder are obviously *pentimenti* since they are brushed over the original outline.

The highlights on Cardinal Astalli's face and black hair bring animation to his features, yet in a somewhat different manner to the portrait of *Monsignore Michelangelo*. A light, which leaves one side of the sitter's face and under the chin in shadow, smooths the flecks of paint used for the flesh tones into as even a surface as that of the creaseless mozzetta.

The other portrait painted by Velásquez in Rome which has come down to us, is that of *Monsignor Camillo Massimi* (page 153), badly in need of careful cleaning. Though Velásquez' hand can be recognised in the quality of the brushwork in spite of the dirt which covers the painting, no meaningful description of its original colour scheme, apparently keyed to a harmony of blue tones, can be attempted.

We are acquainted through written sources with the character of Innocent X, know something about Cardinal Astalli's, hardly anything about Pareja's or Monsignor Massimi's, and nothing about the so-called barber to the Pope. Yet, neither our understanding nor our enjoyment of any of these portraits hinges on any knowledge we may have, or lack, about the sitter. The character traits of each of them are expressive in themselves.

THE SPINNERS ('LAS HILANDERAS') also known as *'the Fable of Arachne'*.
Oil on canvas; 220 × 290 cm. (86 $\frac{1}{2}$ × 113 $\frac{1}{2}$ × in.) (including additions)
c. 1644-1648
Madrid, Prado (1173)
Originally the canvas measured approximately 167 × 250 cm
It was enlarged to its present proportions some time before 1772, when a broad strip was added to the upper edge, another somewhat irregular strip to the lower one and two narrower strips were added, one at each side. The painting was substantially restored (most probably in the eighteenth century) and today is in precarious condition.
Detail: *pages 144-145*

Royal portraits

Soon after his return to Madrid in 1651 Velásquez painted a portrait of the Infanta María Teresa, whom he had last portrayed some three years earlier (page 147). Only the head of this likeness of the Infanta has come down to us (page 154); she has developed the Habsburg lower lip; her left eye is more sharply almond-shaped, while the underlid of the right one still projects, and the convex line of her temple is somewhat more marked.

María Teresa was about ten years old when Velásquez painted her earliest extant portrait (page 147) and just a few months over fourteen when he painted the latest of those that have come down to us (page 155). The teenager's features were obviously changing under the eyes of the painter, who, between the sitting for one portrait and that for another, saw a somewhat different presence which he fashioned into a new pictorial likeness.

The case was similar, though not quite the same, with the portraits of Queen Mariana, who was just four years older than her blood cousin, María Teresa. Velásquez probably had a more challenging task with the Infanta Margarita, whom he portrayed from the time when she was a couple of years old up to when she was eight. If, while in Rome, he had enjoyed painting the Pope and members of the Papal Court, back in Madrid he obviously continued to delight in his work, as the Queen and the Infantas came to have their likenesses put on canvas by him.

A portrait of the *Infanta María Teresa* by Velásquez, together with a workshop replica of it, left Madrid on 22 February 1653 as presents from the Spanish King,

one for the Emperor Ferdinand III, in Vienna, and the other for the Duke Leopold Wilhelm, in Brussels. The original, now in Vienna, must consequently have been painted late in 1652 or early in 1653; unfortunately, it has been cut down, particularly at the bottom (page 155). Velásquez fashioned the likeness of the Infanta into the subtlest harmony of white, silver and pink against a greenish-blue background. Everything, the voluminous and richly decorated head-dress, the pleated tulle yoke, the bodice tight over the stiff corset and the ample farthingale on which ribbons and watches rest, is keyed to the tones of the Infanta's face. The make-up and costume were a Spanish fashion which French ladies of the time found hideous. In more recent times, Velásquez has been pitied for having to portray faces which looked so lifeless and cumbersome

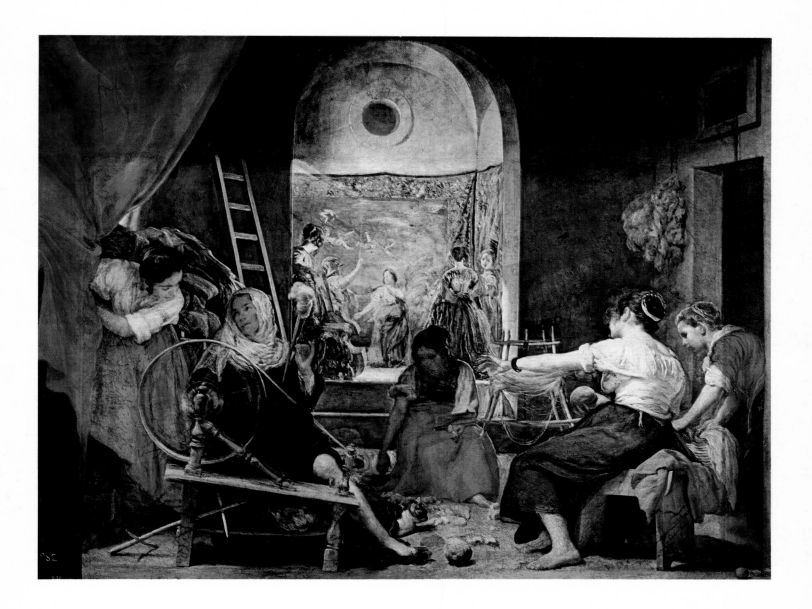

costumes which made the sitter's figure and pose quite unnatural. However, if the paintings themselves may be taken as evidence, it would rather seem that Velásquez enjoyed painting such portraits.

In the portrait of the *Infanta María Teresa* (page 155), he contrasted the artificial tones of her make-up to the natural pink and ivory hues of her broadly painted hands. Yet it is the face, rouged and pearly, that is the key to the whole composition. Lit by a silvery light, the Infanta stands against the greenish-blue of a cloth-covered table and background curtain. She is made into a vivid pictorial presence without putting the emphasis on the particulars of fashion, in a manner that Velásquez' imitators generally failed to achieve.

143

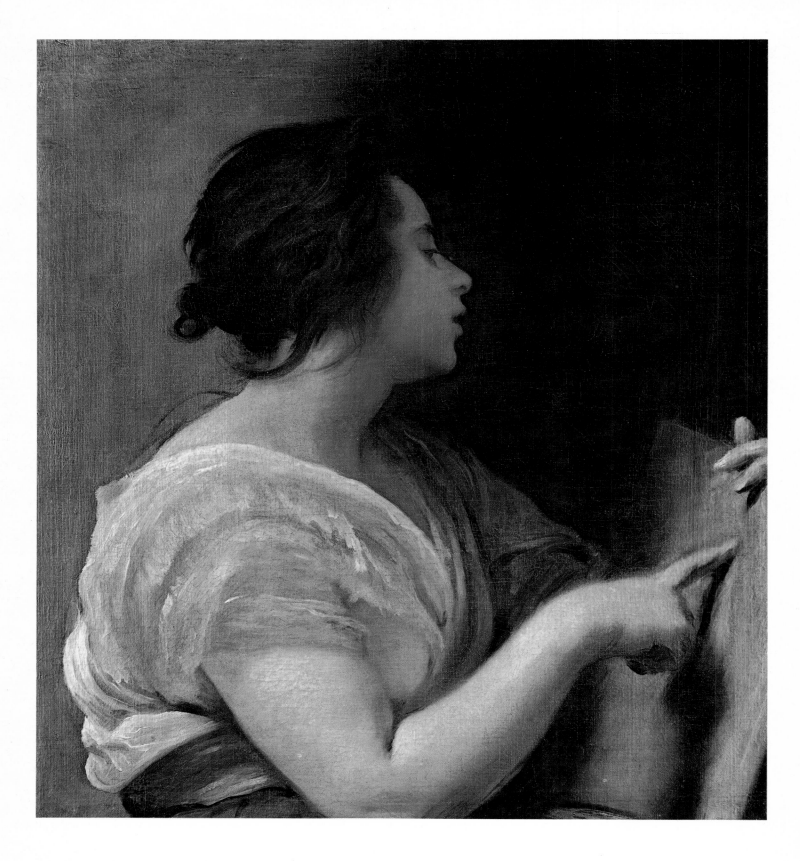

The *Infanta Margarita* does not look more than two years old in the earliest extant Velásquez portrait of her, datable to the middle of 1653 (page 162) which can be compared to the portrait of the sixteen-month-old Prince Baltasar Carlos, done more than twenty years earlier. Velásquez represented the Infanta standing on a dais covered by a rug. The Infanta's round face, rose and ivory, is framed by her flaxen hair. On her right there is what looks like a small table covered with a blue cloth, the folds of which occupy part of the foreground and blend, higher up, with the greenish-blue drapery which then opens into the background shadow. This background opening marks a fluid diagonal, continued by the tablecloth, which runs across the composition setting off the

ARACHNE
Oil on canvas; 64 × 58 cm.
(25 $\frac{1}{4}$ × 23 in.)
c. 1644-1648
Dallas (Texas), The Meadows
Museum at Southern
Methodist University (74.1)

146

figure of the Infanta, dressed in a pink and silver costume decorated with black lace. She stands against the greenish blue curtain and the dusky tints of the background, her right hand resting on the blue tablecloth on which lies a white rose by a crystal vase containing other flowers.

In this portrait, Margarita's neck is short and her chin round, which probably corresponded to her true appearance. However, in Velásquez' later portraits of her, shadow and light is used to elongate the neck and make her jaw look somewhat more pointed, though in none does the chin have quite the same shape as in the others nor, for that matter, have the eyes.

Late in 1652 or early in 1653 Velásquez completed his first portrait of the nineteen-year-old *Queen Mariana* (pages 159, 160-161). She is seen full-length, wearing a silver-braided black costume decorated with gold chains and a large gold brooch pinned to the stiff bodice. Her pose is almost identical to that of María Teresa, her right hand resting on the back of a chair. The sense of depth is stressed by the shadow of the farthingale in the foreground; moreover the golden yellows of the clock in the background echo the similar colour of the jewels on the Queen's costume and headdress, making all the more vivid the depiction of aerial space.

This portrait of *Queen Mariana*, with her rouged face looking rather small under a heavy headdress, encased in a tight bodice, and the rest of her figure, including her feet, lost to the eye in the stiff fullness of the farthingale, has led to suggestions that the fashion of his time resulted in some sort of handicap for Velásquez who, nevertheless, did his best to do justice to the splendid attire of his royal sitter.

If a parallel between Velásquez' painting and the literature of his day were permissible, without implying its being either necessary or conclusive, I would suggest that his vivid depiction of his sitters' artificial flesh tones as such, and the image of both human likeness and sheer pictorial presence that he thus creates simultaneously, bring to mind the play-within-the-play which, on the stage of the period intensified, again simultaneously, both the true-to-life and the theatrical nature of the action being played.

It cannot be over-emphasized, however, that such parallels between literature and other arts, helpful as they are for setting our understanding of an artist, or just one work, within the context of the time, ought not to be understood as proving, or even suggesting, influence of one art on the other. Nor are they to be taken as evidence of the existence of a preordained, or otherwise fixed, plan to which artists of the same period worked. They are no more than coincidences helpful for describing rather than circumscribing the current of creative life at a given point of historial time.

As Philip, newly married but with no male heir, seemed to be bringing to a close the days of his dynasty in Spain, other European Courts eyed with worry, hope, or impatience the immediate future of the Spanish throne. As a result, many requests were made for portraits of Philip, by then rather infirm, his young Queen, his marriageable daughter, and the little Infanta who had disappointed the Spaniards' hope for a male heir to the throne. Hence the sizeable number of portraits of the sovereigns and the two Infantas which have come down to us.

Except for the image of the King, reflected, together with that of the Queen, in a mirror in the background of *Las Meninas* finished in 1656 (pages 165, 166, 168-169), there is extant only one likeness of Philip IV painted by Velásquez in the 1650's.

Though Philip was by then rather infirm in appearance, Velásquez portrayed him unmarred by age or illness (page 157). The light which, as in earlier portraits by Velásquez bathes the face of the King, elongates his well-turned neck, and only the thinnest of shadows are used to model the features. The costume, a black doublet and cloak, is just roughed in with bold strokes and subtle highlights which impart a statuesque fullness to the bust.

This portrait is the only extant one of Philip IV undisputedly held to have been painted by Velásquez after his return from Italy in 1651. From then on he allowed other painters, including his assistants, to paint somewhat different versions of it. All these versions have in common that they represent Philip with

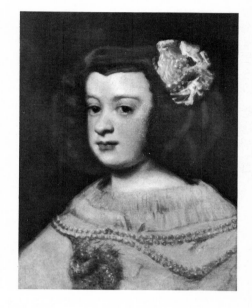

INFANTA MARIA TERESA
Oil on canvas; 48 × 37 cm.
(19 × 14 ½ in.)
1648
New York, Metropolitan Museum of Art, The Robert Lehman Collection
Daughter of Philip IV and Isabella de Bourbon, Infant a Maria Teresa was born in 1638 and died in 1683. In 1660 she married Louis XIV of France.

a double chin, which makes his neck look short and contributes to his ageing appearance.

Doubtless the likeness of the ageing Philip corresponded to the truth of his appearance more closely than that painted by Velásquez. The large number of such portraits which have come down to us indicates that the likeness they embodied was the one preferred by those familiar with the appearance of Philip. It might even be that Philip himself, who was by then self-critical and well aware of his shortcomings as King, also preferred the portraits in which the flaws of his appearance were depicted.

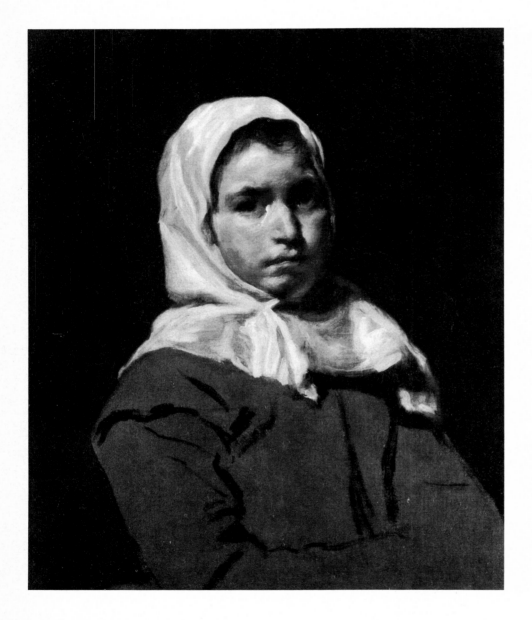

GIRL
Oil on canvas; 60 × 46.5 cm. (23 ¾ × 18 ½ in.)
1645-1650
New York, Private Collection.
Unfinished.

JUAN DE PAREJA
Oil on canvas; 81.3 × 69.9 cm. (32 ¼ × 27 ½ in.)
1649 or 1650
New York, Metropolitan Museum of Art (1971.86)
Juan de Pareja (1610-1670) joined Velásquez' workshop on an unspecified date, but certainly after 1630.

Mazo, Velásquez' chief follower

There is reason to believe that Mazo was the painter in Velásquez' circle who, in the 1650s, originated the version of the bust-length portrait of Philip IV in which, contrary to Velásquez original, the sitter's natural characteristics are accented. A bust-length portrait of the ageing King hangs prominently on the wall of Mazo's *The Family of the Artist*, in Vienna (page 164). In this group portrait, a painter is seen working, though not from life, on a portrait of the Infanta Margarita, which resembles, even to the green of the dress, a copy, now in the Budapest, of the portrait that Velásquez painted of her in 1659.

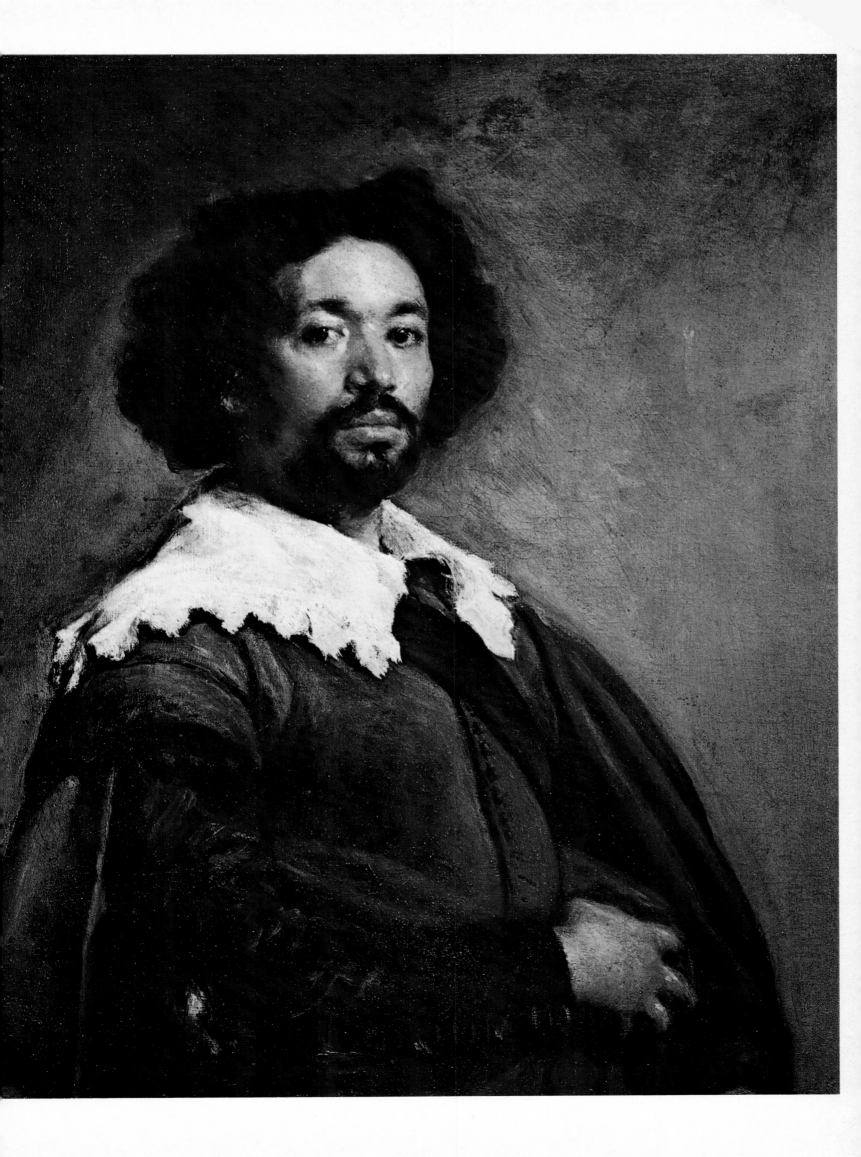

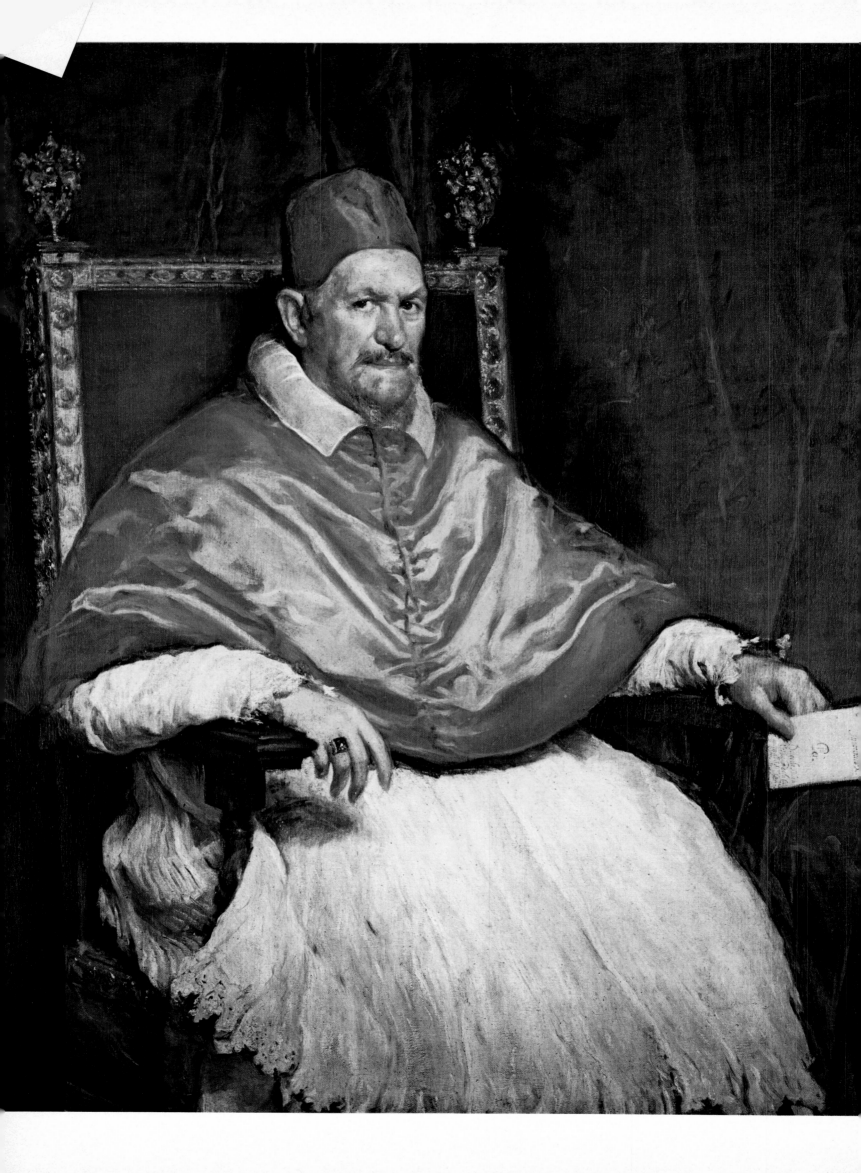

POPE INNOCENT X
Oil on canvas; 140 × 120 cm. (55¼ ×
47¼ in.)
1650
Rome, Galleria Doria Pamphilj
The sheet of paper in the Pope's hands
bears the words: *'Alla Santa di Nro Sigre
Innocencio Xo per Diego de Silva
Velázquez dela Camera di s. Mat Catta'*

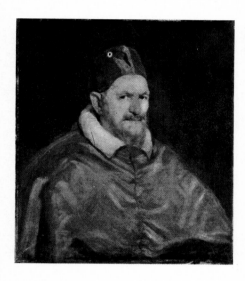

POPE INNOCENT X
Oil on canvas; 78 × 68 cm.
(30¾ × 27 in.)
1650
London, Wellington Museum, Apsley
House (1590)
The head is certainly painted by
Velásquez, but the garments and the
background are by another hand. Copy
of the painting on the previous page.

Right:
PORTRAIT OF A MAN
(known as 'the Pope's barber')
Oil on canvas; 48.3 × 44.4 cm. (19¼ ×
17½ in.)
1650
New York, Private collection

The coat of arms in the upper left-hand corner displays a mallet (*mazo*) hel
a hand in armour. This clearly indicates that the women, young men and
children who occupy the foreground are Mazo's family and that he is the painter
seen at work in the background. It has been suggested that the room represented
is the same depicted in *The Fable of Arachne*, seen from another angle. It
should be added that the bust of a woman seen below the portrait of the King
seems to be one in marble, from the second century A.D., then at the Royal
Palace, where Mazo had his workshop after Velásquez' death.

The portrait of the King in the background of *The Family of the Artist*
corresponds quite closely in appearance, proportions and modelling to the
likeness of the ageing Philip in the National Gallery, London. Hence, it would

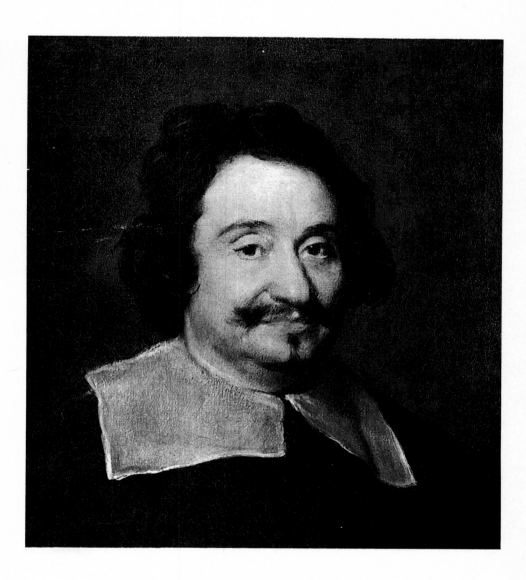

seem that it was Mazo who originated the variant of Velásquez' portrait of *Philip
IV*, of which the London picture is the finest though not necessarily the earliest
example, that gained acceptance in the mid-1650s. If so, it may be that his
success prompted him to display that likeness of the King in the picture of his
own workshop, probably after Velásquez' death, when he became Court
painter. In that capacity, he went on painting portraits of the King and of the
Infanta Margarita until the mid-1660's when both he and Philip IV died.

While contemporary writers on art, as well as administrative documents of the
time, including petitions to the King signed by Mazo himself, often refer to him
as Velásquez' son-in-law, none mentions him as his pupil, and there is, indeed,
no indication that he was, before his marriage, in that or any other professional
capacity in the Master's workshop. Nor is there any evidence that he later

151

formally became an assistant to Velásquez, a position which would hardly have been helpful for his advancement at the Court. At the same time, it is true that he came closer than any other painter to Velásquez' manner, though not so close as the misattributions of works of one to the other has led one to believe. As his contemporaries noted and his signed or fully documented works plainly show, Mazo had a personality of his own, however much he, in fact, owed to Velásquez.

Jusepe Martínez (1601-82), a friend of Velásquez, praised Mazo for his mastery in painting small figures, certainly a cardinal compositional element in both his hunting pictures and city views, such as that of *Saragossa* (page 167), which Martínez, a native and resident of the city, most likely saw in 1646 when Mazo was at work on it. In 1657, Lázaro Díez del Valle, an enthusiastic admirer of

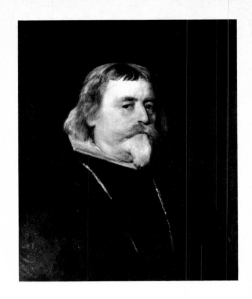

KNIGHT OF THE ORDER OF SAINT JOHN
Oil on canvas; 66.5 × 56 cm. (26¼ × 22¼ in.)
End of the decade 1640-1650
Dresden, Staatliche Kuntsammlugen, Gemäldegalerie (698)

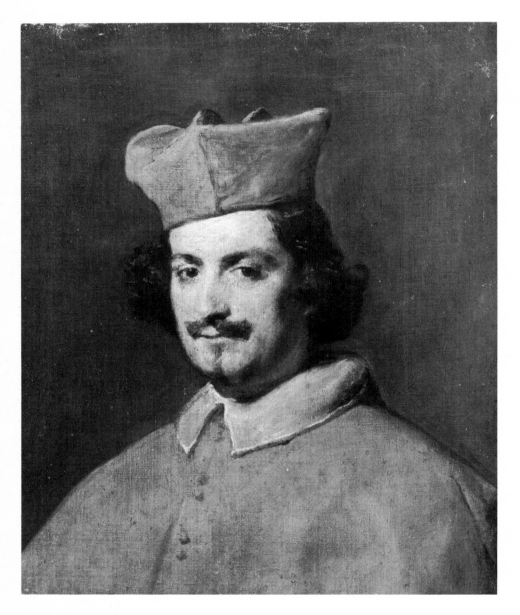

CARDINAL ASTALLI
Oil on canvas; 61 × 48.5 cm. (24¼ × 19¼ in.)
1650 or 1651
New York, The Hispanic Society of America (A 101)
The Cardinal was born in 1616 or 1619 and died in 1662 or 1663.

Velásquez, wrote that Mazo painted admirable hunting subjects and views of cities, among which he cited that of Saragossa, executed at Philip IV's command. Díez del Valle also praised Mazo for his portraits of Philip IV and Queen Mariana.

Mazo's palette is similar to Velásquez', except for a penchant that he often shows for stressing blue or bluish tints. Of greater import as a departure from Velásquez style is Mazo's way of shaping men and objects by the use of highlights which 'flash' the pictorial image, as it were, toward the surface of the painting, even from the background. As a counterbalance, an explicit, even emphatic, perspective design marks out the spatial confines of the composition.

A further departure from Velásquez is Mazo's luxuriant depiction of detail or incident, which he achieves with brilliant, light strokes, whether used in the figure of a sitter, a curtain, a wall, a floor, or the surface of a river. These stylistic traits ought not to be understood merely in a negative sense, as failures to be Velásquez-like; they reveal Mazo's own personality. Such traits are, indeed, as manifest in *The View of Saragossa*, of 1647, as in the portrait of *Queen Mariana*, of 1666, to cite his earliest and latest extant dated works. They are manifest, too, in the portrait of *Infanta Margarita*, most likely painted about 1664-65, where the background curtains build the space behind the glimmering figure of the Infanta as if they were stage flats, which is quite unlike Velásquez, as comparison with his portrait of *Queen Mariana*, of about 1652-53, also at the Prado, makes evident.

MONSIGNOR CAMILLO MASSIMI
Oil on canvas; 73.6 × 58.5 cm. (29 ¼ × 23 ¼ in.)
1650
Wimborne (Dorset), Kingston Lacy, Ralph Bankes collection (87)
Camillo Massimi (1620-1677) was Treasurer to Pope Innocent X.

In 1666, following the death of Philip IV, Mazo began an inventory of the paintings at the Madrid Royal Palace, in which he described a large painting 'portraying' the Infanta Margarita with 'her ladies-in-waiting and a female dwarf, by the hand of Velásquez'. Nothing else is known from any other of Velásquez' contemporaries concerning the title, subject or significance of the painting. The inventories of the Royal Palace of 1686 and 1700 noted that in this work Velásquez had 'portrayed himself painting'. Later it was described as *The Family of Philip IV*, and from 1843 on it has commonly been known as *Las Meninas*, yet *Velásquez and the Royal Family* seems preferable as a somewhat

more matter-of-fact title (pages 165, 166, 168-169).

According to Palomino, who was well informed about Velásquez' last decade, this masterpiece 'was finished' in 1656, and, while Velásquez was painting it, the King, the Queen, and the Infantas María Teresa and Margarita often came to watch him at work. Palomino's account of this work is quite detailed, and the truth of it has been verified by documentary evidence in most respects. He identified by name and occupation nearly every person, and even the room, represented in the large group-portrait. The location is the main chamber of the apartment which Prince Baltasar Carlos had occupied in the Royal Palace up to

his death, in 1646. Some time later, Velásquez was allowed to use the apartment. In 1660, when he died, he had his workshop there and a sort of office for his activities as Chamberlain of the Palace, which involved a great deal of paperwork.

Mazo, painter to the late Baltasar Carlos, had executed the forty paintings which decorated the main chamber of the Prince's apartment; thirty-five of them were copies after Rubens or other Flemish painters, and only five, small canvases representing a wild boar and some dogs, were original. The forty paintings were inventoried there again, in exactly the same order, in 1686 and 1700.

In *Las Meninas*, Velásquez himself is seen at the easel; a mirror in a black frame on the rear wall reflects the half-length figures of Philip IV and Queen Mariana under a red curtain. The Infanta Margarita is in the centre attended by two

Left:
INFANTA MARIA TERESA
Oil on canvas: 44.4 × 40 cm.
(17½ × 16 in.)
1651-1652
New York, Metropolitan Museum of Art
Fragment of a portrait, with additions on all four sides.

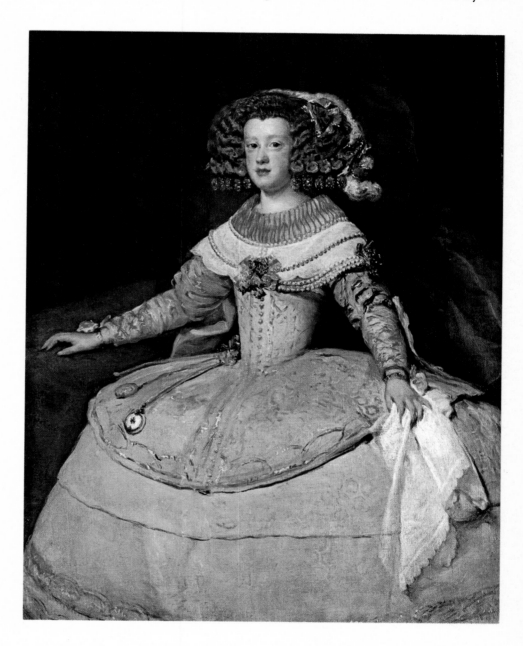

INFANTA MARIA TERESA
Oil on canvas; 127 × 98.5 cm. (50 × 38½ in.)
End of 1652 or beginning of 1653
Vienna, Kunsthistorisches Museum, Gemäldegalerie (353)

meninas, or ladies-in-waiting, who curtsy as one of them offers her mistress a drink of water in a *búcaro*, a reddish earthenware vessel, on a tray. In the right foreground stand a female dwarf, Mari-Bárbola, and a midget, Nicolás de Pertusato, who playfully puts his foot on the back of the mastiff lying on the floor. Linked to this large group there is another formed by a female attendant to the ladies-in-waiting and a male escort. In the background, the Palace marshal to the Queen, Don José Nieto Velásquez, stands on the steps leading into the room from the lit-up doorway.

Philip IV had married the new Queen in 1649, and the Infanta Margarita, born

on 12 July 1651, was then their only child; her apparent age in the painting confirms that this could not have been executed substantially earlier or later than 1656. Palomino explained that the red cross of the Order of Santiago on Velásquez' doublet had been added by the command of Philip IV after the painter's death. In fact, Velásquez did not become a knight of Santiago until 28 November 1659.

There is another portrait of the *Infanta Margarita* by Velásquez that most probably was also painted in 1656 (page 163). She is wearing a white dress decorated with red rosettes and black lace and is standing on a rug, against a reddish ochre background, enlivened by a red curtain.

Palomino called attention to the pictures decorating the walls of the room in Velásquez' composition, the 'gallery' in Prince Baltasar Carlos' apartment, and said that one could see, if only dimly, that they were subjects from Ovid's *Metamorphoses* painted by Rubens. He obviously had in mind the two pictures hanging high on the rear wall, over the mirror, the only ones whose subjects, *Pallas and Arachne* and *Apollo and Pan*, are recognizable. Mazo's copies of Rubens' *Pallas and Arachne* and of Jordaen's *Apollo and Pan*, after a Rubens' sketch, actually hung side by side on one of the walls of the chamber represented by Velásquez, as is recorded in the royal inventories of 1686 and 1700.

In 1855, Stirling, wrote in praise of *Las Meninas*: 'Velásquez seems to have anticipated the discovery of Daguerre, and taking a real room and real chance-grouped people, to have fixed them, as it were, by magic, for all time on canvas'. A quarter of a century later, Justi further explained that Velásquez' grouping of the figures of the Infanta and her attendants 'would be inexplicable' as the painter's own 'invention' and that it must consequently have been brought about 'by chance', at the sight of an actual event. Beruete rather thought that 'Velásquez, a realist by temperament and education, surpassed himself in this work, to such a degree' that the viewer 'may believe himself to be actively present at the scene' depicted.

Lately, there has been a tendency to consider Velásquez' composition as mainly allegorical. Diverse readings of the painting have been suggested, based on one or other of the various allegorical or emblematic interpretations to which either portraits of objects included in the composition lend themselves; major differences of interpretation concern the two mythological pictures dimly depicted in the background, both of which, as we know, did actually hang side by side on a wall of the chamber which Velásquez represented in the painting. Few will, I believe, nowadays regard the painter of this masterpiece as a precursor of Daguerre. This is not to imply that Velásquez, who had painted *The Fable of Arachne*, was unaware of, or indifferent to, the various allegorical meanings, notably those bearing on the arts, of the two picture over the mirror on whose surface he chose to portray the King and the Queen as refected images. He was doubtless as aware of the current interpretations of the two mythological subjects as he was also of the concept that the painter's true-to-life achievements emulated the images reflected in a mirror. Yet, it would be inconsequential to reduce the significance of this masterpiece to an illustration of these ideas, which constituted a small part of current thought.

Van Eyck's portrait of *Arnolfini and his Wife*, of 1434, where the images of persons not otherwise included in the composition are reflected in a background mirror, was in the Spanish royal collection in Velásquez' time. There can be no doubt that Velásquez knew it well, and hence he might have had it in mind during the composition of the group portrait. Nor can there be any doubt that the composition which he achieved is essentially different from Van Eyck's, where the convex mirror on the rear wall reflects, not only the two men coming in through a door at the opposite end of the room, but also, and equally distinctly, the other three walls and the back view of the two sitters, none of whom is related by action or gesture to the space lying beyond of the picture frame. Grouped together, indeed, they centre about themselves the space of the interior, which the reflection in the mirror makes the more definite. This has little in common with Velásquez' composition. The closest and most meaningful antecedent to which is to be found within his own *oeuvre*, in *Christ in the*

PHILIP IV
Oil on canvas; 69 × 56 cm. (27 $\frac{1}{4}$ × 22 in.)
1652-1653
Madrid, Prado (1185)

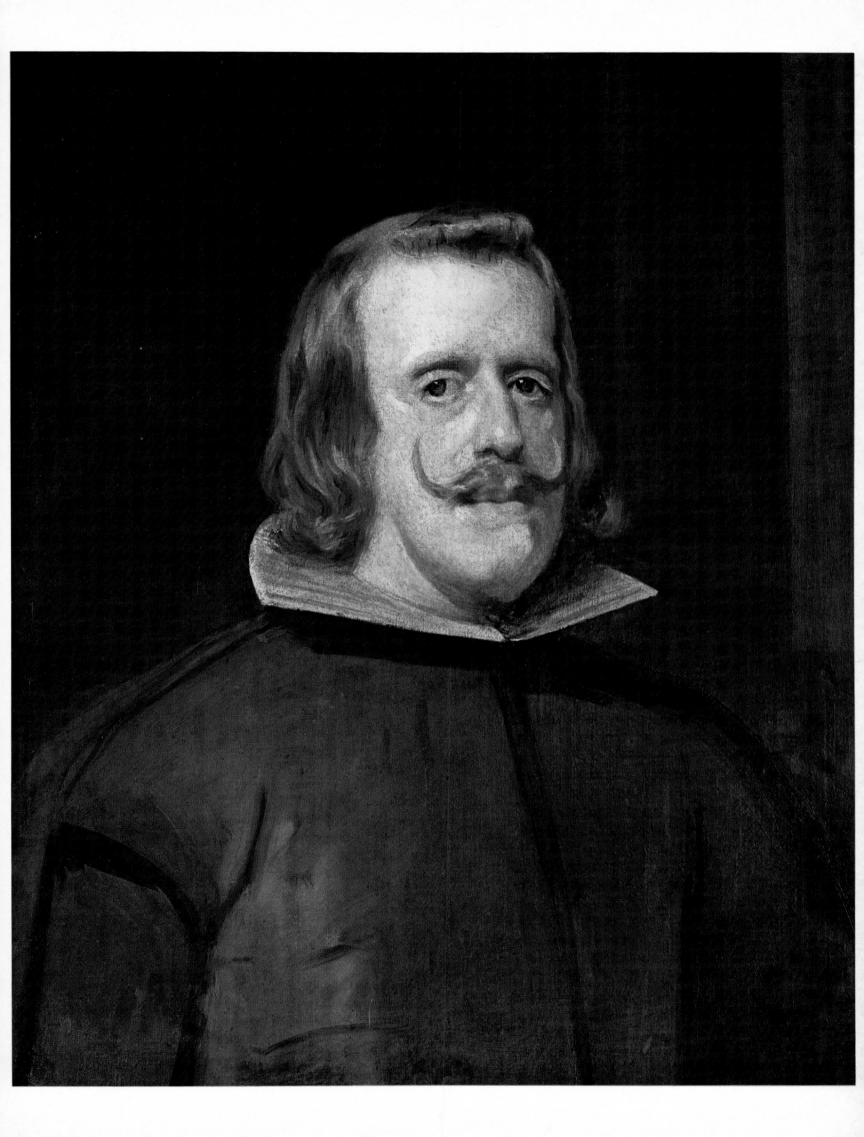

House of Martha and Mary, painted almost forty years earlier, in Seville, before he could have seen the Arnolfini portrait at Madrid.

X-rays made in 1960 show that Velásquez introduced several changes during the process of composition which, as we know, was often one with that of execution. He made slight changes to most of the figures, and altered his own pose. He had sketched himself at first with his head bent to his right rather than to his left as he appears in the painting; there is no indication, however, that he depicted himself at any time looking at the Infanta or at any other of the figures in the group behind which he stands.

The composition that Velásquez represented himself putting on canvas is not shown. It has sometimes been suggested that he represented himself portraying the Infanta Margarita, who is being offered a drink of water. Given the large size of the canvas on which he is seen working, it could be taken that he is painting the very composition which he put before the viewer's eyes, including the portraits of the royal persons and their attendants, and his own likeness. Neither suggestion takes into account the fact that in the painting Velásquez stands behind the Infanta and the *menina* who brings her a drink of water, looking at neither. Moreover, he has his back to the wall which in the painting is depicted in full view.

More plausible, though not conclusive, is the prevailing belief that Velásquez represented himself in the act of portraying Philip IV and Queen Mariana, whose half-length figures are reflected in the rear mirror. Yet, there is validity to the objection that the canvas is too large even for a double portrait of the King and the Queen; moreover, there is no record that Velásquez ever painted a double portrait of the King and the Queen, except, of course, the one which appears in this composition as a reflection in the mirror.

Whatever subject, if any, Velásquez had in mind for the painting that he portrayed himself working on, the significant fact is that he chose not to show it. The images of the King and Queen reflected in the mirror on the rear wall are undisturbed by the reflection of anything else. These reflected images unequivocally suggest the presence of the King and the Queen in the depicted chamber, though in the space lying outside the picture plane. The Infanta, one of her *meninas*, the girl dwarf, the courtier in the rear doorway, and Velásquez himself are looking, each from a different point, into this outlying space, obviously at the sovereigns. The viewer's attention is thus directed to the very edge of the luminous foreground and to the highlit, half-length images of the King and the Queen reflected in the background. Again a painting, apparently reality, within the painting. Thus, an interplay of variable distances to and from an outer focal point is established, which spans, and hence underlines, the chasm between the realm of painting and that of reality.

Velásquez has built a vast perspective setting where contrasts of light and shadow, roughed-out shapes and vivacities of touch heighten his depiction of the surroundings. He has portrayed himself, the brush in his right hand, a palette and a mahlstick in the other, with the key of his office of Chamberlain at his belt, at work on a canvas. His face and hands are lit as he stands in the area of shadow which fills most of the composition.

If the painting that Velásquez is working on is not shown, the back of the canvas is depicted in detail, the stark structure of the stretcher and easel and the coarse texture of the canvas, its uneven edge lit up along the upright strut, is sharply rendered. As somewhat of a contrast, the painter's right hand is luminously modelled, the fingers tapering to the point where they hold the slender brush, unerringly shaped by strokes of light. The pose of the hand as he holds the brush in readiness between the palette and the canvas is coupled with the thoughtful expression on his face. The face of Infanta appears elongated by thin shadows and by luminous strokes which make her hair and body almost translucent, an image which Velásquez never repeated.

The composition has three points of focus: the figure of the Infanta Margarita is the brightest, the portrait of Velásquez himself is another; and the third is provided by the half-length images of the King and the Queen in the mirror on the rear wall.

QUEEN MARIANA
Oil on canvas; 231 × 131 cm. ($91\frac{1}{4}$ × $51\frac{3}{4}$ in.) (including an addition along the top edge)
1652-1653
Madrid, Prado (1191)
Queen Mariana was the daughter of the Emperor Ferdinand III and the Infanta Maria, the sister of Philip IV. She was born in 1634 and died in 1696; in 1649 she married her uncle, Philip IV. The upper part of the curtain was painted by another hand on a piece of canvas added to the orginal composition.
Detail: *pages 160-161*

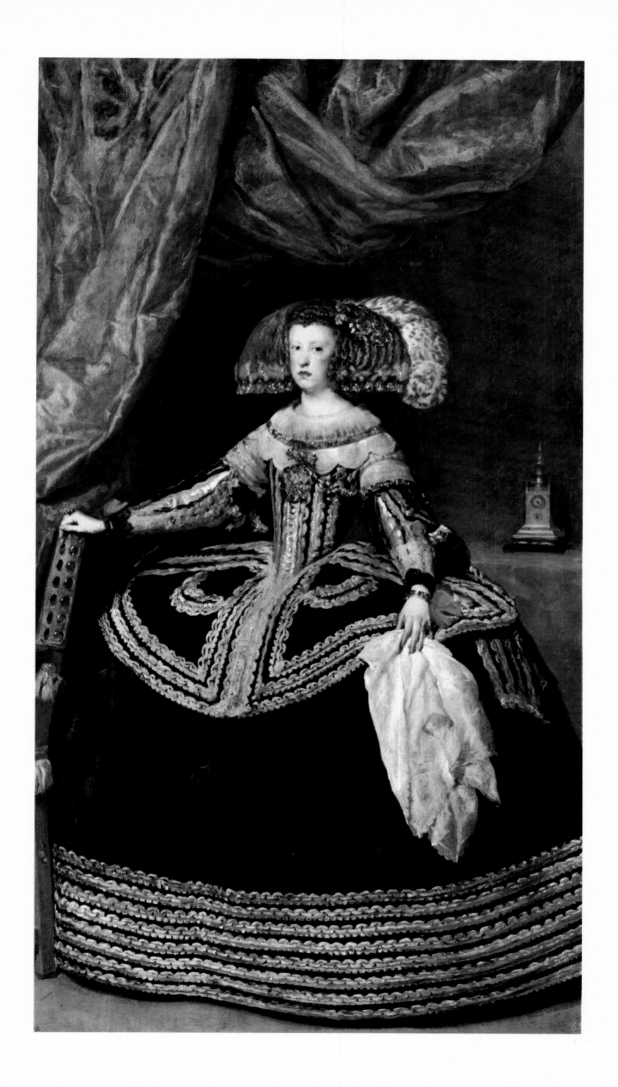

In no other painting has Velásquez rendered space in so architectural a manner as in this, the only work in which he has depicted a ceiling. There are, of course, spatial uncertainties which enhance the representational character of the work. The composition is built on diagonals, anchored, as it were, by the two diagonals which intersect at about the point where the Infanta stands, and encompass at one end the mirror in the background and the lit-up doorway, and at the other the expanse of light which fans out into the foreground to the very edge of the picture plane. The interlocking of these luminous areas is the more compelling as the middle distance is cut off by the shadows which spread across the floor. Yet, the depth of the room is stressed by the alternating window jambs and picture frames on the right-hand wall, the stretcher of the large

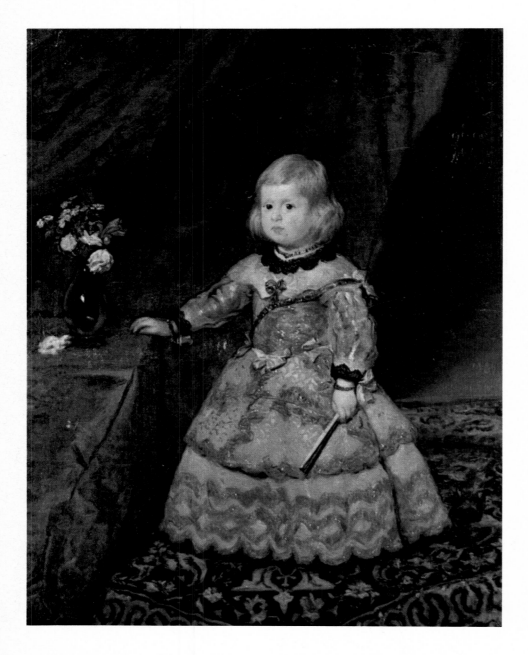

INFANTA MARGARITA
Oil on canvas; 128.5 × 100 cm. (50 $\frac{1}{2}$ × 39 $\frac{1}{2}$ in.)
1653
Vienna, Kunsthistorisches Museum, Gemäldegalerie (321)
Infanta Margarita, the daughter of Philip IV and Queen Mariana, was born in 1651 and died in 1673; in 1666 she married the Habsburg Emperor Leopold I.

Right:
INFANTA MARGARITA
Oil on canvas; 105 × 88 cm. (41 × 34 $\frac{1}{2}$ in.)
c. 1656
Vienna, Kunsthistorisches Museum, Gemäldegalerie (3691)

canvas in the left foreground, and the perspective sequence of the empty lamp hooks, which mark as central the spot in the rear wall where the King and the Queen are seen reflected in the mirror.

Nor is there any other composition which Velásquez tied so dynamically to areas which are out of the viewer's sight: the front of the canvas, where the viewer is compelled to imagine Velásquez' work taking shape, and the space lying outside the composition where the viewer imagines the presence of the King and the Queen.

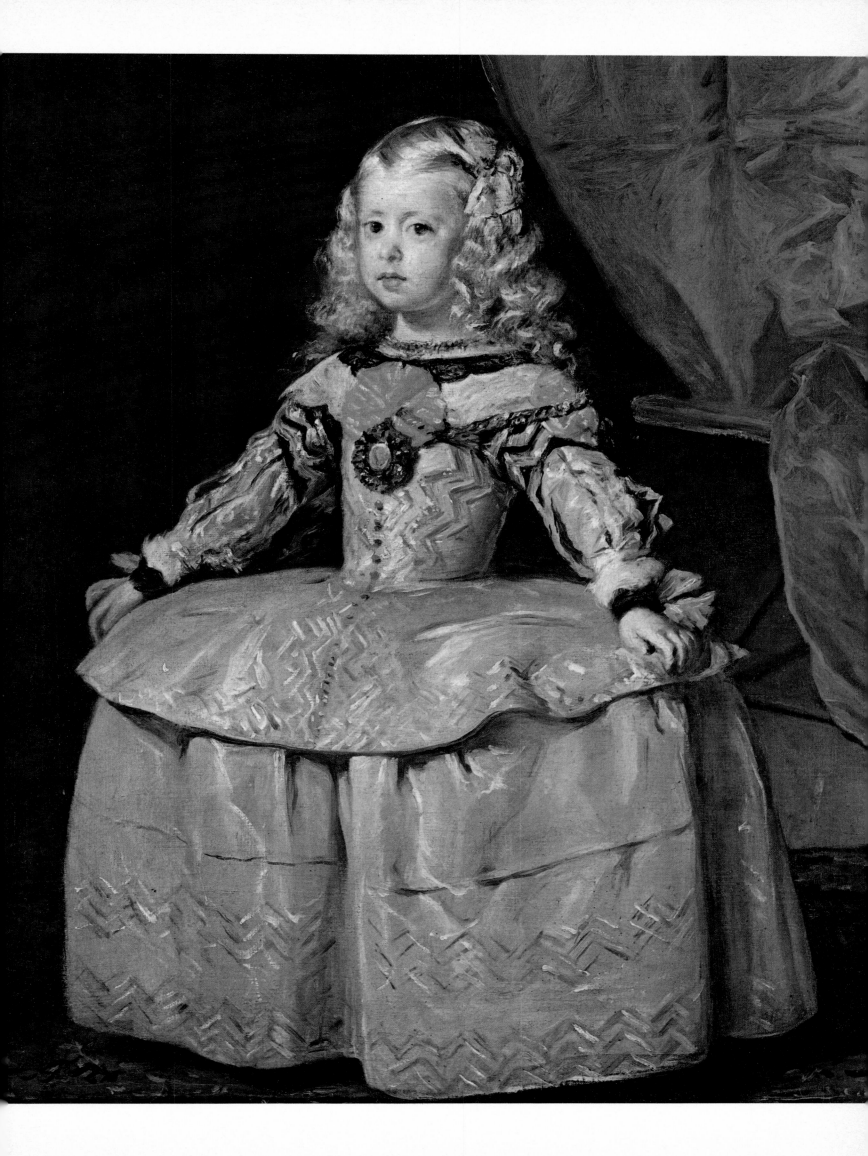

The vast ceiling, without decoration but for the two empty lamp hooks, under-
lines the bareness of the chamber, unfurnished and unadorned except for the
pictures and the mirror on the walls. This bareness, further emphasized by the
stark view of the upright canvas on which Velásquez is seen at work, sets off the
radiant and richly textured group of the Infanta and her entourage, and creates a
world in which ancient myths are dimly seen in the distance, and painted like-
nesses, more vivid than the reflections in a mirror, people, the room, and before
the large canvas which the painter stands brush in hand.
Little is known of the make-up of Velásquez' workshop either in Seville or
Madrid. It is plain that his pupils and assistants turned out a large number of
workshop replicas, copies or imitations of his works, notably his royal portraits.
In 1620 he signed up Diego Melgar as an apprentice for a period of six years, but

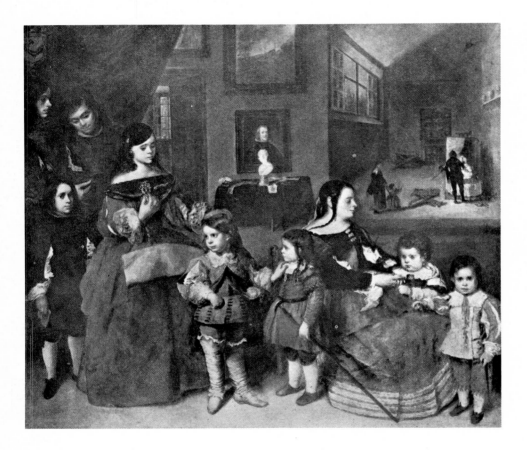

Juan Bautista Martinez del Mazo
THE ARTIST'S FAMILY
Oil on canvas; 148 × 174.5 cm. (58 $\frac{1}{2}$ ×
69 in.)
c. 1659-1660
Vienna, Kunsthistorisches Museum,
Gemäldegalerie (320)

there is no indication as to whether or not he went with Velásquez to Madrid.
No contemporary copy of any of the religious compositions painted by
Velásquez in Seville has ever been mentioned. However, there are extant
enough copies or replicas of his *bodegones* to conclude that, even as a young
artist, he had a substantial following, which must have included pupils and
assistants. In these copies one misses the fluid handling of light, shade and
colour by which Velásquez achieved his rendition of both texture and aerial
space. Instead, one finds a sharp contrast of light and shade which is more
Caravaggesque than Velásquez-like, that is, more in keeping with the
'modernism' which Velásquez had left behind as a young man, but which
remained ingrained in other painters of his day, including some of his followers.
Soon after his appointment as painter to the King, Velásquez was given the use
of a workshop in one of the buildings within the compound of the Royal Palace.
He was later allowed to use as a workshop some rooms of the apartment that
Prince Baltasar Carlos had occupied in the Royal Palace up to his death in 1646.
Most of Velásquez' pupils in Madrid were well born, like Don Diego de Lucena,
who probably entered the workshop in the mid-1620s, and later won admiration
for his portraits. Francisco de Burgos Mantilla, born about 1609, and quite
successful in Madrid in the late 1640s, had been a pupil of Velásquez, whose
manner he reportedly tried to imitate; yet his only extant work, signed and

LAS MENINAS (THE LADIES IN
WAITING)
Oil on canvas; 318 × 276 cm. (125 ×
118 $\frac{1}{2}$ in.)
1656
Madrid, Prado (1174)
Seriously damaged in the fire which
destroyed the Royal Palace in Madrid in
1734 and later restored. The canvas has
been cut down on both sides, particularly
on the right-hand side. The work has
been known as 'Las Meninas' since 1843.
Details: *pages 166, 168-169*

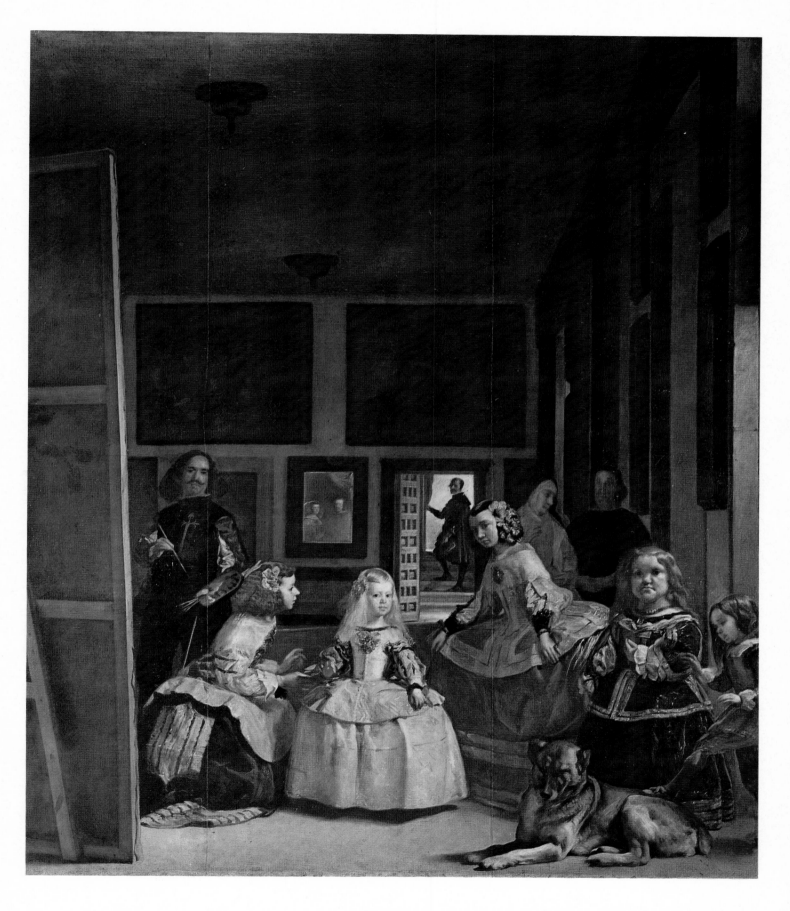

dated 1631, is a straight still-life, a genre at which Velásquez never tried his hand.

Don Nicolás de Villacis (1616-94) also studied with Velásquez soon after the latter's return from Italy, and where Villacis went afterwards; hardly anything is known about his work though a few paintings have been attributed to him. A Francisco de Palacios, who died at the age of thirty-six in 1676, is said to have been a pupil of Velásquez and to have distinguished himself also as a portrait

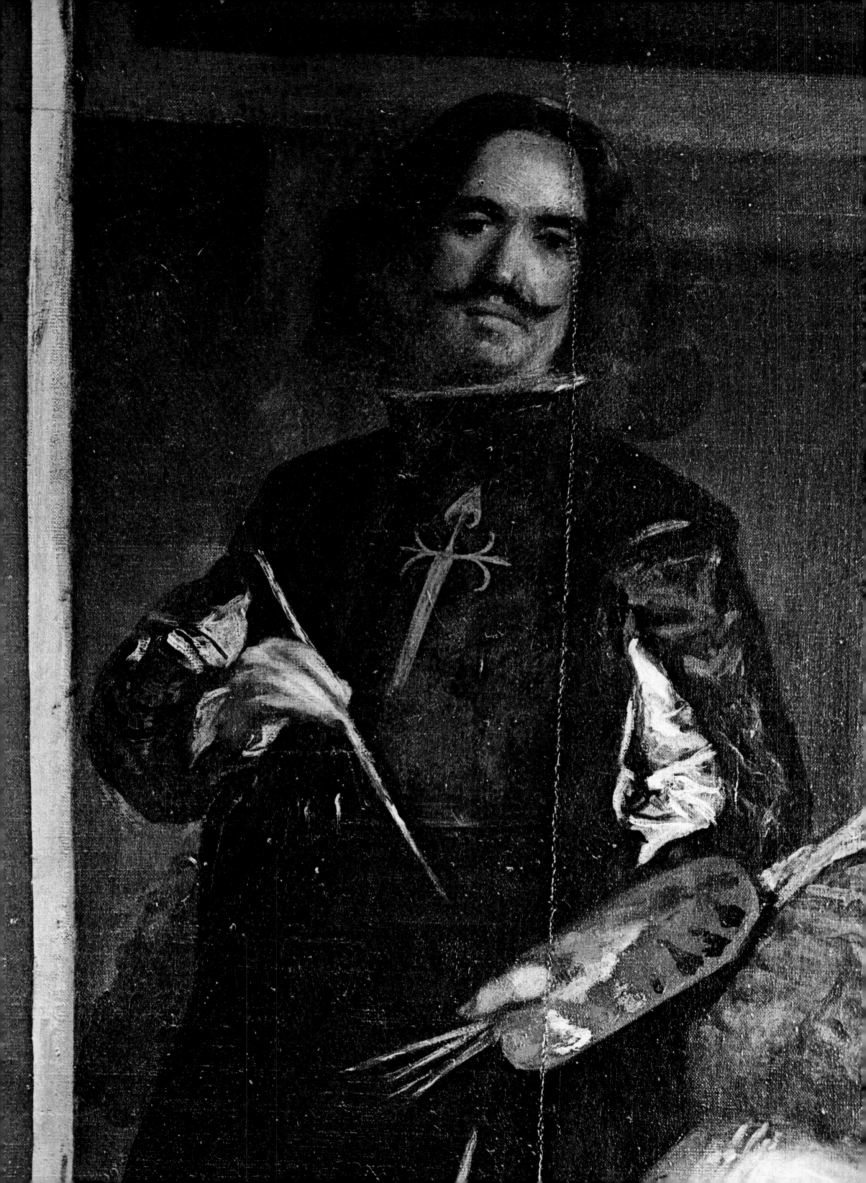

Juan Bautista Martinez del Mazo
VIEW OF SARAGOSSA
Oil on canvas; 181 × 331 cm. (71½ × 130¾ in.)
1647
Madrid, Prado (889)

LAS MENINAS
Facing page: detail
Self-portrait of the artist
Pages 168-169: detail of the Infanta Margarita with a lady in waiting

painter. However, no work is extant that could reasonably be ascribed to him. Most of the information that we have about Lucena, Villacis and Palacios was gathered by Antonio Palomino, a painter and writer on art who had been closely associated with Juan de Alfaro, another pupil of Velásquez. According to Palomino, Alfaro was allowed, because of his status as Velásquez' pupil, to make copies of the great masters' works, such as Titian's and Rubens', at the Royal Palace. He excelled particularly in copying Van Dyck, whose manner soon had a greater impact than Velásquez' on his works. Alfaro, however, remained an enthusiastic admirer of Velásquez, at whose death, in 1660, he composed, with the help of his brother, Dr. Enrique Vaca de Alfaro, a Latin epitaph which Palomino printed in his life of Velásquez.

Juan de Pareja (c. 1610-70) was Velásquez' assistant but not his pupil in any meaningful sense of the word. He was born, apparently of Moorish descent, in Seville, where by 1630 he was a professional painter. There is no indication of when he became an assistant to Velásquez, whom he accompanied in that capacity on his Italian journey of 1648-1651. His extant works show no more than a competent knowledge of the painter's craft. Probably Velásquez entrusted him mainly with menial tasks, such as grinding and mixing pigments, preparing varnishes, fixing canvases on stretchers and priming them.

One of Velásquez' duties was to make sure that his assistants or other painters, such as Mazo, kept up with the demand for replicas or copies of his portraits of members of the royal family, or for that matter of the Count-Duke Olivares, whose painter he also was. Copies of other portraits were commissioned by the sitters, their families or institutions with which they were associated. The copyists, of course, were not necessarily Velásquez' assistants, not even in the case of royal portraits, which were much in demand, particularly those of the King.

In the bust-length copy of his *Innocent X*, Velásquez painted little more than the sitter's head: the rest is plainly by another hand (page 151). Assistants sometimes completed a portrait begun by Velásquez. An instance of this is the three-quarter length portrait of *Queen Isabella*, sent to Vienna in 1632, in which the head is by Velásquez, while the lesser work of assistants is noticeable nearly everywhere else in the painting (page 80). Likewise, the portrait of *Prince Baltasar Carlos*, of about 1639, now also in Vienna only the head appears to be by Velásquez, though he may have sketched the whole composition (page 121).

Some assistants were obviously given a free hand to devise new compositions, which was readily achieved by borrowing compositional elements from other works. For example, the full-length of *Queen Isabella* sent to England late in 1639 reproduces the head of the portrait sent to Vienna in 1632, and includes details such as the barking dog and the somewhat disarranged rug, taken from *Joseph's Coat Brought to Jacob*, from which the device of the background view is also taken.

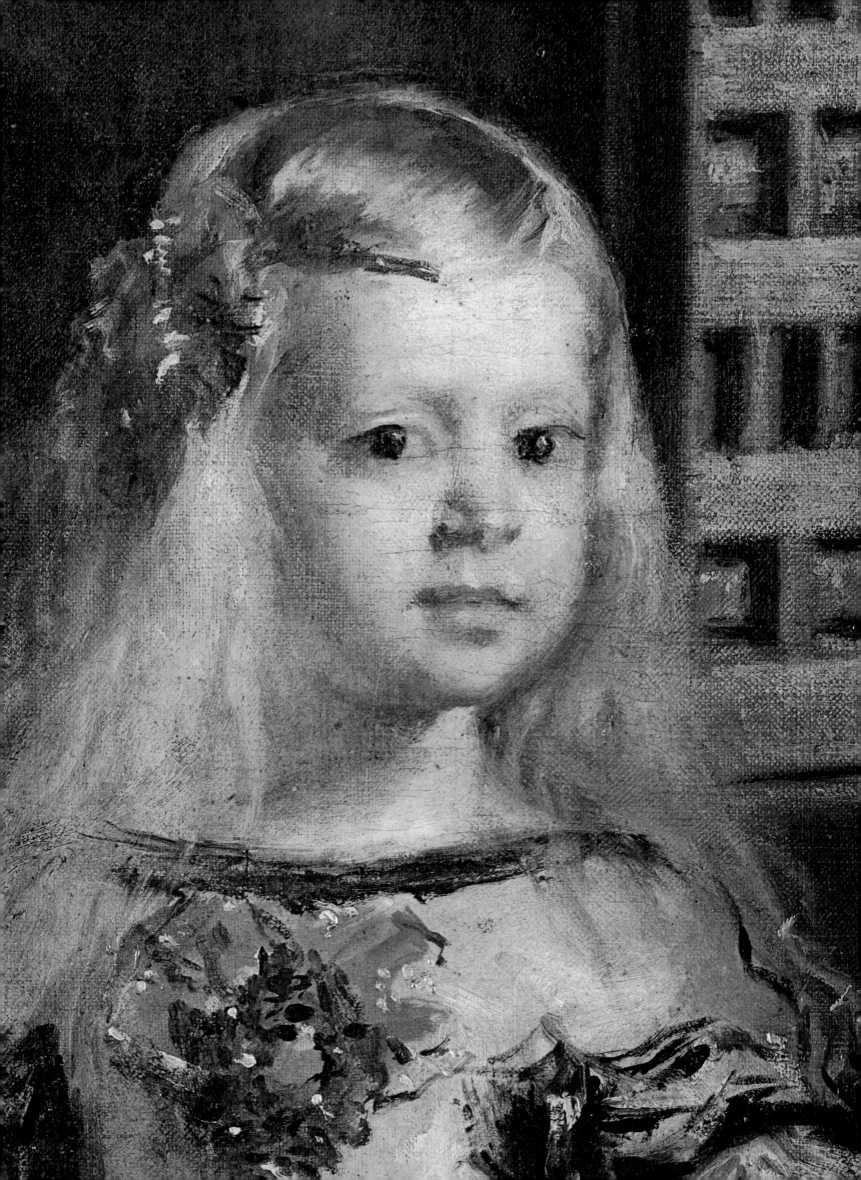

Admirers and imitators

Except for *The Triumph of Bacchus*, *Democritus* and *Supper at Emmaus*, all painted by Velásquez in Madrid before his departure for Italy in 1629, and the *Crucified Christ* which he most likely painted about 1632, after his return to Spain, there is extant no contemporary copy of his religious, mythological or historical compositions, not even by those of his pupils or followers, such as Alfaro or Mazo, whose practice it was to copy paintings by other masters in the royal collections.

Velásquez made many drawings from Michelangelo's and Raphael's frescoes at the Vatican in 1629-30. Yet, no deep or lasting impact of either Raphael's or Michelangelo's art is discernible in his works. As we know from his words and works, Titian was the painter whom he admired above all others; but this admiration did not lead to imitation. Velásquez never copied any of the Venetian master's works, with the exception of *The Rape of Europa*, then at the Royal Palace in Madrid, which he openly used, meaning it to be readily recognized as Titian's composition, in *The Fable of Arachne*.

It may be that Velásquez had come to realise during his first Italian journey that, contrary to Pacheco's views, copying did not help the creative intent, and in consequence he discouraged others from copying his works, except, of course, for his royal portraits, copies of which, with or without variations, had to be made in his workshop. It might also be that from the 1630s on Velásquez' large compositions appeared to other painters too overpowering to be imitated.

There is a painting by Velásquez, a life-size *White Horse*, which some of his followers appropriated for their works as if it had discovered, or abrogated, for them the live reality that it portrayed (page 89). It is probably one of the three

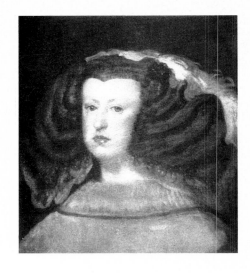

QUEEN MARIANA
Oil on canvas; 46.5 × 43 cm.
($18\frac{1}{2}$ × 17 in.) (including additions)
c. 1656-1557
Dallas (Texas), The Meadow Museum at Southern Methodist University (78.01)
Fragment of a painting, partially restored. Strips about 4.3 cm ($1\frac{3}{4}$ in.) wide have been added at the top and on the left-hand side; the one on the left takes in part of the figure's hair.

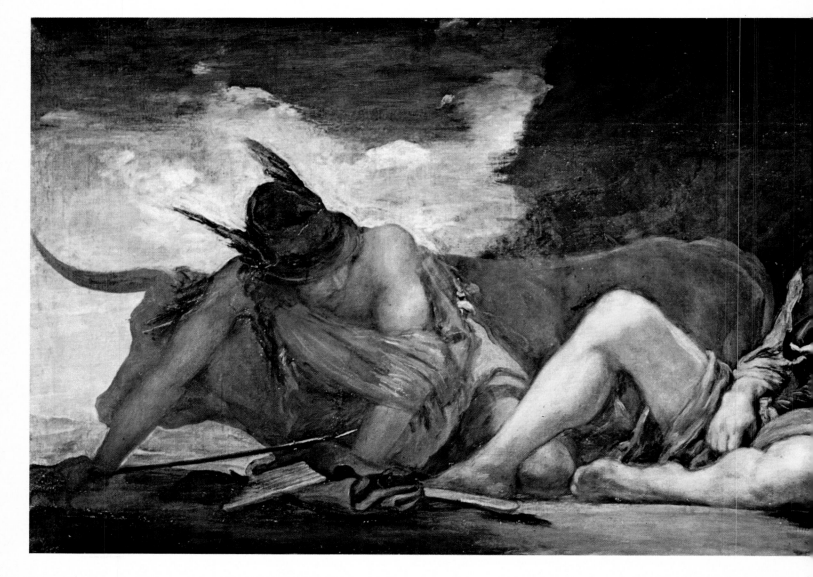

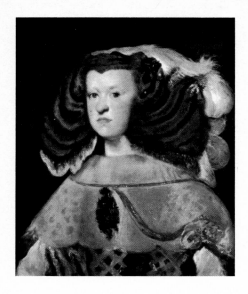

QUEEN MARIANA
Oil on canvas; 64.7 × 54.6 cm. (25 ½ ×
21 ¾ in.)
c. 1656-1657
Lugano-Castagnola, Baron Thyssen-
Bornemisza collection (435)
The neck and the left temple have been
slightly altered by light cleaning.

paintings of riderless horses, each of a different colour — the other two being grey or chestnut, which were in Velásquez' workshop at his death. The painting has suffered from cleaning and restoration, but the design that masterfully builds the shape of the horse into space remains alive. Apart from the colour, Velásquez' *White horse* is quite close in shape, pose and design to the chestnut mount in his equestrian portrait of the *Count-Duke Olivares*, painted around 1634-5 (pages 89, 90-91).

Mazo also included Velásquez' white horse, riderless, in *The Stag Hunt at Aranjuez*, in the Prado (page 88). It appears again, dappled brown and white, as the mount of the Duke of Feria in *The Taking of Brisach*, painted about 1634-5 by Jusepe Leonardo for the Great Hall of the Buen Retiro.

As we know, the impact of Velásquez' portrait of *Innocent X* (page 150) on Italian and Spanish painters of the time was intense. No fewer than thirteen copies, executed either after the original three-quarter length of after Velásquez' own bust-length replica, have come down to us. Some of them are, of course, copies of copies. This appears to be the case with the bust-length copy at the National Gallery of Art, Washington, D.C., in which, to mention only one telling difference, the eyes of Innocent X are brown with a little touch of grey rather than blue-grey as Velásquez painted them.

Pietro Martire Neri, who was close to Velásquez in 1650 in Rome, signed two copies of Velásquez portrait of *Innocent X*. In one of them, he enlarged the composition to a full-length double portrait of *Innocent X with a Prelate*.

From the mid-1620s until some time after Velásquez' death, Spanish portrait-painting was to a very large extent under his spell. It was as if he had forged afresh, for the benefit of his fellow painters, the reality of the individual. By comparison with Velásquez' originals, the extant portraits from his workshop or by his followers often seem garish, and almost invariably make the sitter look relatively small in a space which is either pictorially arid or too contrived. Naturally most of them are mediocre; a few, however, are executed with a sense of emulation, making use of brilliant accents which add weight to the naturalism of the pictorial image.

Velásquez must have been aware of the gap between his work and that of his gifted assistants or followers, especially evident in their replicas of his portraits of the King. He probably was also aware that the imitation and emulation of his works was an expression of the admiration felt for him.

MERCURY AND ARGUS
Oil on canvas; 127 × 250 cm. (50 ×
98 ½ in.)
c. 1659
Madrid, Prado (1175)
The original size was about 83.5 ×
250 cm (33 × 98 ½ in.) but at a date sometime before 1772, the height of the picture was increased by the addition of a broad strip along the upper edge and another narrower piece along the bottom edge.

INFANTA MARGARITA IN BLUE
Oil on canvas; 127 × 107 cm. (50 ×
42 $\frac{1}{8}$ in.)
1659
Vienna, Kunsthistorisches Museum
Gemäldegalerie (2130)
Damaged and restored in several areas,
including the face.

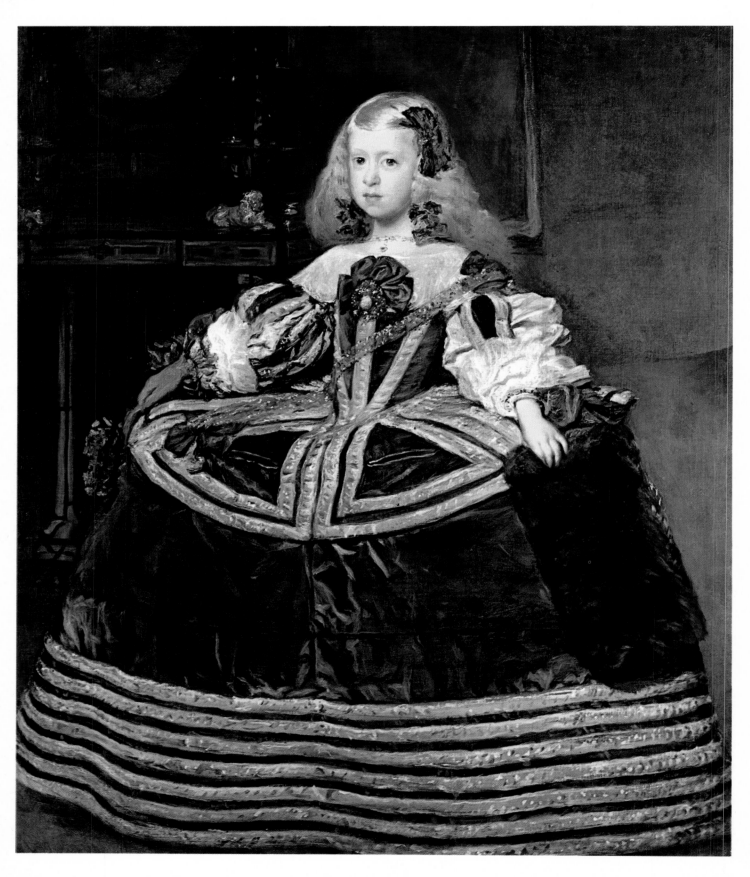

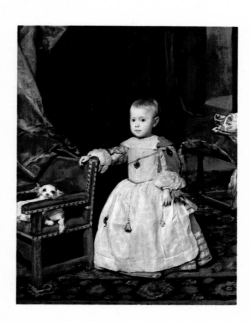

PRINCE FELIPE PROSPERO
Oil on canvas; 128.5 × 99.5 cm. (50 ½ ×
39 in.)
1659
Vienna, Kunsthistorisches Museum,
Gemäldegalerie (319)
The Prince, son of Philip IV and Queen
Mariana, was born in 1657 and died in
1661.
Detail: *pages 174-175*

Last works

Of the four mythological compositions painted by Velásquez about 1659 for the
'Room of Mirrors' only one was salvaged from the fire that gutted the Madrid
Royal Palace in 1734. Rescuers succeeded in cutting *Mercury and Argus* (page
170) out of its frame which like its lost companion piece, *Apollo Flaying
Marsyas*, hung in a narrow space above a large window, which explains the some-
what unusual proportions of the canvas, the height of which was originally one-
third of its width. Sometime between 1746 and 1772, narrow strips were added
at the bottom and the sides of the canvas, and a substantially larger one at the
top, with the result that the height, was increased by half to its present 127
centimetres.

For all the monumentality of the figures, and the depth and breadth of the
composition, Velásquez has once more stressed the denseness of the world of the
fable in *Mercury and Argus'* broad brushstrokes. As dark tones make both Argus
and Mercury almost featureless, the highlights on their bodies accent the
murderous treachery of the action depicted. Argus, in black and grey rags, is
weighed down by sleep in the shadow of the cave, as Mercury, dressed in red and
dull-yellow, steals in on his knee, while the earthen coloured Io, the heifer, is
quietly outlined against both the shadows of the cave and the distant cloudy sky.

In 1659, Philip commanded Velásquez to paint the portraits of Felipe Próspero
(pages 173, 174-175) and that of his sister, the Infanta Margarita (page 172), for
Emperor Leopold I, whom she was to marry years later. These two paintings, still
extant, and a lost miniature portrait of Queen Mariana, were, as far as it is
known, the last works painted by Velásquez.

Margarita was then eight years old, and Felipe Próspero about two. The portrait
of the *Infanta Margarita* was altered into an oval shape in the eighteenth
century. Though now skilfully restored, it lacks the sense of depth that it must
have had originally when the chariot of the Sun could be distinctly seen circling
around the numerals of the hours on the face of the huge clock in the back-
ground. For pervasive harmony of colour, this portrait still is an outstanding
work. Everything is linked to the Infanta's blue eyes and pearly face, faintly
rouged, and framed by the pale gold of her hair and necklace: the gold and
faded red of the hanging on the wall, the golden yellow of the *passementerie*
across her chest and of the gilt-bronze lions on the sideboard, the silver
trimmings on the blue velvet costume, harmonising with the tint that suffuses
her white collar, undersleeves, and cuffs.

As for *Prince Felipe Próspero*, Velásquez represented him wearing a silver-
banded rose dress under a transparent white pinafore against which a pomander,
to prevent infection, and several amulets to ward off the evil eye, are con-
spicuous. He looks scarcely older than the sixteen-month-old Baltasar Carlos was
when, twenty-eight years earlier, Velásquez portrayed him.

In that portrait of *Baltasar Carlos* (page 67), Velásquez included the figure of a
dwarf as a foil to the majestic hearing of the Prince. In the painting of Felipe
Próspero, a playful little dog, one which, according to Palomino, was very dear
to Velásquez, brings a note of warmth into the composition where the frail
figure of the Prince is seen against a looming space.

A rug marks out a rectangle on which the Prince stands by a short-legged
armchair set on the diagonal to the full-size stool behind him. He rests a hand
on the gold-braided armchair, where the dog is sitting and his silver and rose cap

lies casually on the silver-tasselled cushion, building up the height of the stool, a compositional device which emphasises the stature of the Prince without dwarfing him. The diagonal rhythm is furthered by the perspective relation between the illuminated drapery hanging from above in the foreground and the one in shadow near the half-lighted doorway at the rear.

The bloodless face of the blue-eyed Felipe Próspero is modelled with greyish tones, which also tinge the top of the white pinafore: the Prince looks all the paler as highlights silver his straw-coloured hair. The cheerless half-light coming from the distant doorway reveals a high floor line and accents the vertical lines of a wainscoted door against whose bottom panels the head of the Prince is silhouetted. Thus, the vastness of the chamber is stressed, and the shadowy space is made to loom over the child Prince, whose melancholy face and comely bearing are enhanced by the brilliancy and casualness of his surroundings. It is a somewhat dramatic portrait, painted with as much warmth as feeling, the first portrait in which Velásquez embodied a rather dismal sentiment. As it happened, it was one of his very last works.

As suggested in the preceding pages, Velásquez, like other great masters, was more a maker than a recorder of his epoch, and it is for this reason that the images that he brought into being live in the continuum of historical time, the ever widening present. Hence, it is not surprising that his truly great disciples are not of his day but Goya and Manet.

NOTES

1. Gabriel de Bocángel y Unzueta, Obras de ..., edited by R Benítez Claros, Madrid 1946, vol I, pp. 251-2.

2. Giulio Mancini, Considerazioni sulla Pittura, edited by Adriana Marucchi, Rome 1956, vol. I, p.223

3. José López-Rey, Idea de la imitación barroca, in "Hispanic Review". July 1943, pp. 253-7.

4. Diego Saavedra Fajardo, República literaria (published for the first time posthumously in 1655), edited by Vicente García de Diego, Madrid 1942, pp. 18-21.

5. Francisco de Quevedo, Obras completas ..., Obras en verso, edited by Luis Astrana Marín, Madrid 1932, pp. 496-9.

6. Giovanni Battista Marino, Epitalami, Venice 1646.

CATALOGUE OF EXTANT WORKS

Works have been included here which I did not mention in my last study of Velasquez. In some cases, their poor condition, noted where relevant in the caption, makes it difficult to attribute them definitely to Velásquez.

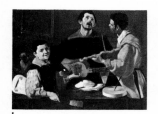

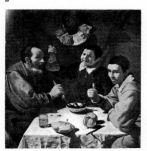

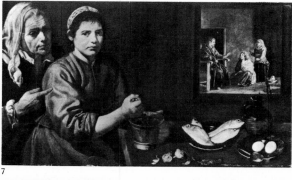

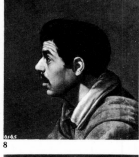

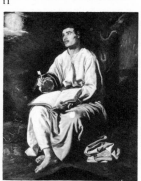

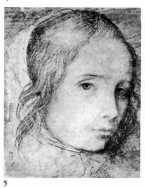

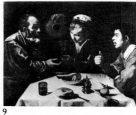

1. Three Musicians
Oil on canvas; 87 × 110 cm. (34 $\frac{1}{4}$ × 43 $\frac{1}{4}$ in.)
1617-1618
Berlin, Staatliche Museen Preussischer Kulturbesitz, Gemädegalerie (413F)

2. Child's Head
White and red chalk on yellowish paper; 21.8 × 16.8 cm. (8 $\frac{1}{2}$ × 6 $\frac{1}{2}$ in.)
1617-1618
Madrid, Private Collection.

3. Three Men at Table
Oil on canvas; 107 × 101 cm. (42 $\frac{1}{4}$ × 39 $\frac{3}{4}$ in.)
c. 1618
Leningrad, Hermitage Museum (389)

4. Bust of a Girl
Charcoal on yellowish paper; 20 × 13.5 cm. (8 × 5 $\frac{1}{4}$ in.)
c. 1618
Madrid, Biblioteca Nacional (16-40, 21)

5. Head of a Girl
Charcoal on yellowish paper; 15 × 11.7 cm. (6 × 4 $\frac{3}{4}$ in.)
c. 1618
Madrid, Biblioteca Nacional (16-40, 22)
Has been crudely retouched by another hand along the jaw-line.

6. Old Woman Frying Eggs
Oil on canvas; 99 × 116.9 cm. (39 × 46 in.)
Dated 1618
Edinburgh, National Gallery of Scotland (2180)

7. Christ in the House of Mary and Martha
Oil on canvas; 60 × 103.5 cm. (23 $\frac{3}{4}$ × 40 $\frac{3}{4}$ in.)
Dated 1618
London, National Gallery (1375)

8. Young Man in Profile
Oil on canvas; 39.5 × 35.8 cm. (15 $\frac{5}{8}$ × 14 $\frac{1}{8}$ in.)
c. 1618-1619
Leningrad, Hermitage Museum (295)

9. Girl and Two Men at Table
Oil on canvas; 96 × 112 cm. (37 $\frac{7}{8}$ × 44 $\frac{1}{4}$ in.)
1618-1619
Budapest, National Museum (3280)

10 Saint Thomas
Oil on canvas; 94 × 73 cm. (37 × 28 $\frac{3}{4}$ in.)
1618-1620
Orléans, Musée des Beaux-Arts (264)

11. The Immaculate Conception
Oil on canvas; 134.6 × 101.6 cm. (53 × 40 in.)
c. 1619
London, National Gallery (6424)

12. Saint John on Patmos writing the Apocalypse
Oil on canvas; 135.8 × 102.3 cm. (53 $\frac{1}{2}$ × 40 $\frac{1}{4}$ in.)
c. 1619
London, National Gallery (6264)

13 The Adoration of the Magi
Oil on canvas; 204 × 126 cm. (80 $\frac{1}{4}$ × 49 $\frac{1}{4}$ in.)
Dated 1619
Madrid, Prado (1166)

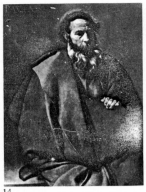

14

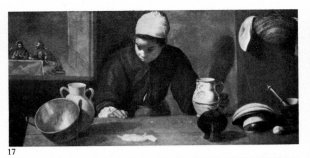

17

22

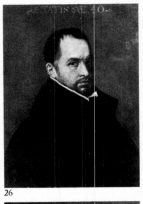

26

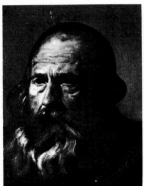

15

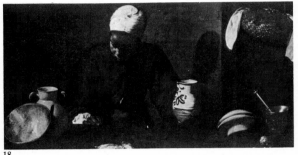

18

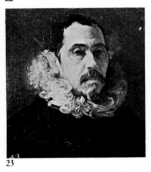

23

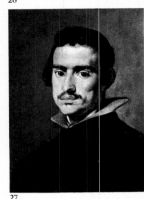

27

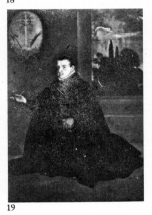

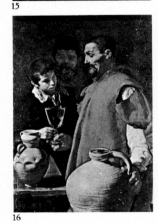

16

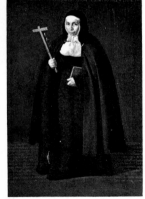

19

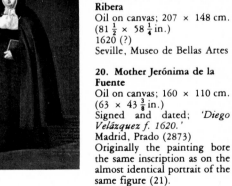

21

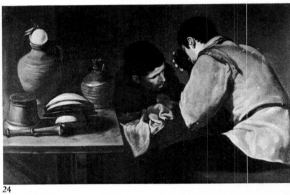

24

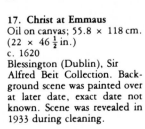

20

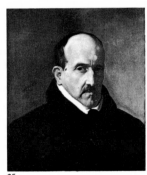

25

14 Saint Paul
Oil on canvas; 98 × 78 cm.
(38⅝ × 30¾ in.)
c. 1619-1620
Barcelona, Museo de Bellas
Artes de Cataluña (24242)

15. Saint Paul (?)
Oil on canvas; 38 × 29 cm.
(15 × 11½ in.)
Madrid, Countess de Saltes
Collection
The bad state of the canvas
does not permit positive attri-
bution to Velásquez, although
in theory this is quite feasible.

16. The Waterseller
Oil on canvas; 106.5 × 82 cm.
(42 × 32¼ in.)
c. 1620
London, Wellington Museum,
Apsley House (1600)

17. Christ at Emmaus
Oil on canvas; 55.8 × 118 cm.
(22 × 46½ in.)
c. 1620
Blessington (Dublin), Sir
Alfred Beit Collection. Back-
ground scene was painted over
at later date, exact date not
known. Scene was revealed in
1933 during cleaning.

18. The Scullery-maid
Oil on canvas; 55 × 104 cm.
(21¾ × 41 in.)
c. 1620
Chicago, Art Institute
Replica of above (17) without
background scene.

**19. Father Cristobal Suárez de
Ribera**
Oil on canvas; 207 × 148 cm.
(81½ × 58¼ in.)
1620 (?)
Seville, Museo de Bellas Artes

**20. Mother Jerónima de la
Fuente**
Oil on canvas; 160 × 110 cm.
(63 × 43⅜ in.)
Signed and dated; *'Diego
Velázquez f. 1620.'*
Madrid, Prado (2873)
Originally the painting bore
the same inscription as on the
almost identical portrait of the
same figure (21).

**21. Mother Jerónima de la
Fuente**
Oil on canvas; 160 × 106 cm.
(63 × 41¾ in.)
Signed and dated: *'Diego
Velázquez f. 1620'*
Madrid, Fernández de Aroaz
Collection

**22. Saint Idelfonso receiving
the chasuble from the Virgin
Mary**
Oil on canvas; 165 × 115 cm.
(64¾ × 45¼ in.)
Beginning 1620 (?)
Seville, Museo de Bellas Artes

23. Man with a Goatee Beard
Oil on canvas; 40 × 36 cm.
(15¾ × 14¼ in.)
1620-1622
Madrid, Prado (1209)

24. Two Young Men at Table
Oil on canvas; 64.5 × 104 cm.
(25½ × 41 in.)
c. 1622
London, Wellington Museum,
Apsley House (1593)

**25. Don Luis de Góngora y
Argote**
Oil on canvas; 51 × 41 cm.
(20¼ × 16¼ in.)
1622
Boston, Museum of Fine Arts
(23.79) Maria Antoinette
Evans Fund

26. Portrait of an Ecclesiastic
Oil on canvas; 66.5 × 51 cm.
(26¼ × 20¼ in.)
1622-1623
Madrid, Private Collection

27. Portrait of a Young Man
Oil on canvas; 56 × 39 cm.
(22¼ × 15½ in.)
1623-1624
Madrid, Prado (1224)

28

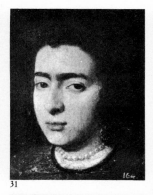

31

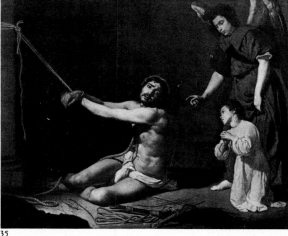

35

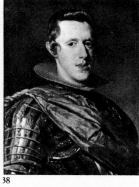

38

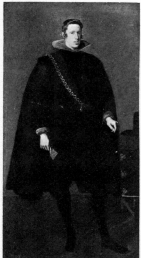

29

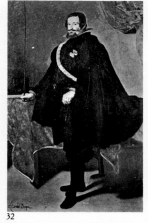

32

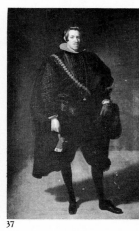

36

39

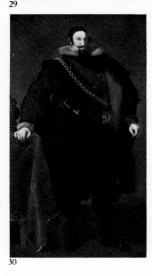

30

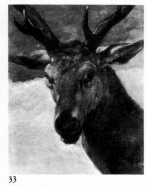

33

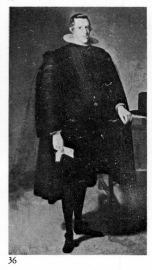

37

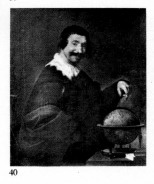

40

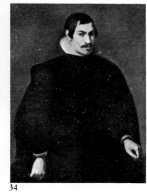

34

28. Philip IV
Oil on canvas; 61.6 ×
48.2 cm. (24½ × 19 in.)
1623-1624
Dallas (Texas) The Meadows
Museum at Southern
Methodist University (67.23)

29. Philip IV
Oil on canvas; 199.9 ×
102.8 cm. (78½ × 40½ in.)
1624
New York, Metropolitan Mus-
eum of Art (14.40.639)
bequeathed by Benjamin
Altmann, 1913

30. Count-Duke Olivares
Oil on canvas; 201.2 ×
111.1 cm. (79½ × 43¾ in.)
1624
San Paolo (Brasil), Museu de
Arte

31. Head of a Woman
Oil on canvas; 32 × 24 cm.
(12¾ × 13½ in.)
c. 1625
Madrid, Royal Palace

32. Count-Duke Olivares
Oil on canvas; 216 ×
129.5 cm. (85¼ × 51 in.)
1625 (?)
New York, The Hispanic
Society of America (A 104)
The condition of the canvas
and the lack of accurate
documentation as regards the
commissioner of the painting,
its execution and early
provenance make it impossible
to attribute it definitely to
Velásquez.

33. Head of a Stag
Oil on canvas; 66 × 52 cm
(26 × 20½ in.)
1626-1627
Madrid, Viscount de Baigueur
Collection

34. Portrait of a Man
Oil on canvas; 104 × 79 cm.
(41 × 31¼ in.)
1626-1628
New York, location unknown
Attribution to Velásquez
uncertain.

**35. The Christian Soul Con-
templating Christ After the
Flagellation**
Oil on canvas; 165 × 206 cm.
(65 × 81¾ in.)
1626-1628
London, National Gallery
(1148)

36. Philip IV
Oil on canvas; 198 × 102 cm.
(22½ × 17½ in.)
Painted originally in 1623, and
then repainted by Velásquez in
about 1628.
Madrid, Prado (1182)

37. Infante Carlos
Oil on canvas; 209 × 126 cm.
(82¼ × 49¼ in.)
1628
Madrid, Prado (1188)

38. Philip IV
Oil on canvas; 57 × 44 cm.
(22½ × 17½ in.)
c. 1628
Madrid, Prado (1183)

**39. The Court Jester
Calabazas**
Oil on canvas; 175.5 × 106.7
cm. (69¼ × 42 in.)
c. 1628-1629
Cleveland, The Cleveland
Museum of Art (65.15)

40. Democritus
Oil on canvas; 98 × 80 cm.
(88¾ × 31½ in.)
1628-1629
Rouen, Musée des Beaux-Arts

179

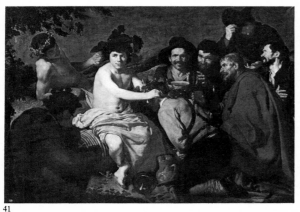

41

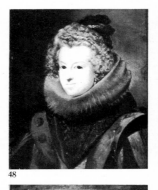

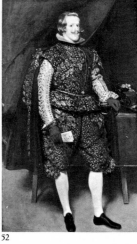

45

48

52

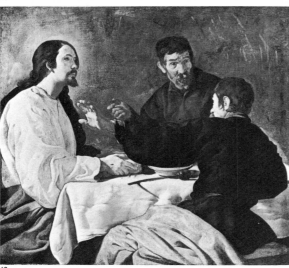

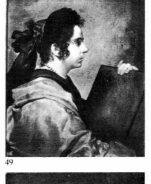

46

49

42

53

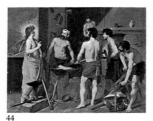

47

50

43

44

51

54

41. The Triumph of Bacchus (The Topers)
Oil on canvas; 165 × 227 cm. (64 $\frac{3}{4}$ × 88 $\frac{1}{2}$ in.)
Probably begun in 1628; finished before 22nd July, 1629.
Madrid, Prado (1170)

42. The Supper at Emmaus
Oil on canvas; 123 × 132.6 cm. (48 $\frac{1}{2}$ × 52 $\frac{1}{4}$ in.)
1628-1629
New York, Metropolitan Museum of Art (14.40.631)

43. Joseph's Coat Brought to Jacob
Oil on canvas; 217 × 285 cm. (85 $\frac{3}{4}$ × 112 $\frac{3}{4}$ in.)
1630
Salas Capitulares, Palace of the Escorial

44. The Forge of Vulcan
Oil on canvas; 223 × 290 cm. (87 $\frac{3}{4}$ × 114 in.) (including additions)
1630
Madrid, Prado (1171)

45. Study for the head of Apollo in the Forge of Vulcan
Oil on canvas; 36 × 25 cm. (14 $\frac{1}{4}$ × 10 in.)
1630
New York, location unknown

46. View from the Villa Medici in Rome
Oil on canvas; 44 × 38 cm. (17 $\frac{1}{2}$ × 15 in.)
1630
Madrid, Prado (1211)

47. View from the Villa Medici in Rome
Oil on canvas; 48 × 42 cm. (19 × 16 $\frac{1}{2}$ in.)
1630
Madrid, Prado (1210)

48. Infanta Doña Maria, Queen of Hungary
Oil on canvas; 58 × 44 cm. (23 × 17 $\frac{1}{4}$ in.)
1630
Madrid, Prado (1187)

49. Portrait of a Woman as a Sibyl (?)
Oil on canvas; 62 × 50 cm. (24 $\frac{1}{2}$ × 19 $\frac{3}{4}$ in.)
1630-1631
Madrid, Prado (1197)

50. Portrait of Young Man
Oil on canvas; 89.2 × 69.5 cm. (35 $\frac{1}{4}$ × 27 $\frac{1}{2}$ in.)
1630-1631
Munich, Bayerische Staatsgemäldesammlungen (518)

51. Prince Baltasar Carlos with a Dwarf
Oil on canvas; 136 × 104 cm. (53 $\frac{1}{2}$ × 41 in.)
1631
Boston, Museum of Fine Arts (01.104)

52. Philip IV in Brown and Silver
Oil on canvas; 199.5 × 113 cm. (78 $\frac{1}{2}$ × 44 $\frac{1}{2}$ in.)
1631-1632
London, National Gallery (1129)
The figure portrayed holds in his hand a piece of paper bearing the inscription: *'Senor... Diego Velázquez, Pintor de V. Mg.'*

53. Queen Isabella
Oil on canvas; 203 × 114 cm. (80 × 45 in.)
1631-1632
Zurich, Private collection

54. Doña Antonia de Ipeñarrieta y Galdós
Oil on canvas; 215 × 110 cm. (85 × 43 $\frac{1}{2}$ in.)
1631-1632
Madrid, Prado (1196)
Pendant of no. 55

55

56

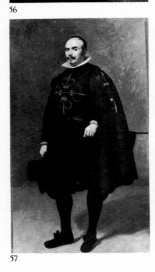

57

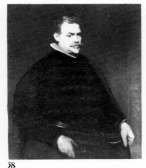

58

59

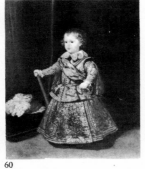

60

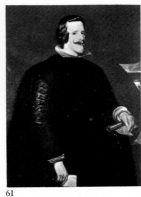

61

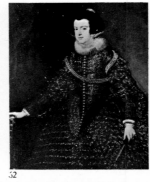

62

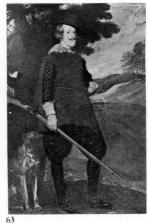

63

63

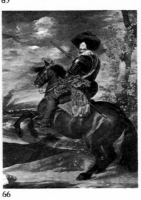

64

64

65

66

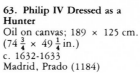

67

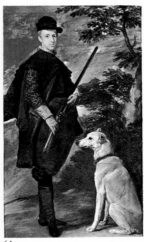

68

55. Don Diego del Corral y Arellano
Oil on canvas; 215 × 110 cm. (85 × 43 ½ in.)
1631-1632
Madrid, Prado (1195)
Pendant of no. 54

56. Hand of an Ecclesiastic
Oil on canvas; 27 × 24 cm. (10 ¾ × 9 ½ in.)
1630-1640
Madrid, Royal Palace

57. Don Pedro de Barberana y Aparregui
Oil on canvas; 198.2 × 111.8 cm. (78 ¼ × 44 ¼ in.)
1631-1632
New York, Private Collection

58. Don Juan Mateos
Oil on canvas; 108 × 89.5 cm. (42 ½ × 35 ¼ in.)
c. 1632
Dresden, Staaliche Kunstsammlungen, Gemäldegalerie (697)

59. Crucified Christ
Oil on canvas; 248 × 169 cm. (97 ½ × 66 ¾ in.)
c. 1632
Madrid, Prado (1167)

60. Prince Baltasar Carlos
Oil on canvas; 118 × 95.5 cm. (46 ½ × 37 ¾ in.)
1632
London, Wallace collection (12)

61. Philip IV
Oil on canvas; 127.5 × 86.5 cm. (50 ¼ × 34 ¼ in.)
1632
Vienna, Kunsthistorisches Museum (314)
It is probable that Velásquez entrusted most of this work to an assistant.

62. Queen Isabella
Oil on canvas; 132 × 106.5 cm. (52 × 42 in.)
1632
Vienna, Kunsthistorisches Museum (731)
Apart from the head, much of this portrait must have been painted by assistants.

63. Philip IV Dressed as a Hunter
Oil on canvas; 189 × 125 cm. (74 ¾ × 49 ¼ in.)
c. 1632-1633
Madrid, Prado (1184)

64. Cardinal-Infante Fernando Dressed as a Hunter
Oil on canvas; 191 × 109 cm. (75 ½ × 43 in.)
c. 1632-1633
Madrid, Prado (1186)

65. The Jester Don Juan of Austria
Oil on canvas; 210 × 133 cm. (73 × 52 ½ in.)
1632-1633
Madrid, Prado (1200)

66. Count-Duke Olivares on Horseback
Oil on canvas; 313 × 242 cm. (124 × 95 ¾ in.)
c. 1634-1635
Madrid, Prado (1181)

67. White Horse
Oil on canvas; 310 × 245 cm. (122 ¾ × 97 in.)
c. 1634-1635
Madrid, Royal Palace

68. Philip III on Horseback
Oil on canvas; 300 × 314 cm. (118 ½ × 124 in.) (including additions)
1628, 1634-1635
Madrid, Prado (1176)
Probably started by Velásquez in 1628 and finished by a lesser painter during the artist's absence from Spain in the period 1629-1631. The artist then went over it with the help of an assistant in 1634-1635.

69

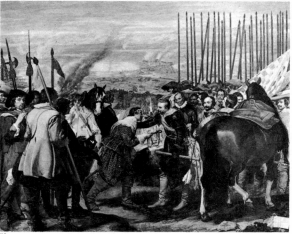
73

77

80

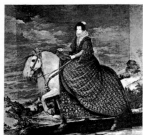
70

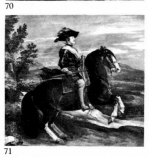
71

74

75

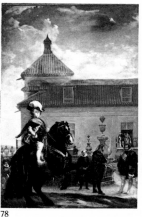
78

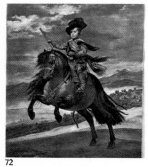
72

76

79

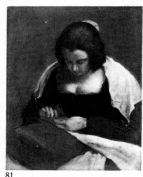
77

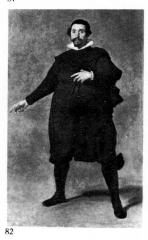
81

82

69. Queen Margarita of Austria on Horseback
Oil on canvas; 297 × 309 cm.
(117 $\frac{1}{4}$ × 122 $\frac{1}{4}$ in.) (including additions)
1628, 1634-35
Madrid, Prado (1177)
As with 68, this portrait was also probably started in 1628 by Velásquez and finished by a lesser painter during the artist's absence from 1629-1631; later repainted by the artist with the aid of an assistant in 1634-1635.

70. Queen Isabella on Horseback
Oil on canvas; 301 × 318 cm.
(119 × 125 $\frac{1}{2}$ in.)
1628, 1634-35
Madrid, Prado (1179)
Very probably started by Velásquez in the autumn of 1628 and finished by another painter during the artist's visit to Italy in 1629-1631. In 1634-1635 Velásquez repainted the bust and head of the Queen, as well as the white horse and a good deal of the landscape.

71. Philip IV on Horseback
Oil on canvas; 301 × 318 cm.
(119 × 125 $\frac{1}{2}$ in.)
1634-1635
Madrid, Prado (1178)

72. Prince Baltasar Carlos on Horseback
Oil on canvas; 210 × 175 cm.
(82 $\frac{1}{4}$ × 68 in.) (including additions)
1634-1635
Madrid, Prado (1180)

73. The Surrender of Breda
Oil on canvas; 307 × 370 cm.
(120 $\frac{1}{2}$ × 125 in.)
1634-1635
Madrid, Prado (1172)

74. Study for the Surrender of Breda
Black chalk on yellowish paper; 26.2 × 16.8 cm.
(10 $\frac{1}{2}$ × 6 $\frac{3}{4}$ in.)
1634-1635
Madrid, Biblioteca Nacional (16-40, 20)

75. Study for the figure of General Spinola in the Surrender of Breda
Black chalk on yellowish paper; 26.2 × 16.8 cm. (10 $\frac{1}{2}$ × 6 $\frac{3}{4}$ in.)
1634-1635
Madrid, Biblioteca Nacional (16-40, 20)
'Velázquez' written in ink, has been added at a later date. Verso of previous study.

76. Martinez Montanes
Oil on canvas; 109 × 83.5 cm.
(43 × 33 in.)
1635-1636
Madrid, Prado (1194)

77. Prince Baltasar Carlos Dressed as a Hunter
Oil on canvas; 190 × 103 cm.
(75 × 40 $\frac{1}{2}$ in.)
End 1635 or 1636
Madrid, Prado (1189)
Inscription on canvas 'Anno aetatis suae VI' confirms that the prince was six years old when the picture was painted.

78. Prince Baltasar Carlos with Count-Duke Olivares at the Royal Stables
Oil on canvas; 144 × 91 cm.
(56 $\frac{3}{4}$ × 36 in.)
c. 1636
Eccleston (Chester), Grosvenor Estate
Studio painting, retouched extensively by Velásquez.

79. Lady with a Fan
Oil on canvas; 93 × 68.5 cm.
(36 $\frac{3}{4}$ × 27 in.)
Middle of decade 1630-1640
London, Wallace Collection (88)

80. Young Woman
Oil on canvas; 98 × 49 cm.
(38 $\frac{3}{4}$ × 19 $\frac{1}{4}$ in.)
Middle of decade 1630-1640
Chatworth, Duke of Devonshire's Collection

81. Woman Sewing
Oil on canvas; 74 × 60 cm.
(29 $\frac{1}{4}$ × 23 $\frac{3}{4}$ in.)
c. 1635-1642/43
Washington, National Gallery of Art (81)
Unfinished.

82. Pablo de Valladolid
Oil on canvas; 209 × 125 cm.
(82 $\frac{1}{2}$ × 49 $\frac{1}{4}$ in.)
c. 1636-1637
Madrid, Prado (1198)

83

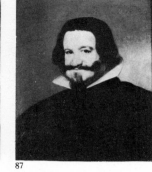

87

89

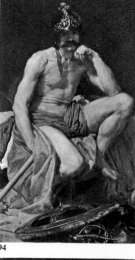

94

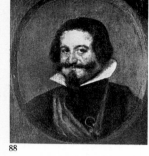

84

88

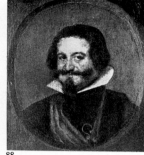

92

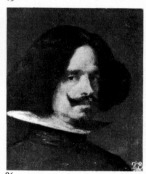

95

85

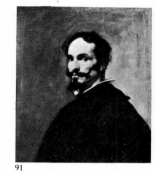

90

91

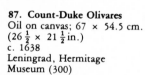

93

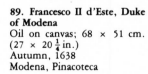

96

83. The Court Jester Calabacillas (Calabazas)
Oil on canvas; 106 × 83.5 cm. (41 ¾ × 32 ¾ in.)
1637-1639
Madrid, Prado (1205)

84. The Court Jester Don Christobal de Castañeda y Pernia
Oil on canvas; 198 × 121 cm. (78 × 47 ¾ in.)
1637-1640
Madrid, Prado (1199)
Unfinished. Part of the Turkish costume of the jester has been painted at a later date, apparently some time between 1772 and 1794.

85. Saint Anthony Abbot and Saint Paul the Hermit
Oil on canvas; 260 × 192 cm. (102 ¾ × 75 ¼ in.)
Middle or end of decade 1630-1640
Madrid, Prado (1169)

86. Study for the head of Saint Anthony Abbot
Oil on canvas; 56 × 40.5 cm. (22 ¼ × 16 in.)
Middle or end of decade 1630-1640
Geneva, Private collection (Not illustrated). Preparatory study for 85.

87. Count-Duke Olivares
Oil on canvas; 67 × 54.5 cm. (26 ½ × 21 ½ in.)
c. 1638
Leningrad, Hermitage Museum (300)

88. Count-Duke Olivares
Oil on copper; 10 × 10 cm. (4 × 4 in.)
c. 1638
Madrid, Royal Palace

89. Francesco II d'Este, Duke of Modena
Oil on canvas; 68 × 51 cm. (27 × 20 ¼ in.)
Autumn, 1638
Modena, Pinacoteca

90. Prince Baltasar Carlos
Oil on canvas; 128.5 × 99 cm. (50 ½ × 39 in.)
c. 1639
Vienna, Kunsthistorisches Museum (312)
The figure's face appears to be the work of Velásquez: the artist probably sketched the whole composition himself, but entrusted the actual execution to an assistant.

91. Portrait of Bearded Man
Oil on canvas; 76 × 64.8 cm. (30 × 25 ¾ in.)
End of decade 1630-1640
London, Wellington Museum, Apsley House (125)

92. Aesop
Oil on canvas; 179 × 94 cm. (70 ¾ × 37 ¼ in.)
c. 1639-1641
Madrid, Prado (1206)

93. Menippus
Oil on canvas; 179 × 94 cm. (70 ¾ × 37 ¼ in.)
c. 1639-1641
Madrid, Prado (1207)

94. Mars
Oil on canvas; 167 × 97 cm. (70 ½ × 37 ½ in.)
c. 1639-1641
Madrid, Prado (1208)

95. Don Francisco Bandrés de Abarca
Oil on canvas; 64 × 53 cm. (25 ¼ × 21 in.)
1637/39-1640/43
New York, Private Collection

96. Self-Portrait
Oil on canvas; 45.5 × 38 cm. (18 × 15 ¼ in.)
After 1640 (?)
Valencia, Museo de Bellas Artes

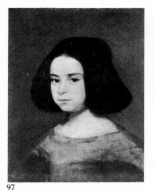

97

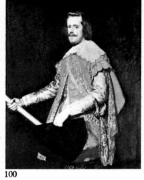

100

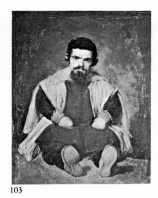

103

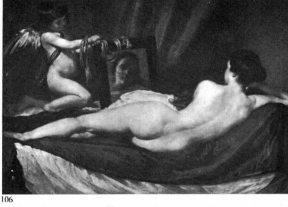

106

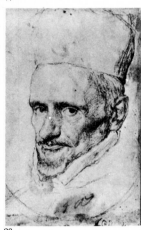

98

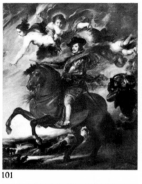

101

104

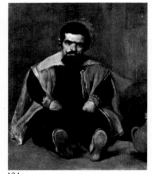

102

105

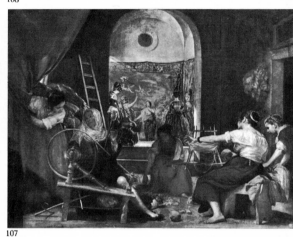

107

99

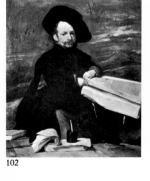

108

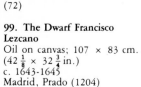

109

97. Portrait of a Girl
Oil on canvas; 51.5 × 41 cm.
(20 ½ × 16 ¼ in.)
Beginning of decade 1640/
1650
New York, The Hispanic Society of America (A 108)
Unfinished.

98. Head of Cardinal Borgia
Black chalk on white paper glued onto another sheet of paper bearing an inscription dating from the middle of the nineteenth century:
'El Cardenal Borja, Arzobispo de Toledo, dibujado pr. d. Diego Velázquez.'
1643-1645
18.6 × 11.7 cm. (7 ½ × 4 ¼ in.)
Madrid, Real Academia de Bellas Artes de San Fernando (72)

99. The Dwarf Francisco Lezcano
Oil on canvas; 107 × 83 cm.
(42 ⅛ × 32 ¾ in.)
c. 1643-1645
Madrid, Prado (1204)

100. Philip IV in the Uniform of Commander-in-Chief
Oil on canvas; 133.5 × 98.5 cm. (52 ¼ × 40 in.)
June 1644
New York, Frick Collection (138)

101. Allegorical Portrait of Philip IV
Oil on canvas; 339 × 267 cm.
(133 ¾ × 105 ½ in.)
c. 1645
Florence, Galleria degli Uffizi
Velásquez painted only the head of the King; the rest is a studio copy from a portrait (now lost), also of Philip IV, painted by Rubens during his stay in Madrid in 1628-1629.

102. Dwarf with a Book on his Knee
Oil on canvas; 107 × 84 cm.
(42 ¼ × 32 ½ in.)
Middle of decade 1640-1650
Madrid, Prado (1201)

103. Dwarf Sitting on the Floor
Oil on canvas; 107 × 82 cm.
(41 ¾ × 31 ¾ in.)
Middle of decade 1640-1650
Madrid, Prado (1202)

104. Dwarf Sitting Near a Pitcher
Oil on canvas; 103 × 82 cm.
(40 ¾ × 31 ¾ in.)
Middle of decade 1640-1650
New York, Private collection
Copy of no. 103 and probably executed by Velásquez and an assistant.

105. The Coronation of the Virgin
Oil on canvas; 179 × 135 cm.
(69 ½ × 49 in.)
Middle of decade 1640-1650
Madrid, Prado (1168)

106. The Rokeby Venus (the Toilet of Venus)
Oil on canvas; 122.5 × 177 cm. (48 × 70 in.)
c. 1644-1648
London, National Gallery (2057)

107. The Spinners ('Las Hilanderas')
Oil on canvas; 220 × 290 cm.
(87 × 114 in.) (including additions)
c. 1644-1648
Madrid, Prado (1173)
This painting is also called the 'Fable of Arachne'.

108. Arachne
Oil on canvas; 64 × 58 cm.
(25 ¼ × 23 in.)
c. 1644-1648
Dallas (Texas), The Meadows Museum at Southern Methodist University (74.1)

109. Infanta Maria Teresa
Oil on canvas; 48 × 37 cm.
(19 × 14 ½ in.)
1648
New York, Metropolitan Museum of Art, The Robert Lehman Collection

110

113

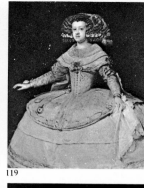

116

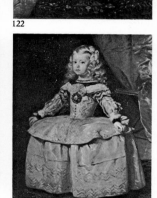

119

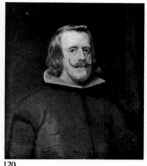

114

117

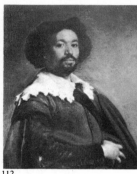

111

120

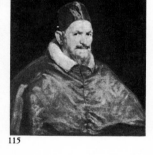

123

115

112

118

121

110. Knight of the Order of Saint John
Oil on canvas; 66.5 × 56 cm.
(26 $\frac{1}{4}$ × 22 $\frac{1}{4}$ in.)
End of decade 1640-1650
Dresden, Staatliche
Kunstsammlungen,
Gemäldegalerie (698)

111. Girl
Oil on canvas; 60 × 46.5 cm.
(23 $\frac{3}{4}$ × 18 $\frac{1}{2}$ in.)
1645-1650
New York, Private Collection
Unfinished.

112. Juan de Pareja
Oil on canvas; 81.3 × 69.9 cm. (32 $\frac{1}{4}$ × 27 $\frac{1}{2}$ in.)
1649 or 1650
New York, Metropolitan Museum of Art (1971.86)

113. Portrait of a Man (known as 'the Pope's barber')
Oil on canvas; 48.3 × 44.4 cm. (19 $\frac{1}{4}$ × 17 $\frac{1}{2}$ in.)
1650
New York, Private Collection

114. Pope Innocent X
Oil on canvas; 140 × 120 cm.
(55 $\frac{1}{4}$ × 47 $\frac{1}{4}$ in.)
1650
Rome, Galleria Doria-Pamphilj
The sheet of paper in the Pope's hand bears the words: *'Alla Santa di Nro Sigre Innocencio Xo per Diego de Silva Velázquez dela Camera di s. Mta Gatta.'*

115. Pope Innocent X
Oil on canvas; 78 × 68 cm.
(30 $\frac{3}{4}$ × 27 in.)
1650
London, Wellington Museum, Apsley House (1590)
The head is certainly painted by Velásquez, but the garments and background are by another hand. Copy of 114.

116. Monsignor Camillo Massimi
Oil on canvas; 73.6 × 58.5 cm. (29 $\frac{1}{4}$ × 23 $\frac{1}{4}$ in.)
1650
Wimborne (Dorset)
Kingston Lacy, Ralph Bankes Collection (87)

117. Cardinal Astalli
Oil on canvas; 61 × 48.5 cm.
(24 $\frac{1}{4}$ × 19 $\frac{1}{4}$ in.)
1650 or 1651
New York, The Hispanic Society of America (A 101)

118. Infanta Maria Teresa
Oil on canvas; 44.4 × 40 cm.
(17 $\frac{1}{2}$ × 16 in.)
1651-1652
New York, Metropolitan Museum of Art

119. Infanta Maria Teresa
Oil on canvas; 127 × 98.5 cm.
(50 × 38 $\frac{1}{2}$ in.)
End 1652 or beginning 1653
Vienna, Kunsthistorisches Museum, Gemäldegalerie
(353)

120. Philip IV
Oil on canvas; 69 × 56 cm.
(27 $\frac{1}{4}$ × 22 in.)
1652-1653
Madrid, Prado (1185)

121. Queen Mariana
Oil on canvas; 231 × 131 cm.
(91 $\frac{1}{4}$ × 51 $\frac{3}{4}$ in.) (including an addition along the top edge)
1652-1653
Madrid, Prado (1191)
The upper part of the curtain was painted by another hand on a piece of canvas added to the original composition.

122. Infanta Margarita
Oil on canvas; 128.5 × 100 cm. (50 $\frac{1}{2}$ × 39 $\frac{1}{2}$ in.)
1653
Vienna, Kunsthistorisches Museum, Gemäldegalerie
(321)

123. Infanta Margarita
Oil on canvas; 105 × 88 cm.
(41 × 34 $\frac{1}{2}$ in.)
c. 1656
Vienna, Kunsthistorisches Museum, Gemäldegalerie
(3691)

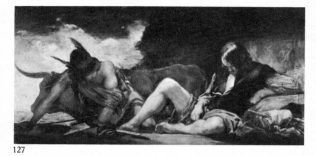

127

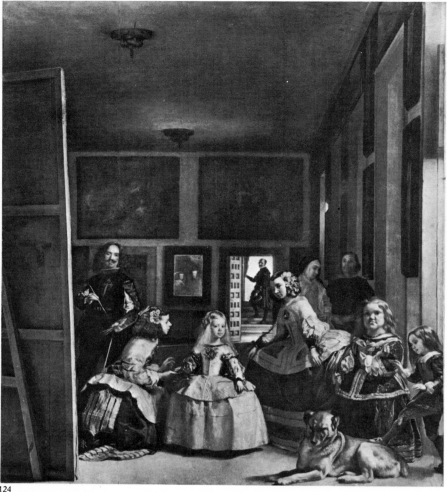

124

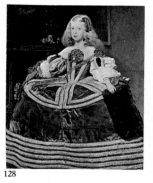

128

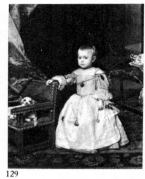

129

124. Las Meninas (The Ladies in Waiting)
Oil on canvas; 318 × 276 cm.
(125 × 118 $\frac{1}{2}$ in.)
1656
Madrid, Prado (1174)

127. Mercury and Argus
Oil on canvas; 127 × 250 cm.
(50 × 98 $\frac{1}{2}$ in.)
c. 1659
Madrid, Prado (1175)

128. Infanta Margarita in blue
Oil on canvas; 127 × 107 cm.
(50 × 42 $\frac{1}{8}$ in.)
1659
Vienna, Kunsthistorisches
Museum, Gemäldegalerie
(2130)

129. Prince Felipe Prospero
Oil on canvas; 128.5 ×
99.5 cm. (50 $\frac{1}{2}$ × 39 in.)
1659
Vienna, Kunsthistorisches
Museum, Gemäldegalerie
(319)

125

126

125. Queen Mariana
Oil on canvas; 46.5 × 43 cm.
(18 $\frac{1}{2}$ × 17 in.) (including additions)
c. 1656-1657
Dallas (Texas), The Meadows Museum at Southern Methodist University (78.01)

126. Queen Mariana
Oil on canvas; 64.7 ×
54.6 cm. (25 $\frac{1}{2}$ × 21 $\frac{3}{4}$ in.)
c. 1656-1657
Lugano-Castagnola, Baron Thyssen-Bornemisza (435)

Bibliography

For biographical details not mentioned in the text see *Arte de la Pintura* by Pacheco or *Varia velazqueña*, quoted in the following list:

SOURCES

V. Carducho. *Dialogos de la Pintura*, Madrid 1633 (published in 1634)

Instituto Diego Velázquez, *Velázquez: Biografías de los siglos XVII y XVIII. Comentarios a él dedicados en los siglos XVII y XVIII. Su biografía a través de cartas y documentos contemporáneous. Autográfos. Facsimiles de documentos e impresos – Homenaje en el tercer centenario de su muerte.* Madrid 1960.

Ministero de Educación Nacional, Dirección General de Bellas Artes, *Varia velazquena, Homenaje a Velázquez en el III contenario de su muerte. 1660-1960,* vol. II, *Elogios poéticos – Textos y comentarios críticos – Documentos – Cronología* vol. II, – Madrid 1960. Includes the major part of the documents relating to Velásquez' life and works; the transcriptions, however, contains many errors and literals.

F. Pacheco, *Arte de la Pintura*, edited by F. J. Sánchez Cantón, 2 vols., Madrid 1956. Pacheco finished his manuscript on 24 January 1638, but the book did not appear until 1649, in Seville, five years after the death of the author.

A. Palomino Velasco, *El Museo pictórico*, Madrid 1947; first edition: 1724. Palomino notes that his biography of Velásquez partly uses 'some details on the life of Velásquez' by Juan de Alfaro, Velásquez' pupil in about 1650.

M.R. Zarco del Valle. *Documentos inéditos para la historia de las Bellas Artes en España*, Madrid 1870.

MONOGRAPHS

The volumes marked with an asterisk include a catalogue of works.

J. Allende-Salazar, *Velázquez, Des Meisters Gemälde*, vol. VI di *Klassiker der Kunst*, 4th edition Berlin and Leipzig n.d. (1925)

P.M. Bardi, *L'opera completa di Velázquez*, Milan 1969.

A. de Beruete, *Velázquez*, Paris 1898; English edition: London n.d. (1906); German edition: Berlin 1909. Although written originally in Spanish, this work has never been published in Spanish.

A. Borelius, *Etudes sur Velázquez*, Linköping 1949

R. Causa, *Velázquez*, Milan 1965

G. Cruzada Villaamil *Anales de la vida y de las obras de Diego de Silva y Velázquez*, Madrid 1885. This volume includes many hitherto unpublished documents.

C. B. Curtis, *Velázquez and Murillo*, London and New York 1883.

K. Gerstenberg, *Diego Velázquez*, Munich and Berlin 1957.

J. Gudiol, *Velázquez*, Barcelona 1973.

K. Justi, *Diego Velázquez and sein Jahrhundert*, Bonn 1888; 2nd edition revised by the author: Bonn 1903; 3rd edition: Bonn 1922; 4th edition edited by Ludwig Justi: Zurich 1933; English edition abridged and revised by the author: *Diego Velázquez and his times*, London 1889; Spanish translation: *Velázquez y su siglo*, Madrid 1953; Italian translation: *Velázquez e il suo tempo*. Florence 1948.

E. Lafuente Ferrari. *Velázquez*, London 1943.

E. Lafuente Ferrari. *Velázquez*, Barcelona 1944.

J. López-Rey, *Velázquez: a catalogue raisonné of his oeuvre*. With an introductory study, London 1963.

J. López-Rey, *Velázquez' Work and World*, London 1968.

J. López-Rey, *Velázquez: The artist as a maker*. With a catalogue raisonné of his extant works, Lausanne 1978.

A.L. Mayer, *Kleine Velázquez-Studien*. Munich 1913.

A.L. Mayer, *Diego Velázquez*. Berlin 1924.

A.L. Mayer, *Velázquez. A catalogue raisonné of the pictures and drawings*. London 1936.

J. Ortega y Gasset, *Papeles sobre Velázquez y Goya*, Madrid 1950.

R.A.M. Stevenson, *The Art of Velázquez*, London 1895; 2nd edition revised: *Velázquez*, London 1899; 3rd edition: London 1962; German translation: *Velázquez*, Munich 1904.

W. Stirling, *Velázquez and his works*, London 1855; French translation: *Velázquez et ses oeuvres*, Paris 1865 (with a catalogue of works edited by W. Bürger, pseudonym of Etienne Joseph Thoré). Chronologically the first monograph on Velásquez and the first catalogue of Velásquez' works.

E. Trapier du Gué, *Velázquez*, New York 1948.

P. Troutman, *Velasquez*, London 1966.

Index

The numbers in italics refer to illustrations

Photographic References

A = above; B = below; C = centre; R = right; L = left;

AME archive: pp. 12, 17, 28A, 40L, 41L, 44L, 50, 51, 62A, 64, 66, 82, 88, 96, 114, 121, 130, 164, 167. Courtesy of the Hispanic Society of America, New York: p. 128R. Freeman: pp. 16-17. Gallery Photography and Company (Jackson): pp. 25, 126-127. Kodansha: pp. 62, 65, 67, 68, 86, 101, 104, 109, 110, 112, 128L, 132, 149, 157, 162, 165, 173. Manso: pp. 49, 74-75, 90-91, 93, 102-103, 116-117, 124-125, 144-145, 160-161, 168-169. MAS: pp. 6, 8A, 10, 11, 19, 24, 30, 31R, 39, 44R, 45, 46, 59A, 69, 72, 74, 85, 89A, 100, 105, 118, 128R, 151R, 153. Meyer: pp. 155, 163, 172, 174-175. Nimatallah: pp. 113, 127. Novosti: pp. 9, 18, 119. Savio: pp. 2-3, 150. Scala: pp. 37, 41R, 54-55, 58, 59B, 60-61, 63, 70, 73, 83, 89B, 120, 123, 131, 134, 137, 143, 170-171. Scott: pp. 13, 14-15. Strehorn: p. 40R. Victoria and Albert Museum, Crown Copyright: pp. 36, 151L. Courtesy of Professor Jose Lopez-Rey: pp. 71, 126, 135, 146, 148.

All photographs not specifically mentioned here have been kindly provided by the Museum or Collection in which the works are housed, whose names appear in the relevant caption.